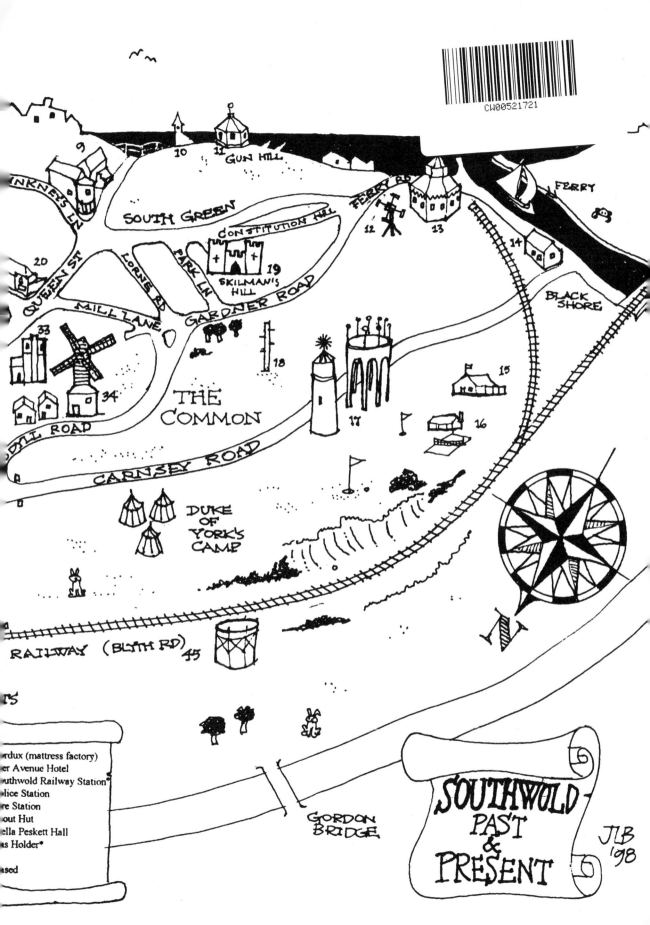

GUN HILL

FERRY

PINKNEY'S LN

SOUTH GREEN

FERRY RD

CONSTITUTION HILL

BLACK SHORE

QUEEN ST

LORNE RD

PARK LN

GARDNER ROAD

SKILMAN'S HILL

MILL LANE

33

34

DYLL ROAD

THE COMMON

18

17

15

16

CARNSEY ROAD

DUKE OF YORK'S CAMP

RAILWAY (BLYTH RD) 45

GORDON BRIDGE

SOUTHWOLD PAST & PRESENT

JLB '98

SOUTHWOLD
Portraits of an English Seaside Town

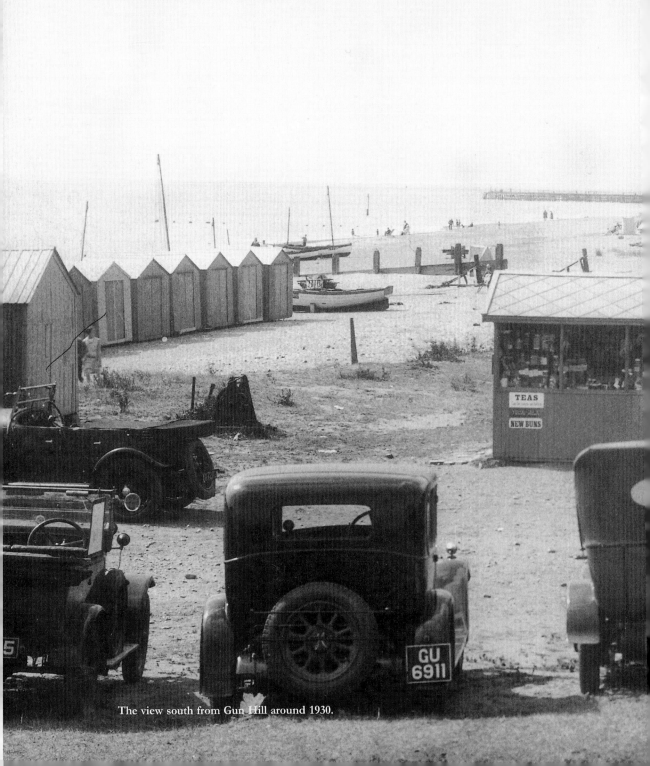

The view south from Gun Hill around 1930.

SOUTHWOLD

Portraits of an English Seaside Town

edited by
Rebecca and Stephen Clegg

Foreword by
P. D. JAMES

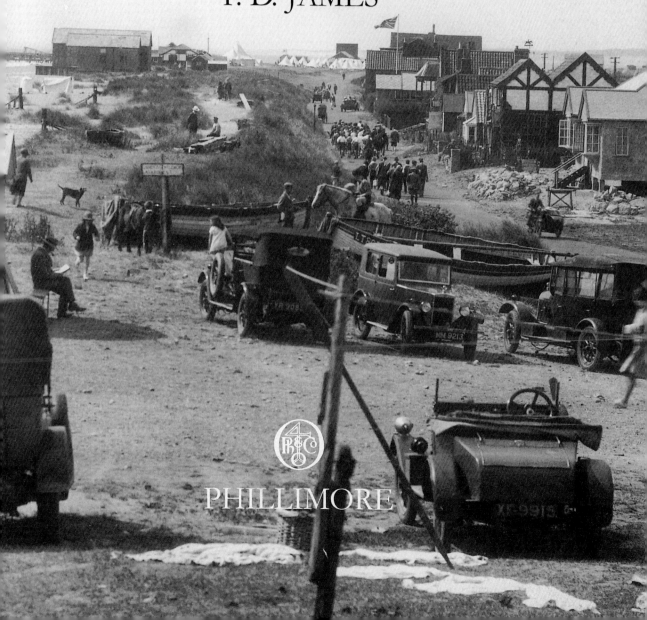

PHILLIMORE

First edition 1999
Reprinted 2004

Published by
PHILLIMORE & CO. LTD
Shopwyke Manor Barn, Chichester, West Sussex, England

ISBN 1 86077 097 5

Printed and bound in Great Britain by
BUTLER & TANNER LTD
London and Frome

Contents

Foreword

P. D. JAMES

✧

I first saw Southwold some forty-five years ago when my parents-in-law retired to Wissett.
I would visit them with my two young daughters and they would take a beach-hut for the
season. My husband and I, with the girls, would cycle to Southwold nearly every day. I fell
in love with the town then, and it is a love affair which has endured. Later my father retired
here and lived in the area until his death. For me, Southwold is peopled with many friendly
ghosts, and when I was asked by Garter King of Arms to choose a territorial designation
for my title, I was proud to become Baroness James of Holland Park of Southwold in the
County of Suffolk.

Many thousands of visitors over the years have asked themselves the same question:
why is Southwold so special? There is, of course, its beauty. Every street and every vista
holds its own particular charm, delighting eye and mind. There is the magnificent church,
one of the glories of East Anglia; the wide East Anglian skies; the bird-loud marshes; the
beach-huts, small symbols of individualism holding within their sun-warmed interiors all
the nostalgic joys of childhood. And then there is the sea, not the seaside of raucous piers,
candy-floss and the pervasive smell of fish and chips, but the North Sea, breaking
untrammelled in all its various moods on sand and shingle. Above all, Southwold is neither
artificial nor self-consciously quaint. It is progressive in the best sense of the word, honouring
and valuing the past while looking forward confidently to the future. We have a living
community of people, working or retired, of many backgrounds, experiences, interests,
trades and professions who value what Southwold has to offer and who serve it with their
love.

It is they, the people of Southwold, who have written this admirable and much-needed
new history. For me, reading the manuscript, every chapter was a delight. I congratulate
everyone concerned with this imaginative enterprise and am confident that it will be
welcomed by residents and visitors alike and will prove a lasting tribute to the history,
tradition and the vigorous contemporary life of our very special town.

P. D. James

Subscribers

in the Numbered Edition

Those numbers for which no name is given have been allocated to subscribers who wish to remain anonymous.

1 Judy and Fred Butter
2
3
4
5 Mr & Mrs M.I. Gilchrist
6 } Charles & Alice Bunbury
7 }
8 Jack & Margaret Storer
9 B.M. Challener
10 Dallas Smith
11 Mike & Frances Medland
12 Dr & Mrs R.N. Cooper
13 Dr Alan Mackley
14
15 Penelope Bray
16 Gary Doy
17 Eileen Muir
18 Nick & Yana
19 Ivor & Maggie Watkins
20
21 W.P. Clegg
22
23 Derek C. Fowler
24 } Bert Bales
25 }
26 James Grathwohl
27 Ros McDermott
28 Leslie & Jean Brinton
29 }
30 }
31 } Michael & Rachel Lawrence
32 }
33 Kathy Oliver & John Trussler
34
35
36
37 Brian Burrage
38
39 Joyce Hollingworth
40 Tony Bilson
41 Keith & Shirley Smith
42 Jane Williams
43
44 A.J. Cozens
45 Dr Christopher R. Castle
46 Derek & Sue Doy
47 Richard M. Fisk

48 Steve & Jude Webberley
49 John F. Garrood
50 Ronald Whiting
51 Bill & Peggy Cannell
52 Roger Lee & Alyson Pearce
53 Mr S. Boyes
54 Frank John Mortlock
55 Mr & Mrs John Lytton
56 }
57 } David & Shirley Smith
58 Russell Day
59 David & Kathryn Halford
60 Joy Day
61 Ian & Judith Norman
62 Jamie & Irene Thompson
63 Andrew B. Jenkins
64 }
65 } Southwold Town Council
66 R.E. Crown
67 Fiona Hayward
68 Paul Scriven
69 Mrs H.D. Denyer
70 Pamela J. Calver
71 Brian Kirk
72 Erika Clegg
73 }
74 } Bunty Lewin
75 Derek Edward Self
76 Brian & Tessa Crane
77 Diane E. Miller
78 Roger Skipsey
79 A.J. Stockwell
80 Joan Childs
81 Avis Forrester
82 Jerry & Cathy Forrester
83 Garth Blanchflower
84 Joyce Davis
85 Elizabeth Stone
86 Mr & Mrs Graham Smith
87 Edward G. Brooks
88 Mr C.R. & Mrs R.M. Salisbury
89 Pamela C. Marriner
90
91 Harold Kemp
92 Stewart Simpson
93 Mo Jackson
94 Graham & Margaret Lyons

95 }
96 } Bob Cross & Katie Whitcomb
97 The Bazeley Family
98 Rita Mary Brown
99 Michael & Anita Hall
100
101 }
102 } Jeff & Catherine Fuller
103 }
104 }
105 J.S. Austin
106
107 John Donovan
108 A. & E. Sinclair Thomson
109 John & Brenda Smith
110 Michael & Doreen Wingate
111 John R. Simpson
112
113 D. & J.D. Pope
114 Andrew J. Court
115 Doreen Thompson
116 Mr & Mrs J. Gooch
117 Simon & Chris Ive
118 Margaret Child
119 Denis Moriarty
120 Derek Brown
121 Ruth E. Chapman
122 Mary J. King
123 Dave Craddock
124 Jack Howes
125
126 Anne-Marie Elizabeth Ashford
127 Brian & Hilary Huckstep
128 Robert Powell
129 Charles & Amanda Cooper
130 Jean & Allan Cawsey
131 Daphne Pilkington
132 Mr & Mrs J.P. White
133 Mr & Mrs R.A. McMillan
134 John Alfred Barker
135 Major John William Denny
136 Mrs Gladys Sadler
137 Nita Thompson
138
139 Adrian & Terry Barnard
140 }
141 } Barrie & Barbara Martin

142	196 Mary Nuttall	250 Gordon Hawley
143	197 Francis Wright	251 Lord Remnant of Wenhaston
144 D.K.G.J. Boddey	198 Stephen Foot	252 Mike & Jenny Coates
145 Mrs I. Robertson	199 Mr & Mrs A.J. Burg	253
146	200 B. & M.E. Newton	254 Kathleen & Gordon Meadows
147 Rob & Meg Shorland-Ball	201 Sandra Mary Baker	255 ⎱ Patrick Mullin &
148	202 William Gray	256 ⎰ Debbie Pearson
149 Mr V.A. & Mrs M. Bramhall	203 Ian Smith	257 Brian Bowley
150 Mr & Mrs T.F. Martin	204 Dr Anne M. Lee	258 Trevor Le Tocq
151 Eve Scott	205	259 J.S.R. & P.N. Baxter
152 H.W.G. Griggs	206 Barry Rogerson	260
153 Henry & Jane Mitchell	207 Christopher N. Stokes	261 Dr John Black
154	208 Eric James Warby	262 Mrs Joan Curtis
155	209 Judy Gane	263 Lawrence Townsend
156 Pauline Duthoit	210 Martin Wright	264 David & Pauline Heigham
157	211 Jeremy S.W. Smith	265 Norman & Maud Akers
158 Stella Percival	212 Margaret Poll	266 Andrew, Claire & Robert Peck
159 P.S. Gray	213 Robert S. Newton	267
160 Peter S. Gray	214	268 Mr & Mrs D.R. Fentiman
161 Dr Donald R. Wright	215	269 Mr D. & Mrs S. Walker
162	216 Hugo Grimwood	270 J.N.C. Healey
163	217 Christine Rosemary Titmus	271 Andrew & Celine Carney
164 Roy & Nina Phillips	218	272 Mr & Mrs V.J. Shaw
165 Chris & Den Newman	219 J.H. Franklin	273 Rex Goldsmith
166 Philip & Jean Matthews	220 A.W. Torrens	274 John William Bolton
167 Elizabeth & John Shellard	221 Frances Slack	275 Kenneth Robinson
168 Nigel Johnson	222 Mrs Vilma M. Green	276 G.T. Brewster
169 John Lovelace Dulley	223	277 Paul & Maureen Baker
170	224	278 Ivan & Jennifer Green
171 K. Deal	225	279 Rose & Tony Fisher
172 Alun & Clare Owen	226 Susie Worthington	280 John & Audrey Isles
173 Christine Veitch	227 Zoë H. Wray	281 ⎫
174 Michael Ridgway	228 John Kellett	282 ⎬ David J. de B. Lyon
175 Wright, A.A. & L.J.	229 Ronald E. Porter	283 Lady M.P. Hope
176 Mrs Sue Cooper	230 Alan & Anthea Stutchbury	284 Marigold D. Smith
177 Janet Leaver	231 Tony & Moira Evans	285 Anne Tate
178 Michael S. Jones	232 Trevor Kelsall & Sheena Beech	286 Derek Crew
179 Peter Hart & Elaine Andrews	233	287
180 Jane Howl	234 F.H. Prichard	288 Diana Wrathall
181 Jean & Norman Adams	235 Philip C. Godsal	289 Mrs Marion Nathan
182 Joan Herd	236 Mary & Graham Stacy	290
183 Tony Preston	237 Pamela Tether	291 Mr N.P. & Mrs P. Shaw
184 May Bettesworth	238 ⎫	292 Mr M. & Mrs D. Jeffery
185 Mrs Heidi Bourne	239 ⎬ R. Moore & Sons	293 Mr M.J. & Mrs M.L. Mahoney
186	240 ⎪	294 Mr P.L. & Mrs P. Skinner
187 Robert Cleave	241 ⎭	295 Ian & Heather Baxter
188 Norma & Richard Ranson	242 Christine & Bruce Allison	296 Nigel Palk
189	243	297 Shirley Kenney-Taylor
190	244 Mrs A.E.B. Thornton	298 Mike Peer
191	245 Taffy Tom	299 Mr R.L. Tayler
192	246 Lynne & Family	300 Jane Fiddian
193 Arthur Thickpenny	247 Simon H. Ellis	301 John Fiddian
194 Charles R. Legg	248 David Saltmarsh	302 Pru Fiddian
195 Ruth Eastman	249 Gerald F. Ginns	303 Pauline Dunstone

304 Miss J.M. Morgan	357 } Beryl & Robert Stanley	408 Major P.W. Denny
305 Mrs Trixie Preston	358	409 David Taylor
306 } Maurice & Jacqui Ashman	359	410 Chris & Sue Pridmore
307	360 Rowena Knowles	411 Phillip H. Precious
308 Peter & Jane Boult	361 Karen Kerr	412 Michael Mellish
309 Mrs Jacqueline Cheek	362 F.R. Crane	413 A.K. & Mrs E.V. Gathard
310 Chris & Sue Tooley	363 Stella Fleetwood	414 Willoughby Garton
311 } Howard W. Heywood	364 Edith Carrigill	415 Mr & Mrs Matthew Grady
312	365 R. Temple	416 Moya & Kenneth Hutchinson
313 Harry & Kathy Geehreng	366 Peter W. Thompson	417 A.M. Scarfe
314 Richard Bing	367	418 Bob
315	368 Melody & George Green	419 Diana Cherry
316 Sydney & Margaret Scott	369 Southwold Archaeological &	420
317 Stephen J. Denny	Natural History Society	421 Richard W. Jellicoe
318 Berta Browett	370 Joanna Neicho	422
319 William Brewster Bell	371 Dr P.D. Simmons	423 Tracey Martin
320 Lavender & Martin Watson	372 Pam & Keith	424 Mike Randall
321 Dr Douglas Seaton	373 John Nottage	425 John & Margot Blythe
322 Clifford E. Groves	374 Mrs Sylvia Naomi Seekings	426 Benjamin Chase
323 Bob Menzies	375 Martin Campbell	427
324 Ian & Rhoda Cope	376 Barry & Caroline Robinson	428 The Revd Jane Wilson
325 Mr & Mrs David Holme	377 D.A. Rees	429 Michael & Sally Savage
326 Theo, Ursula & Martin Child	378 John Richardson & Eleanor	430 Stephen W. Massil
327 Rosemary Hyde	Stewart-Richardson	431 Edna Falgate
328 Freddie Wiseman	379 Anthony Holmes	432 David Pleasants
329 Charles ap Simon	380 } Matthew D.R. Davis	433 Chris & Michael West
330 Jane & Stephen Cooper	381	434
331 John Rees	382 Mr Derek Charles Fletcher	435 Jenny Burall
332	383 Brian Perry	436 Nobbie
333 John Yarrow	384 David & Jean Airey	437 Jane Lee
334 Alan P. Smith	385 John R.T. Goldsmith	438 Barry Walford
335 Elinor Roper	386 Frances Morrell	439 Nigel & Heather Osmer
336 Peggy Richardson	387 Oliver Payne	440 Anne Watson
337 Alec & Ursula Jeakins	388 Ralph Payne	441 Jill Forgham
338 Sally Palmer	389 C.G. Findlay	442 Andrea & Graham Parr
339 Christopher Rowan-Robinson	390 Dr & Mrs H.M.M. English	443 Dr Amory Thomas
340 Bryan & Muriel Frost	391 David A. Catherall	444 } Ivan & Mary Moseley
341 } Stephan & Linda Cornell	392 Mrs G.D. Horne	445
342	393 David & Sally Kibble	446 John M. Bowler
343	394 Danny Holland	447 Miss Noreen Denny
344 Mr & Mrs E.G. Marmion	395 Shirley & Malcolm Chase	448 Bob White
345 Jean Shirley	396 Elinor M.C. Roper	449 } Douglas & Shirley Alexiou
346 Margaret Osborne	397 John & Rita Taylor	450
347 John Bovey	398 Mrs Stella A. Owen	451 Sarah Sylvia Needle
348 Lewis & Jacqueline Golden	399 Peter Robert Biggs	452 David Puntan
349 Christina T.M. Emanuel	400 Roger H. Collins	453 Patricia Attwood
350 John Liddell	401	454 Robert C. Hall
351 Keith P. Gardner	402 Joan Gooch	455
352 Dr P.M. Morris	403	456 Mr & Mrs Jonathan Ould
353 A.J. White	404	457 Antonia & Whitney Booth
354	405	458 Beryl H. Smith
355 N.A.H. & F.W. Stubbs	406 Brian R.C. Young	459 K.R. Jones
356 Mr & Mrs N. Alan Green	407	460 Sir Anthony Alment

461 Mrs Joy Hale
462
463 Mai & Frank Plewis
464 Charles Tapper
465 Sally Bird
466 Mrs Alan Dix
467 M.J. Solomon
468 Christine Bird
469 Peter Hood
470 Alan & Julie Clark
471 David Smith
472 Alan & Pauline Treacher
473 R.A. Kidd
474 Gill & David Abraham

475 Bronwyn M. Simmons (Swan)
476 Dr & Mrs N.V. Edwards
477
478 Jeffery, Sally & Grace Onions
479
480
481
482 Jean Harrison
483
484 June P.M. Blackstock
485
486 Doreen Thompson
487 Mr John Nicholson
488 Mr Martin Potter

489
490
491 Dick Stride
492
493 John Alington
494
495 Carol Palfrey
496 Miss M.E. Haggerty
497 Amanda Priestley & Douglas Easton
498 Cynthia A. Crawshaw (née Royle)
499 Ian & Sheila Patterson
500 Sue Shaw & Rick Fearn

Subscribers

to Unnumbered Copies

Georgia E. Arundell
Robert Barnes
Keith Bewers
Dr Gordon Bowker
Allen & Kathleen Boyer
The Revd Canon Peter & Mrs Anne
 Bustin
Adrian & Karen Butler
Roger Carling
Beverley & Derrick Carter
S.M.C. Connors
Pauline Cox
P. & F.Y. Crampin
W.D. Crick
Jane Elizabeth Denton (Davis)
Benjamin Derbyshire
Dr Brian & Mrs Joyce Dietz
Robbie Dobbs
Robert F. Dolton
Mr & Mrs Robert J. Doran
Carole & David Dowsing
Dr Jenni Ellingham
B.E. Ellis
Mrs Pam Ellis
Adrian & Sheila Emsden
Nicholas C. Evans
Leonard J. Farrington
Audrey Fry
Michael J.H. Gower
J.M. Grazier
S.J. Grazier

Mary Goldsmith
Tony Goldsmith
Lorraine Greatbatch
Rosemary Harris
Peter Seager Hobbs
Mr & Mrs Jeff Horwood
Mr & Mrs John Howell
C.S. Hudson
Christopher Isles
Stephen Rhys James
Trevor & Sheena Kelsall
Mr & Mrs R.A. Ladds
Mr & Mrs E.S. Laws
Jim & Pat Laws
Betsy Lemmon & Vic Popperwell
Keith Malcouronne
Rosemary Mansbridge
Keith May
Carolyn & Ian McDonald
Miss Isobel Mimpriss & Benjamin
 Hammond, Esq.
Lydia Minahan
The Munn Family
Caroline Munns
Judy Novak
Sharon Novak
Jeff, Sally & Grace Onions
Dr Louise Pack
Maureen & Michael Perry
Mr H.H.D. & Mrs P.L. Phelps
Mike, Val & James Pyke

Raymond T. Rawsthorne
Kaye Richmond
Wendy Roffe
Michael Peter Rowell
Edward & Marjorie Saunders
Emmeline Scarborough-Taylor
Mark Scarborough-Taylor
Janet Shattock
Matt Shattock
Mervyn Sheppard
John Skeats
Mrs Ann Smith (née Stannard)
Mr David Smith
Russell Spargo
Graham & Mary Stacy
Michael S. Sutcliffe
Alan J. Thomas
Jamie & Irene Thompson
Mr & Mrs E.J.K. Tolcher
Mr & Mrs W.J.F. Tolcher
Luka J.D. Traynor-Jones
Howard & Jenny Trust
Victoria Tuck
Catriona Turner-Walker
Vincent Weatherhead
Mr B.R. Wesley
Deborah Wildridge
Mr & Mrs J.N. Wilson
Mary Wooldridge
David & Jean Wright

Introduction

A conversation overheard in a Southwold bookshop made us realise that there is no history of the town more recent than *The Story of Southwold*, published half a century ago.

In considering the idea of a modern local history, we found that there was such a huge amount of material of historical interest, both published and unpublished, and such a large pool of local expertise and knowledge, that to research and write such a book from scratch would have been both a waste of time and a presumption when so much original research was waiting to be drawn on.

The approach of the Millennium and the opportunity that presented to turn the book into a way of generating something of lasting benefit to the town itself determined our decision to approach the project in the way we have. Royalties from the publication will go to the Southwold Millennium Hall Fund. All the authors who have contributed their knowledge and experience to the compilation of the book have done so without payment. Most would have been quite capable of writing at book-length on their particular subject, and indeed some have done so elsewhere.

We are very conscious of the fact that there are important topics that have been barely touched upon, and there are other local experts who could have made important contributions, but whom we did not ask. To them, we apologise.

We hope that you will find the results stimulating and interesting. Some contributions inevitably overlap and we can only explain to the perceptive reader who picks out contradictions that such is the nature of scholarship.

We also hope that the book comes over as a tribute to the spirit and atmosphere of a very special small English town. Over the years, as some of the contributors have pointed out, Southwold has attracted distinguished people from all walks of life, whether as visitors or to retire. Most of them have readily become integrated into what is a real, living, working town, not a museum. Southwold has sometimes been described as 'genteel' by those who do not know it very well: most people who live here would settle for 'self-confident' instead.

Eloquent testimony to the sense of civic pride and duty shared by all the people of Southwold is the fact that at the 1998 local elections, when national turnout reached barely one-third, double the national average turned out in Southwold. Needless to say, all 12 of our town councillors are Independents.

STEPHEN CLEGG

The Physical Setting

TOM GARDNER

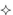

One of the very early guide books to Southwold begins with this epigram:

> When, far removed, my lingering fancy strays
> O'er memories of departed days,
> Southwold shall rise to memory dear
> For worth and virtue yet are cherished here.

The guide book goes on:

> Southwold appears to have had a long and interesting history, but unfortunately
> the greater part of it seems to have been lost, mislaid or overlooked in some
> unaccountable way. Indeed the whole of this corner of East Anglia abounds
> in relics, memorials and traditions of a great and glorious past that is but very
> inadequately reflected in any of the published histories.

Let us then, many years later, attempt to rectify this deficiency as best we may in the light of recent knowledge and offer the reader some explanation for the enduring charm of this East Anglian gem.

Prehistory: The Earliest Residents

Most of our prehistory lies in Easton Bavents. Of the early Stone Age, beginning about half a million years ago, very little is known, but a few flint implements have survived in and around Southwold—large hand axes in particular. The earliest settlement was near the North Warren at Easton Bavents: a few people of the Mesolithic period, about 8,000 years ago, who came from northern Europe and who used stone, bone and antler tools and also wood. Our people at Easton Bavents left behind several barbed harpoons, some needles, carvings, and one flint adze. These artefacts were washed out of the peat beds by stormy seas which also uncovered a rather unusual causeway made with timbers in a lattice pattern, now of course under the encroaching sea. Some 5,000 years later the next arrivals were the long-headed Mediterranean folk—the western Neolithic culture. They occupied the North Cliff area and a thriving community developed there. The site has yielded a wide variety of

artefacts, all made locally in their 'factory', comprising polished flint axe heads, knives and leaf-shaped arrowheads. Remains of substantial hearths were found, obviously used over a long time. This community was replaced (or displaced) by the early Bronze-Age newcomers, the Beaker Folk, so called because their pottery vessels resembled beakers. They also left behind their flint tools, such as scrapers, knives and arrowheads—now tanged and barbed. Only one piece of their pottery has been found at Easton Bavents, but many fragments were recovered from a habitation site in Reydon close to a group of three round barrows. Also in Reydon have been found two flint knives and what was most probably a ceremonial battle axe made of stone. These people had a knowledge of bronze, and one example of an axe was found recently near Blythburgh. Of the Iron Age, a few shards turned up in a field north of Easton Bavents.

The Roman presence is fairly well represented in the area. A road passed through Blythburgh to the south, of which quite distinct traces can be seen even now, particularly between Blythburgh and Westleton. It is very likely that this road served what seems to have been a signal station on the bank of the Blyth near Whitehouse Farm. Many tiles may be seen by the edge of the river, where they fell when the Romans left in the early fifth century. At the bottom of Reydon Grove are several brick and tile kilns, now within the wood. When the kilns were excavated one complete pot was recovered, and a single bronze coin of the emperor Magnentius (A.D. 350). Other stray finds in the area include a bronze oil bottle and a pottery oil lamp, now in Southwold Museum. Other finds have turned up near Covehithe after cliff falls, yielding pottery shards and a rather unusual gold lion, found with a metal detector.

When the Romans abandoned Britain in the early fifth century there followed a period of uncertain history when the Angles and Saxons occupied East Suffolk. No Viking presence is known in Southwold, but a spear head has been found in Blythburgh of Viking age. The other interesting find in Blythburgh was a hoard of coins referable to Danish East Anglia. They were struck in the late ninth century for Edmund—his memorial coins. From this time we pass into well-recorded history as presented by the Anglo-Saxon Chronicle, the Venerable Bede and Domesday Book.

1,500 to 1,000 Years Ago
In the opening years of the fifth century A.D., when the great glory of Rome was fading, the Saxons began to make assaults upon the east coast of Britain to such an extent that the Roman Governor appointed the 'Count of the Saxon Shore' to repel these invaders. A series of Saxon Shore forts had been established during the third century at strategic points in East Anglia. As it happened, Rome itself fell to the northern tribes, making it necessary for all the legions to be recalled for the defence of the homeland. The opportunity thus presented was quickly seized by the north European invaders. By the

1 Conjectural map of Southwold at the time Domesday Book was compiled.

early sixth century settlement was well advanced here by the Angli, according to the chronicler Bede writing in the seventh century about the Angli claiming Norfolk and Suffolk. After some years of warfare, East Anglia became subservient to Mercia until A.D. 825, when the lordship fell to Egbert of Wessex. Edmund became king of the East Angles in 855 but was defeated by a Danish invasion between 866 and 870 and slain some ten years later. Guthrum the Dane (later known as Athelstan) reigned as king until his defeat and death in 890 in the fighting with Edward the Elder, son of Alfred the Great. Subsequently East Anglia was governed by English earls. It was about this time

3

that Alfric, an East Anglian bishop, conferred the land known then as Sudwalda upon the Abbey of Saint Edmund as a gift with the view of provisioning the monks. Southwold then became a very small community established by the abbot to produce such provisions as were required by the abbey.

According to the Domesday entry for Southwold (DB II, Ch XXXII, 371B), the Abbot of St Edmund's held Southwold (Sudwalda) as a manor for the benefit of the abbey and the monks (mensal land is the term used—provisions for the table). It is recorded that there was sufficient arable land available to be ploughed by one ox team in a year. Five villeins (unfree men in bondage) are mentioned, and four bordars (next in status below the villeins). The land in demesne (lordship) had a plough, and there were four others belonging to the villagers. There were four acres of meadowland, a pack horse, four oxen, three pigs and 30 sheep. There was a stake net across the river, of which the men of Southwold used one half and a quarter of the other half. It is assumed that the other part of this net was used by the people of Walberswick; this place is not mentioned in Domesday.

In the time of Edward the Confessor, Southwold was assessed to render 20,000 herrings as a rent, but by 1086 this amount was increased to 25,000. The right and privilege of local jurisdiction was awarded to the Abbey of St Edmund.

So Domesday reports nine villagers here, and we must assume the presence of a representative of the abbot, his steward as the administrator, a bailiff, and a beadle to oversee the work. Quite probably a priest was resident, and a reeve to represent the village community at court. All together a total population of about sixty residents, including families, may reasonably be reckoned. All the produce from Southwold could be delivered to the abbey either by river or

2 Pottery washed out of the cliffs at Easton Bavents: medieval jar, possibly of Middle Eastern origin (left), and 17th-century coarse grey pottery jug of Mediterranean make (right).

by road. There is a very strong possibility of a jetty in what is now Buss Creek.

When reading a modern transcription, it should be understood that the entry in Domesday Book immediately above that for Southwold refers to the village of Southolt which was then in Bishops Hundred, some miles away, and there is no connection whatsoever with Southwold—a trap into which the unwary have fallen when writing about Southwold.

The Geology of the Area

The foundations upon which Southwold now stands were laid down during the retreat of the ice at the end of the Anglian glaciation about a quarter of a million years ago. The deposits left behind are of loosely packed sands and gravels as a rather elliptical terminal moraine with a general contour of about twenty-five feet. Originally this moraine was an easterly extension of the main mass of outwash materials some distance inland. However, the action of the meltwater streams served to detach part of the deposit and leave it as an island. During the long period of time required for the melting of the ice a vast lake was formed by the ponding back of water over this part of East Suffolk, and when this lake eventually dried out a deposit of clay was left over a large area. This deposit is recognised now as the Baventian Clay and it is frequently exposed in the cliffs north of Southwold after cliff falls. The clay is greyish-blue above and brownish below and markedly stratified, indicating the summer melting. The deposit can be traced almost the length of the cliffs, sometimes quite near the top, where it is greatly distorted by the action of a high degree of permafrost which characterised the two later periods of glaciation when this area suffered the extreme cold of periglacial conditions.

By and large, the geography of this area has changed but little since the end of the Anglian Ice Age, probably because of the intense permafrost which would have tended to preserve the surface topography in ice. Permafrost in periglacial conditions has a remarkable effect upon sandy and gravelly soils which become, under the stress of ice formation, grossly deformed. After the early ice age there was a very long interglacial period of some 300,000 years with an almost sub-tropical climate, with lush vegetation and forests. It is a great pleasure, upon a quiet sunlit summer morning, to walk by the cliffs near Southwold and gaze with profound fascination at what may be called geological documentation over some 200,000 years, trying to imagine the sound of rushing water, the occasional cascade of stones down a steep slope, and the dull rumble of partly-frozen outwash material falling from the melting glacier. Up to a few years ago there was a very striking feature to be observed in the south cliff at Easton Bavents. It was an immense distortion of sand and clay, right up to the top of the cliff, known locally as 'the Knot'—very aptly named. Another noticeable feature, also in this south cliff, is the cross-bedded sand, the herringbone pattern caused by the intermittent flows of melt water producing the 'braided' streams on the main channel of sand and gravel trains. This pattern is produced by frequent changes of flow direction which leave deposits of sand behind in layers, first one way then another in parallel sequences.

Deep wells in this area show that prior to the Anglian Ice Age there had been, for many thousands of years, shallow seas when the 'crag' sands were laid down for some 150 feet, resting upon the London Clay. At the base is the chalk of the Cretaceous period, about 60 million years ago—deep down here, but coming to the surface further north in Norfolk.

The shallow seas of the crag period, traces of which are still to be seen in the north cliff at Easton Bavents, gradually retreated to the north and the east as the cold conditions continued, leading to the full Anglian Ice Age. Behind the sea followed a very wide river, probably the ancestral Thames which at that time crossed East Anglia to join the Rhine somewhere in the southern North Sea, ultimately discharging from an estuary in the north west of Europe. The movement of the ice sheets forced the Thames southwards to its present course.

Some years ago in a gravel pit at Thorington, two miles west of Blythburgh, some gravelly deposits were exposed which may very possibly have been laid down by such a river. These gravels upon examination contained rocks which had clearly come from far inland. Elephant and deer bones were quite commonly turning up during the excavation. Vast herds of these animals roamed the home counties and the east of England. A 15-ft-long tusk was found in Reydon Pit, and another, 12ft. long, in Wangford Pit. The deer were large, some as large as a horse. Several rhinoceros bones have been found, including a lower jaw at Wangford.

When the last ice sheets finally melted about 10,000 years ago, the geography changed again. Britain was physically joined to western Europe and what is now the North Sea was marsh and mud flats over which the wide Thames/Rhine flowed. About 4,000 years ago there appears to have been a dense forest of birch trees off East Suffolk—remains of these trees have been exposed after long low tides and it is likely that the forests persisted up to recorded time, and would have been present when the land mass known as Kingsholm eastwards of the present-day coastline existed. Vast quantities of water were released as the ice finally disappeared, and the North Sea basin was filled until about 8,000 years ago Britain became separated from Europe completely.

Before leaving the subject of geology, a mention must be made of the great attraction of amber and carnelian hunting on the beaches. The amber is all Scandinavian and almost always cloudy. Originally it came from North European forests, about 40 million years ago. After a very long period of time the forests were submerged by rising sea levels during the first stage of the early glaciation. After the ice receded vast quantities of material were deposited in East Anglia, roughly between Cromer and Aldeburgh, where most of the amber is found—albeit rarely.

The carnelians and agates are from volcanic sources, originating in Norway millions of years ago in extrusive flows of basalt. These flows often contained pockets of gas which were released upon eruption and left behind air spaces which in time were filled by liquid silica (chalcedony). Eventually cooling, this silica became agate or carnelian. Carnelian is usually a shade of red, depending upon the presence of iron. Agates are frequently 'banded' red and white, owing to differential consolidation, and are much prized as gem stones. Between Easton Broad and Covehithe there is a stretch of beach known as the 'gem gravels' on account of the very many examples of agate to be found there at the appropriate time,

which is about half tide in early spring. On a bright morning with the falling tide the sun will reveal these gems, which have a particular deep red glow. A distinction must be made between carnelians and pink quartzite: the latter is always dry with a matt surface and is opaque, whereas carnelians retain a dull, waxy polish and are translucent.

During the early stage of the first glaciation, ice came to the East Anglian area from Scandinavia, and with it arrived a wide variety of rocks. After a high scouring tide these rock fragments are revealed when the sand has been washed away. Examples have been found of basalt, syenite, nordmarkite, gabbro, rhyolite, ignimbrite, mica/hornblende schist, amphibolite, gneiss, phyllite, hornfels, diorite, garnet-schist, larvikite, dolerite and several types of granite.

Coastal Erosion

Sea levels continue to rise as the climate warms, and erosion will be an ever greater threat. If all the ice at the poles were to melt, the sea level would rise to pre-glacial heights and low-lying land would be submerged. We have seen in East Anglia great changes in the coastline, particularly in recent years, with periodic storm surges as in 1953. To give several examples: at the end of Easton Lane, two miles north of Southwold, 123 yards of cliff were lost in 30 years; South Warren, only a quarter of a mile to the north of Southwold, lost 95 yards in 28 years; in the 1990 surge 21 feet went in 12 weeks. From Covehithe to Southwold 440 yards were lost between 1889 and 1979.

Wind, also, is responsible for a certain amount of loss. In one hot summer day with an easterly wind blowing as much as a foot of sand can fall from the cliffs.

The worst effects of erosion can occur

3 The artist Frank Forward of Reydon was among the people cut off in the town on the night of 31 January/1 February 1953. Working partly from memory and partly from rough sketches made on the night, he made two oil paintings showing the scenes to the north and south of the town as the sea broke in.

during storm surges when there is a combination of low pressure and north-easterly gales. The wind tends to delay the ebb tide to such an extent that the next high tide arrives while the water is still high, amounting to a double tide level. It is of very great interest to observe carefully from the cliffs these surges in action, and marvel at the enormous energy of these destructive waves. The ground swell arrives quite slowly and collides with the cliffs with

4 Centre Cliff, 2 October 1905.

5 7 January 1905, looking south down Ferry Road from Gun Hill.

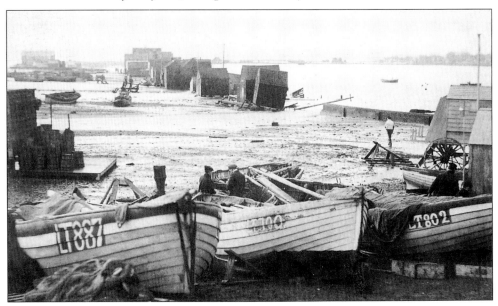

explosive violence, then begins to recede from the recoil, meets the next incoming wave and the two opposing forces cancel each other out and come to a halt for a few seconds— in which time the next wave adds its weight to what may be described as a battering ram. Sometimes the storm surge has been preceded by a scouring tide which strips the beach of all the loose material and provides greater access to heavy and deep waves. When the sea is at its height, the waves tend to trap air at the point of impact, making the effect of collision that much more forceful. It will be appropriate here to emphasise the highly dangerous state of the cliffs when the sea has gone down. Even the slightest vibration by walking near or on top of the cliffs is sufficient to cause thousands of tons of unstable sand to collapse, often with no warning and in silence.

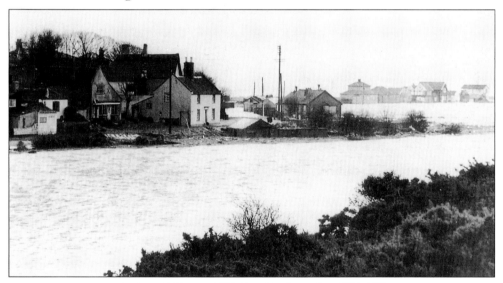

6 1pm, 1 February 1953. Ferry Road seen from Whin Hill.

Southwold has suffered a very great deal from storm surges and flooding, and it is more vulnerable every year as the sea level rises. One can observe the slowly disappearing beach and the growing cracks along the promenade as the ground slips towards the sea. Another severe tidal surge will probably cut through near the boating lake to Mights Bridge, and also into Ferry Road and across to the river. Whether this dramatic change is something to be expected in a post-glacial period or whether it will be caused by global warming, a result of man's insatiable greed, is perhaps debatable, but what is not debatable is that nature will not tolerate any attempt by man to thwart her objectives. Erosion and flooding will continue and in the future much of East Anglia will, once again, be under the sea. It is recorded that during the last 6,000 years East Anglia has sunk by 20 feet, partly because of melting ice and partly because of geological adjustment causing uplifts in northern Britain.

Civic History and Traditions

JENNY HURSELL

'Toy Town!' some people say disparagingly when they see the Town Mayor and Council in their civic regalia, but Southwold was by and large a self-governing community from 1489 until 1974, and not only do old habits die hard but the present Town Council believes that retaining the civic trappings and the town's traditional ceremonies plays a vital part in fostering the sense of continuity and identity which helps both to bind the community together and enhance the town's appeal to visitors.

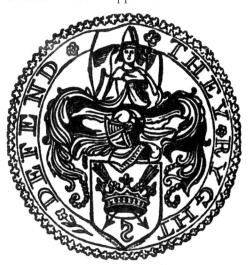

7 The Southwold Town Seal.

Further, and this may come as a surprise, Southwold has often been a progressive place. In the early 1900s it was one of the earliest boroughs to provide council housing, a forward-thinking idea which was in keeping with its early independent spirit.

From the 10th century onwards the small island hamlet that was Southwold was part of the demesne of bishops and then monks, but as the coast eroded on either side of it and its surrounding creeks silted up, joining it to the land, more worldly men looked towards it for gain. In 1259 the Abbot of Bury attempted to appease Richard de Clare, Earl of Gloucester and Hertford, by swapping Southwold for Mildenhall. Southwold was to remain a possession of the barons of Clare for almost two hundred years, a fact which was to lead ultimately to its early independence, because Gilbert de Clare married Joan of Acre, daughter of Edward I, and thus brought the town into the hands of the royal family.

Throughout this time there was rivalry and antagonism between Southwold and Dunwich which increased as the fortunes of the former improved and the latter declined. In 1488 this rivalry was noted in the Parliament Rolls as was the fact that Dunwich was a town corporate whereas Southwold was not. In 1489 King Henry VII remedied this situation by granting Southwold its own Charter, a Charter moreover which not only freed it from its

previous subservience to Dunwich but also made it a legal entity independent of even the Crown, except in the terms of duty and loyalty normally demanded by a sovereign, and the usual fee farm rents paid for the privilege of holding markets. Five years later, in 1504, Henry granted the town a fuller Charter providing the town with the detailed constitution under which it was to function, save for one short period, for the next three centuries. As a result of these Charters the burgesses—the inhabitants—of Southwold were to be both tenants of their manor and its lord as well. The town was administered by two Bailiffs and a High Steward, but they were appointed by the town itself and not by the king as was more usual: in theory, then, a very democratic arrangement. In practice, as in other fledgling local boroughs like Beccles, Orford and Eye, 'upper' and 'lower' houses of townspeople were established. In Southwold, the former comprised 12 portmen, which included the Bailiffs, and the latter 24 councilmen, all of whom could be fined for non-attendance at meetings and if they were not in their designated seats in church wearing their gowns or cloaks of office. There is evidence, though, from the 1700s, where signatures and 'marks' survive

8 Henry VII, who granted Southwold its Charter in 1489.

in Assembly Books, that despite the establishment of the twelve and twenty-four, people at all levels of society did play an active part in the election of the town's officers and the management of the community.

The Steward and the Bailiffs were the town's magistrates, holding various courts in town, and the commonalty, the townspeople, elected their own coroner and built their own gaol. Fines, etc, accruing from the courts and the income derived from the confiscation of the goods of criminals, together with the half-share in wrecks and goods washed up on shore, were now, by virtue of the Charters, the town's money rather than the feudal lord's. Further, the town benefited from the grant under the Charters of extra markets and fairs:

Monday markets were allowed in addition to the Thursday markets held since 1220, whilst St Bartholomew's Fair on 24 August joined the three-day fair following Trinity.

By and large the constitutional arrangements set down in the Charters continued until 1836 when, as a result of the Municipal Commission of 1833, the chartered corporation was made a Mayoralty, with Aldermen and Councillors. This was possibly just as well: the arrival of the Commission had been preceded by wrangles and discord about the management of the town and its finances, disputes which even attained national notice. The *Gentleman's Magazine* of 1835 did not mince its words about the borough's financial mismanagement, its love of litigation and its feuding. It would probably not be unreasonable to suggest that not all those in power acted in a strictly disinterested manner and solely with the interests of the community at heart.

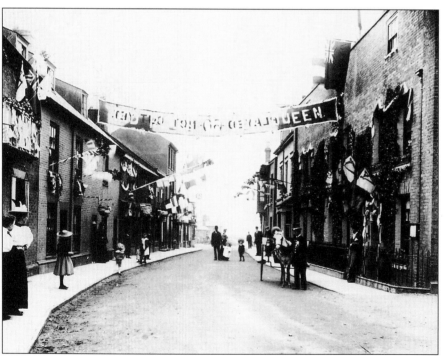

9 Queen Street decorated for Queen Victoria's Diamond Jubilee, 1897.

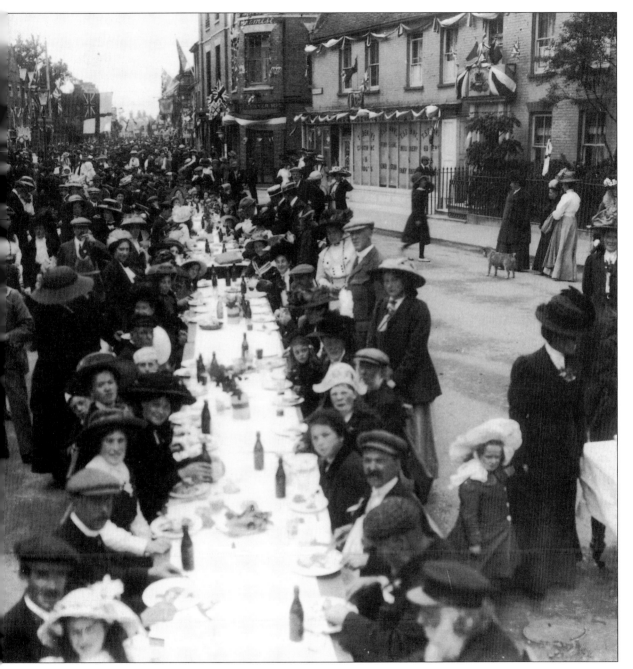

10 Street party held in the High Street to celebrate Queen Victoria's Diamond Jubilee. It was attended by some 1,400 inhabitants, and the catering was by Mr. Marshall, landlord of the *King's Head*.

The first Mayor of the new corporation was William Crisp who was elected in 1836 on the strength of his own casting vote. He was succeeded by 40 others, including three women, some of whom served two or more terms, until in 1974 local government was reformed yet again. Southwold Council then lost its borough status and with it most of its land, its property and its functions, which were transferred to Waveney District Council, based in Lowestoft. Gone was the town's responsibility for council housing and planning, for the harbour, the beach and the seafront, for refuse collection and the maintenance of the greens and gardens, and with all that gone the council felt that perhaps it too should fall in line with the spirit of the times. It decided not to retain its Mayor but to appoint a chairman as leader instead. The council, with 12 members, functioned under a chairman for four years until, in 1978, Eric Hurren, better known as 'Joe', was appointed Town Mayor—and, echoing history, like his predecessor 142 years earlier, on the strength of his own casting vote. From then until now eight people have served the community as Town Mayor, usually for two years at a time.

Losing so much of its authority in 1974 was a sad blow for so proud a town, but the council had managed to retain some of its land and property and its trusteeship of Southwold Common. These provided both the income and the opportunity to allow councillors to continue to have some influence over the way Southwold was managed, and to maintain the traditions which many inhabitants hold so dear.

Prime among these is Trinity Fair. From 1227 onwards Southwold had been entitled to hold a fair on 30 April. Under the terms of the 1489 Charter this became the fair held on the three days succeeding Trinity Sunday, and so it continued until the early 1990s. Problems arose because the late Spring Bank Holiday sometimes coincided with Trinity which made it difficult to organise a fair, the showmen having commitments elsewhere. The Town Council therefore agreed that the Fair would open on the first Monday in June. Over the centuries, of course, the nature of the Fair had changed. Originally it was a hiring fair and market, but these days it comprises fairground rides and sideshows. It is one of the anomalies of Southwold which make it so endearing that the fair with all its accompanying noise, smells and crowds should be sited in one of the more genteel parts of town. Even more anomalous is the sight of the Town Mayor, the Town Councillors, Bellman, Serjeant-at-Mace and the Clerk clambering aboard the dodgems after the official opening of the Fair. It does little for civic dignity, but perhaps a great deal for community spirit.

The Fair has unfortunately been in decline in recent years, which is a matter of concern both to the Town Council and the showmen themselves, who are as anxious to maintain the tradition as the town is. To give them the opportunity to attract more trade the council

11 *(top)*　Trinity Fair, 1910: reading the proclamation in the Market Place.

12 *(bottom)*　Trinity Fair, 1910: the fair on South Green.

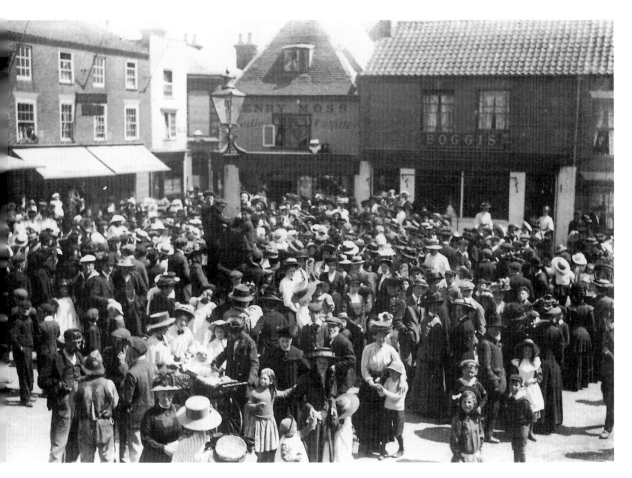

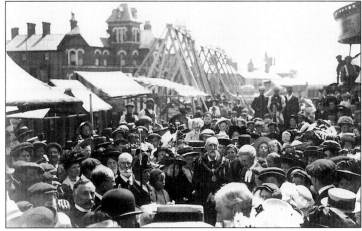

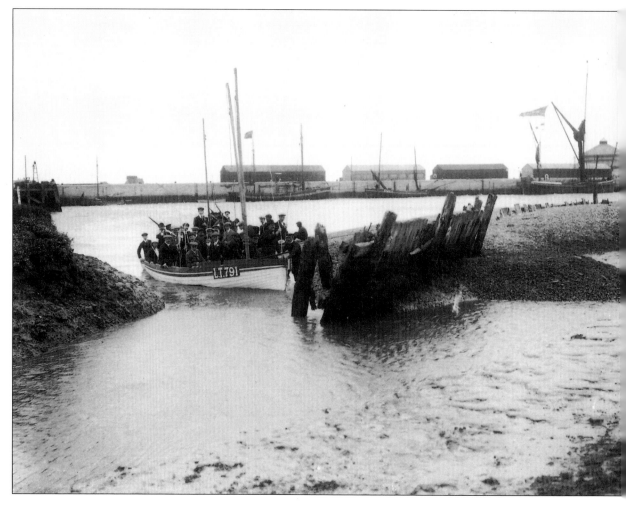

13 Beating the Bounds: landing on the south side of the river. The Fish Market and gutting sheds can be seen on the other bank; some of the passengers are carrying wands with which to 'beat the bounds'.

decided in 1997 that the 1998 fair would be opened on the last Thursday in May and continue through until the following Sunday. It was also decided that as the Fair no longer coincided with Trinity and was open for more than three days it was perhaps inappropriate to continue to call it Trinity Fair. The name Charter Fair was chosen instead. Some people regretted the change, but the more pragmatic accepted that without some change the tradition would be lost altogether.

One tradition which was lost but revived in 1989 is that of St Edmund's Day. St Edmund is the patron saint of the town's parish church, and 20 November is the day set

aside to remember his life and martyrdom. In the afternoon of 20 November the younger schoolchildren of the town gather in the church for a short service commemorating the life and death of St Edmund, after which the Town Mayor and Councillors distribute small, sweet buns to the children. Not surprisingly this occasion is affectionately known as 'Sticky Bun Day'.

The Town Council believes that in a town renowned for a high population of elderly residents it is important to have close ties with the local children; that giving them a sense of history and continuity will help bind them to the community and give it a future.

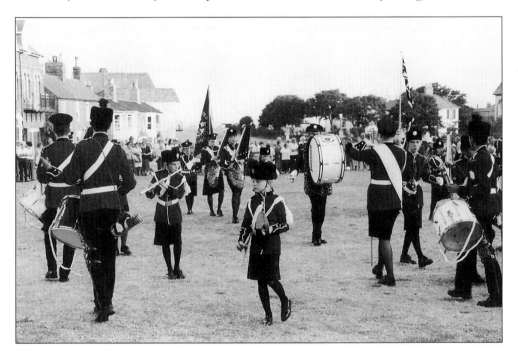

14 The Southwold and Reydon Corps of Drums perform the Sunset Ceremony on South Green, 1995.

Accordingly, as well as involving them in St Edmund's Day, the Town Mayor visits the primary school before the Fair is formally opened to distribute Trinity (now Charter) Money to the children—Southwold's equivalent of Maundy Money. The children are also invited to plant trees in town on Arbor Days and join in Beating the Bounds when that takes place every five or six years. Children are also conspicuous on civic occasions like Mayor's Sunday and Remembrance Day, when as Guides, Brownies, Cubs, Scouts, members of the Corps of Drums, the Red Cross or the Army Cadets they form part of the parade to and from church. On those occasions the full panoply of civic pomp is on display—the Town Mayor,

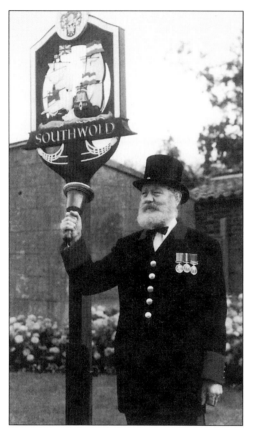

15 Bellman, John Barber. **16** Serjeant-at-Mace, Brian Haward.

Deputy Mayor, senior Councillors and Clerk in robes, the Serjeant-at-Mace and Bellman smartly uniformed and bearing their maces and bell respectively. Perhaps it is anomalous in a town so small, but it is local colour and a link with history, and in preserving it the town continues to live by its motto 'Defend They Ryght'.

Southwold at Work

ZOË RANDALL

✧

The vital word when considering the economy of Southwold is 'Sea'. Visitors come and admire the splendid church of St Edmund, one of the ecclesiastical glories of Suffolk, and assume that this was a wool town. It wasn't. Southwold has earned its living by fishing, boatbuilding, sea trading, wreck salvage, and then when all that declined, tourism. From first to last its friend and foe the sea has dominated the economy of Southwold. However, occasionally some unexpected trades have lent a little variety to the scene.

Southwold began as a fishing hamlet and by medieval times was the main base of the Icelandic fleet. Boats were the lifeblood of the town, where sea trading and boatbuilding were major industries. A curious addition to the normal sea trade was the granting of a licence in 1433 to export cheese. The few small farms on Southwold's 600-odd acres would scarcely have merited such a step, but it is interesting to note that at that time Walberswick produced quantities of cheese but had no easy access to the sea. The nearby local farmers obviously preferred to send their produce to Southwold for shipment rather than to the rapacious merchants of Dunwich, who charged them excessively heavy dues.

In the time of Henry VIII, Southwold 'exceeded all neighbouring towns in shipping and commerce', with over fifty vessels based here. One of the seaborne activities was the salvaging of wrecks. The ever-shifting sandbanks run parallel to the shore on this part of the coast, and many ships foundered in the treacherous inshore waters. Shipwreck yielded as much profit as fishing from the earliest times. As far back as 1237, a 'Right of Wreck' document known as the Butley Cartulary mapped this coast, which in those days had a very different configuration. Eye Cliff, Southwold, is pinpointed on this map, together with the area of sea which was the 'Right' of its residents.

In the 18th and 19th centuries wreck salvage was increasingly organised into limited Beach Companies, operating yawls in which the seamen owned shares. These yawls were huge clinker-built open boats similar to the Norse longships of old, with a shallow draught and 10 or more pairs of oars. They were unique to the stretch of coast between Winterton in Norfolk and Southwold. Skilled in manoeuvring the 60- to 70-ft-long boats, these courageous seamen were not pirates, as is sometimes claimed. Wrecks were certainly profitable, but the Beach Companies took only that which would have been lost to the sea in any case, and in the process saved many lives, though there was much risk and no profit in lifesaving. Eventually the 'Beach Boys' became the nucleus of the Lifeboat Institute. The yawls were also used as lighters, loading and unloading vessels anchored offshore.

Pilotage began with cut-throat competition. Local seamen kept lookout from high points along the cliff, and at the first sight of an approaching vessel rowed out frantically to the waiting ship. The first to arrive got the job. In later times this grinding inefficiency was replaced by a rota system, and the pilots were transported by the yawls. The last yawl in Southwold was the lovely 49-ft. *Bittern*. In 1929 she lay decaying near the pier when Alderman Critten, who was descended from a long line of boatbuilders, rescued her rudder which now stands outside the Sailors Reading Room on East Cliff, whilst a scale model of her can be seen within.

* * *

The great fire of 1659 all but destroyed Southwold, leaving 300 families reduced to poverty. This appalling disaster led to a period of economic depression, until an Act of Parliament was obtained to authorise harbour repairs and improvements between 1749-52. As a result of this work and the facilities offered by the salt works which was set up in 1673, Southwold was chosen to be the headquarters of the Free British Fisheries in 1750.

In earlier times, salt had been stored near the harbour but it had been produced in either Wangford, Uggeshall or Gorleston, all of which had salt works recorded as far back as Domesday. Now the increased demands of the fisheries could be met on the spot. In warm summer weather the rising tide was allowed to flood into Salt Creek, a quiet backwater of the River Blyth. The water was left in deep pans so that sand and grit could settle out. The resulting brine was then drawn off, heated until it crystallised, and then strained and dried to provide coarse salt for the fish warehouses. At times up to 1,000 tons would be in store. Although considerable skill was required to manufacture salt, the profit was poor and was further eroded by the Salt Tax introduced in 1702. There was greater profitability in refined salt for the table, and Southwold salt works produced this using salt mined in Cheshire to strengthen the sea brine. It became as famous in its day as Maldon Sea Salt from Essex. The Salt Tax was increased steadily, until eventually the pleas of the fishermen and the salt workers, together with the wholesale smuggling of salt from France and Scotland, forced the repeal of the tax in 1825.

By this time the fishing trade had declined. Facing further economic depression, the town was saved by rapidly exploiting the growing fashion for seaside holidays. The salt works also earned a reprieve. A small windmill pumped brine into a thatched bath house where it was heated so that visitors and the local population alike could benefit from the warm salt baths which were considered so health-giving. The bath house continued to be a popular attraction in Ferry Road until economic pressure forced the salt works to close down at the end of the 19th century.

We have a tangible reminder of the salt works in the shape of the unusual coats of arms on The Cottage, South Green. The insignia on this Victorian cottage were transferred

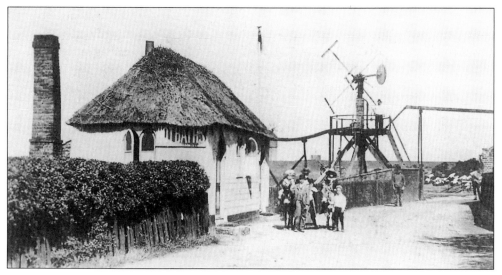

17 The Salt Water Baths in Ferry Road in 1880. The wind pump in the background pumped brine along a trough to the bath house. Another trough went across the road to the evaporation pans.

18 South Green around 1880. The single-storey building in the centre of the picture is the old Salt Office.

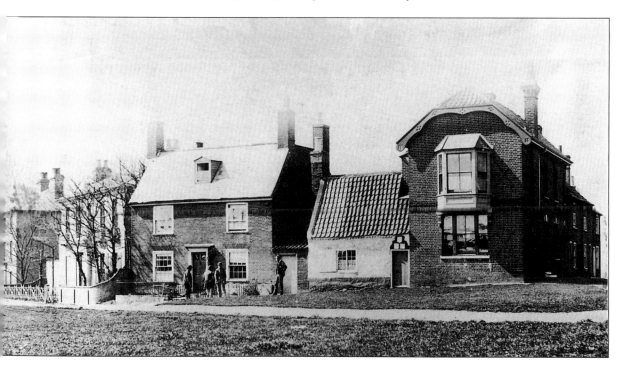

from a far older part of the building which was demolished in 1902. The date, the borough arms, the arms of Strickland (who was the national farmer of the Salt Tax) and those of Chapman of Sibton, his agent, all indicate that this was the salt office. The initials R.M. are those of Robert Milbourne, a bailiff of that time who was almost certainly the Salt Officer.

* * *

Sailors rely on good ropes, and Southwold must have produced them from the earliest days. Town records of 1841 name Jasper Goodwin as the owner of a twine ground near the Baptist Chapel. Henry Oldrings had a rival rope ground on Cumberland Road, with two rope walks. There was a 'short walk' to Field Stile Road, and a 'long walk' along the churchyard wall to North Green. Oldrings closed down in 1880 and Goodwin some 20 years later. Mr Button, who had worked for both these firms, set up his own 'Rope, Twine and Norsel Works' behind what is now Crick Court on Station Road. His rope walk was partly along his own garden, and then on to Spinners Lane.

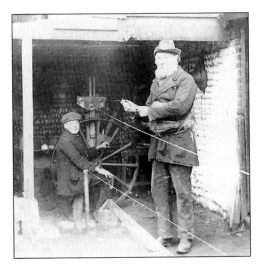

19 Rope making around 1900, probably at the Cumberland Road rope walk.

How was the rope made? After initial preparation, the hemp was 'walked' down the rope walk by a man with great hanks of the fibre wound round his waist. The end of the hemp was attached to a large wooden wheel, and the 'spinner', as he was called, walked backwards paying out the hempen fibres as he went. A boy was employed to turn the wheel, thus twisting the fibres into the initial strands. Several strands would then be 'laced' together mechanically in the rope works to form the finished rope. Finer cords, known as 'norsels' or 'snoods', were also made for use as cod lines and in herring nets.

* * *

It is said with some truth that in lean times the people of Southwold have survived by 'taking in each other's washing'. In 1020 Southwold was described by the Abbot of St Edmondsbury as 'the island of Southwold' and it still has only a tenuous hold on the mainland. This insularity has bred a sturdy attitude of self-sufficiency. Butchers and bakers, brewers and maltsters, blacksmiths and wheelwrights, millers, ropemakers, tinkers and tailors and many others have earned their livelihood providing the services a small town requires, even when the main marine industries were undergoing periods of decline. There cannot

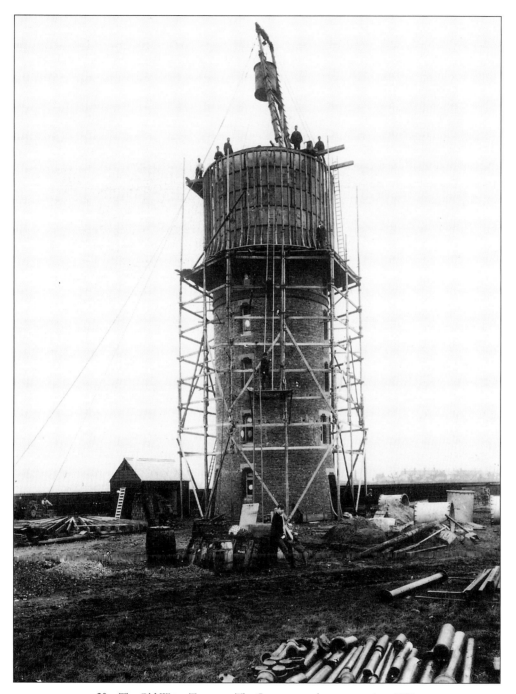

20 The Old Water Tower on The Common under construction, 1886.

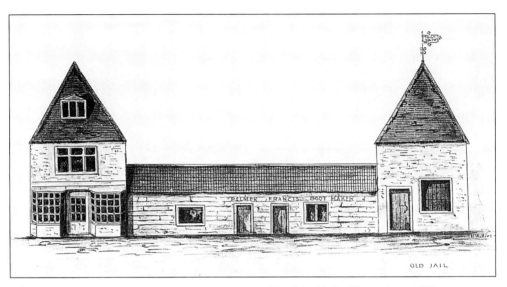

21 Engraving by Hamlet Watling: the east side of the Market Place prior to 1819.

be many other towns of under two thousand souls which have had their own privately-run gas, electricity and water works, for instance. The Old Water Tower on The Common was built in 1886 and was most innovative, with a windmill on top to pump the water which was even then piped to much of the town.

The earliest tangible evidence of a Southwold shopkeeper is that of Thomas Postle, who was a draper. When coins of the realm were in short supply in the 1650s he issued his own tokens, a number of which are in the Southwold Museum. Postle's tokens were of high quality, implying an extensive and highly profitable business. He plied his trade from substantial premises in the Market Place, on the seaward side of *The Swan*. Deeds of the property can be traced back to 1600 at least, and probably as far back as 1523. It seems to have been a draper's shop for much of that time.

There were always lime kilns to serve the town, variously situated on Skilmans Hill, near Blackshore, by The Common and north of the town. Early in its history most of the dwellings would have been made of wood or flint with reed thatched roofs. After the great fire less flammable materials were sought, especially when the tourist trade began at the end of the 18th century. Early maps mark brick fields north of the lime kilns, near the shore; deep hollows at the seaward end of what is now Pier Avenue bear testimony to a brickworks owned by Mr Page Mitchell, Dissident Minister, in 1803.

* * *

At one time Southwold could boast three mills grinding flour for the housewives and the bakers. Milling is a hard trade needing skill and constant vigilance. The miller faces two great hazards, wind and fire. The wind may blow his mill to pieces. Fires arise from the sparks generated by the constantly moving wheel igniting the flour, which is highly inflammable, particularly in a dusty, tinder-dry mill. The millers in windy Southwold had plenty of troubles.

Town records first mention a mill in 1658. The Town, or White, Mill stood towards the south of The Common, opposite the end of Mill Lane. It was leased by a series of millers who paid rents varying from £5 6s. 8d. to £10 a year. In 1738 a fierce gale almost blew the mill over, killing one Rebecca Chilvers. Though repaired, the structure of the mill was permanently weakened and 50 years later further severe storms damaged it so badly that the remains were pulled down and sold. Three months later the windmill was rebuilt on the same spot, but in under twenty years it was again blown down and much damaged. The last remains were removed in 1898.

In 1798 the Great, or Black, Mill was brought from Yarmouth and erected on The Common, on the site now occupied by St Barnabas Home. It was let to a Mr. Edwards, who subsequently bought it. The Black Mill exchanged hands a number of times, for sums varying from £750 to £2,900. In 1860 it lost a pair of sails in a NNW gale, and three years later was damaged by another gale and caught fire. It went from bad to worse and was finally dismantled in 1894.

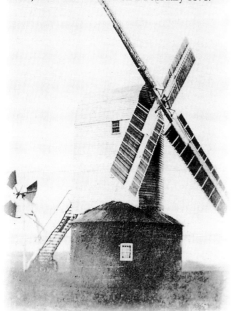

22 Bagott's Mill, August 1872. The mill stood at the junction of Field Stile Road and Cumberland Road, and burned down on 2 February 1876.

New Mill was the last of the windmills, and had a short life of only 35 years. It was erected by the vicar in 1841, abutting Church Green. It was always a bone of contention between Rev. Birch and his parishioners, who composed the following rhyme:

> Who gives to angry passions vent
> And built a mill to grind dissent
> Showing thereby his mal-intent?
> Our Parson.

In 1876, whilst the mill was occupied by Mr. Bagott, the sails were blown off and later that year 'Bagott's Mill' was burnt down, a great loss to the local bakeries which numbered as many as seven at that time.

The last flour mill in the town, owned by Smith & Girling, was not a windmill. It

was a well-built brick factory standing at the edge of North Green, where flour was ground until its closure in 1918.

The building was later used as a bedding factory, trading under the name of Fordux (1947) Mills Ltd. It was known affectionately as The Mattress Factory. Thirty or forty men and women were employed there making quality divans, mattresses, pillows and bolsters, bed-rests and calico covers. The item of which they were most proud was the Gold Seal divan and mattress set made for Slumberland, who already owned six other factories. Slumberland subsequently bought out Fordux, and all the employees were made redundant. The building still stands, and has been converted to flats.

* * *

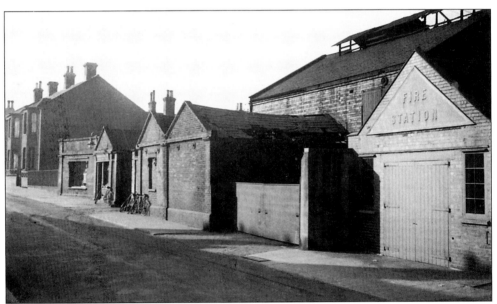

23 The gas works and fire station in Station Road, before 1938.

In the early part of the 19th century a man who was born in Yarmouth in 1781 set up his business in Southwold, an unexpected location for his trade which he described as 'ironmonger, ironfounder, engineer and gas apparatus manufacturer'. Edmund Child lived at 6 Market Place, the house which is now Denny's shop. He set up his foundry at the rear of the premises in what is still known as Child's Yard.

In 1841 Edmund left his premises to his son George Edmund Child, who was something of an engineering genius. He became famous as a builder of gas plant and invented the gasholder, that useful storage structure whose outline was a standard part of the skyline of almost every town until the coming of natural gas. George made all the

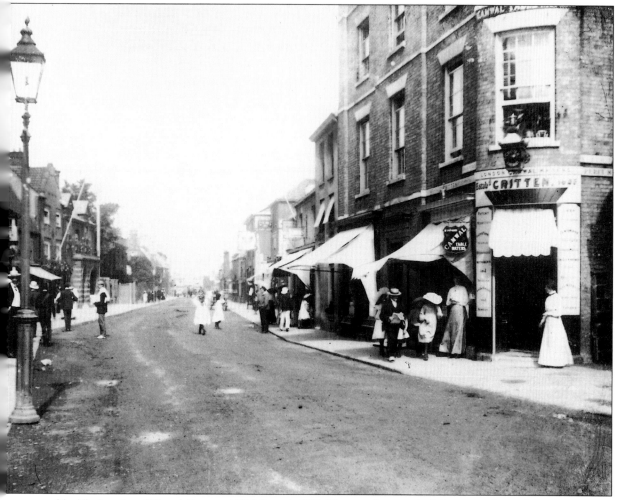

24 The junction of Church Street and High Street in 1891. The street lamp on the left was manufactured at the Child Foundry.

apparatus for the Southwold Gas Company. The works were in Station Road and the gasholder was situated in Blyth Road, near the allotments.

There are many items from the prolific Child Foundry still to be seen in the town, including gas lamps, the church gates, and our unique three-sided Town Pump in the Market Place, which George and Mayor J.E. Grubbe jointly presented to the town in 1873. The pump, with its town crest and frolicking herrings, is delightfully ornamental but no longer functional, though it remained an effective water standby throughout the last war. The unusual iron window frames of the foundry, now part of Adnams' stables in Mill Lane, are worthy of note.

The fame of the Child family spread far and wide. In 1871 Thomas Child installed gas plant for the lighting of Peking. He was almost certainly a relative of George, though investigation of the Child family tree is fraught with difficulty since they had a tendency to give the same name to more than one sibling. History does repeat itself, though. A hundred years after Thomas's efforts in China, British Gas was in Peking to modernise the installations, and was pleased to be able to acknowledge the good work of their compatriot.

* * *

Mr. Arthur Flowers was a thoughtful man who worried that the fishermen were often without employment during the winter when the weather kept them ashore. He conceived the idea of a woodcarving class and managed to obtain the services of an instructor, Mr. Voisey, a silver medallist of the Home Arts & Industries Association. The class began in Trinity Street in 1892, but soon moved to larger premises in Pinkney's Lane. Mr. Flowers generously bore all the working expenses, including the rent of the rooms.

The venture was amazingly successful and very popular, not only with the fishermen and boatbuilders who had a natural flair for the work, but also with women and children.

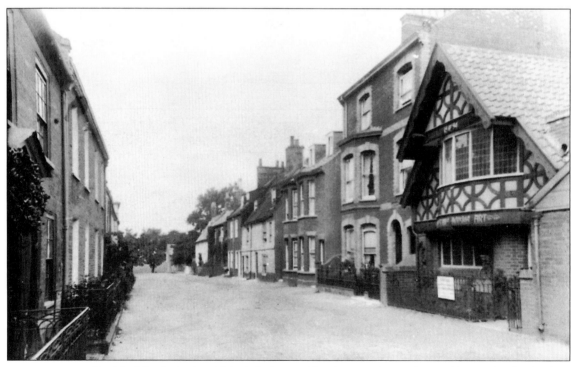

25 The School of Industrial Art in Park Lane. This photograph was taken in 1895 or 1896, shortly after the building was opened.

Pupils had to provide their own tools and wood, mostly oak and walnut, but tuition was free. Within nine months the class had produced so many beautifully carved articles that they were able to mount a display at the Association's annual exhibition at the Albert Hall. The shelves, tables, cupboards, stools, bellows, boxes and picture- and mirror-frames sold readily and were highly commended. In those days of no unemployment benefit the pupils were so grateful for the money raised by their efforts—over £100—that they carved a splendid pipe casket for Mr. Flowers, and a smaller casket for his wife.

The class grew and soon had a waiting list. The rented room became inadequate, so the pupils helped to build a special studio in Park Lane which was ornamented with carved beams. The class was named the Southwold School of Industrial Art and went from strength to strength. Their work won nine certificates of merit at Westminster, and a Gold Medal and other awards at the Albert Hall as well as an order from Princess Louise. When Andrew Matthews received the Freedom of the Borough of Southwold in 1910, the school carved the casket containing his scroll.

Arthur Craigie, aged 94 and the last surviving member of the class when interviewed in 1988, recalled how enjoyable the classes were. 'It kept us boys off the roads on a Saturday,' said he, 'but anybody that was anybody attended the woodcarving class.'

With the onset of the First World War in 1914 the class closed. Afterwards there was no finance to support a reopening of the school. The studio was closed; it became a tea shop, and is now a private residence. Despite the loss of the school, many former pupils continued their craft. In the early 1920s a thousand-year-old trunk of bog oak was washed up on Benacre beach. It was so heavy that Sir Thomas Gooch needed six horses to move it to his wood yard, where it was sawn up and left to dry, and in 1926 William Bennett, a former member of the class, made and carved a Mayor's chair from this oak at the request of Alderman Jenkins, who presented it to the town. Later that year the same carver made a Mayor's desk from the rest of the oak for Mr. Critten, who did likewise. Both these articles are in the Council Chamber at the Town Hall.

Many other artefacts made by the woodcarvers remain in the town. Among the most notable are a magnificent carved settle

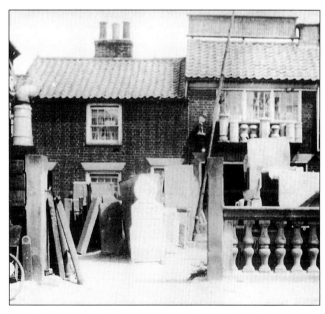

26 Allen's Masons' Yard in the High Street, opposite the *King's Head*.

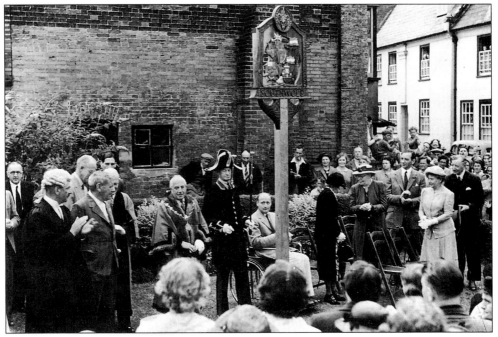

27 Unveiling the town sign on Electricity Green, 1951. Among those present are Town Clerk H.A. Liquorish,
Serjeant-at-Mace 'Rolly' Wells and Mayor J.B. Denny.

and chair at *The Crown* hotel, the town sign on Electricity Green which was carved for the
Festival of Britain and, most unusual of all, a carved wooden headstone made by Wm.
Tooke for his own grave in St Edmund's churchyard.

<p style="text-align:center">* * *</p>

Another successful venture was launched in Southwold in 1909. Mr. and Mrs. Andrew
Critten began to manufacture hosiery in the New Hall in the Market Place. At first there
were only six employees, but they also took apprentices who started work at 14 years of
age, working from 8 a.m to 6 p.m. During their four-year apprenticeship their wages advanced
from 1s. to 8s. a week. This sounds very little, but the youngsters also had 'meat, drink,
lodging and all other necessities'. The testimony of those whose relatives worked at
Homeknit indicates that the workers were very happy there.

In 1914 the factory moved to a much larger building near *The Pier Avenue Hotel*. About
a hundred workers were employed, and new machinery enabled jumpers, suits and other
knitted garments to be produced. They were of the finest quality and were sold at high-
class London stores such as Harrods and Peter Robinson, as well as being exported. During
the First World War underwear was made for soldiers. Bonnets were produced for the girls
of Saint Felix School and pullovers for the boys of Eversley School. On one occasion two

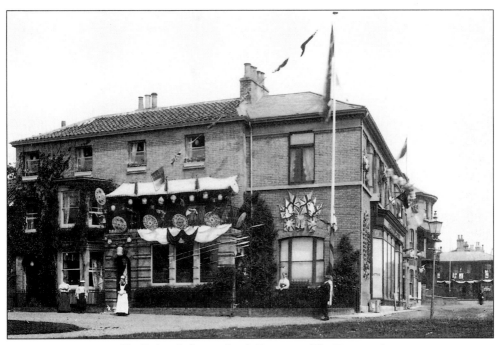

28 Debney's shop on South Green, now The Homestead.

silk jumpers were presented to the royal family for the young Princesses Elizabeth and Margaret. Men and women had equal pay. They took great pride in their work, and regarded their employers with affection. They obviously enjoyed 'job satisfaction'.

In 1960 the company closed, but at least two of the workers bought their knitting machines and continued to produce further orders for a few years. The Homeknit premises were later used as offices by Field & Son Ltd, a company started with a government subsidy to create employment 'in a depressed area'. Field's employed forty to fifty men and women at their factory between Station Road and St Edmund's Road, where they produced all manner of electrical equipment including storage heaters and radiators. Eventually Field's was taken over by Hubbards, makers of vending machines, and the factory is now situated in the light industrial estate in Reydon.

* * *

Nowadays Adnams Brewery is the largest single employer in the town. Nevertheless, Southwold is still dominated by the sea for it is now a popular holiday resort and the main occupation is supplying the needs of the visiting holidaymakers, who not only flock in during the bright summer months but also come in the cooler, more unseasonable times of the year.

The Fishing, the Harbour and the River Blyth

RACHEL LAWRENCE

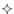

Southwold's great benefactor has been the North Sea herring. Over centuries herring fishing provided the inhabitants of this offshore settlement—practically an island—with a decent livelihood and sometimes with considerable wealth. But, much more than that, the herring fleets provided a great school of seamanship which spawned hardy sailors, skilled and resourceful and accustomed to facing stormy waters, bitter conditions and often death. And this seamanship has been passed on over many generations.

The great shoals of herring which moved down the east coast of England were found off the Suffolk coast between September and December. Domesday Book records that both before and after the Norman Conquest Southwold, then a hamlet of Reydon, was supplying the monks of Bury with a rent of herring—20,000 before the Conquest and 25,000 in 1086. And when in the mid-13th century the Abbot of Bury transferred his Southwold lands to Richard de Clare, the de Clares claimed this herring rent. In 1407 around 17,000 herrings were paid to the de Clare manor.

Herrings were depicted on Southwold tokens, and rents and wills show us that the herring fishery was the basic local industry through the Middle Ages. Spratting overlapped the herring season, and both herring and sprats were salted, while red herring and sprats were salted and then smoked over wood. Herrings endured as a source of local income, but by the 16th century the herring fishery was masked by other ventures—the Iceland fishing and the coastal trade.

The boats used for herring fishing—'farcosts'—ranged from five to 50 tons. They could be used for cross-Channel voyages, but they were hardly big enough for the lucrative voyages to Iceland which were now beginning and which were to make fortunes for some Southwold shipowners. As both the size and the numbers of boats increased the men of Southwold and Walberswick required a convenient haven and one free from the shackles and restraints imposed by the port of Dunwich to the south. Eroding seas and drifting shingle were on their side.

In the 13th century great Dunwich was the leading port in Suffolk. The River Blyth came towards Southwold from Blythburgh, but it turned south and ran parallel to the coast until it met the little Dunwich river and entered the sea on the north side of Dunwich. Here it provided that town with a superb natural harbour until the unpredictable winds and seas brought a devastating change. In 1328 a terrible storm severely damaged part of the town

and the north-east winds utterly choked the harbour with shingle which proved unmoveable. The frustrated river turned back and opened a new mouth two miles nearer to Southwold and Walberswick. There then followed over more than two centuries a long and acrimonious struggle between Dunwich, Walberswick and Southwold, during which four more new mouths were cut, each nearer to Southwold, until in 1590 the men of Southwold and Walberswick forcibly opened a new mouth very near the present one. It was a mouth which gave the River Blyth a straight fall into the sea.

The quarrel between Dunwich and Southwold involved long disputes about shipping dues which Dunwich determinedly claimed. However, at last Dunwich's claim to tribute was abolished when in 1489 King Henry VII granted Southwold the splendid Charter which established its independence. Among many other benefits it gave the town Admiralty rights and the inlet and outlet of waters, reciting 'That the navigation of the inhabitants of that Town by their industry exceeded and excelled above that of the ancient privileged Towns of those parts'. In 1497 a Southwold boat, the *Barbara*, was among the vessels which drew warlike stores from the Tower ready for the invasion of Scotland. In the mid-16th century it was recorded that Southwold had 174 mariners and one ship of over 100 tons.

So it is evident that long before the last mouth was dug in 1590 Southwold men had seized on the opportunities provided by earlier cuts which made it possible for boats of up to 150 tons to pass into the sea. The 15th century was a period of prosperity to which the churches of Walberswick and Southwold bear witness. Southwold church (built all of apiece) was not a 'wool' church but a 'fish' church, and ship owners, merchants and fishermen contributed generously to the building.

The herring industry continued, but the great new source of wealth was to be Iceland, a frightening realm of midnight sun and perpetual darkness set amid a dreary waste of icy water, but where cod and ling could be obtained in abundance. Ships sailed in March and returned in August in time for the herring fishery. The English trade to Iceland was successful in the early years of the 15th century, but was restricted by statute in 1430. How much this decree was observed is open to question, but it possibly explains why there is little documentary evidence before 1490 when full trade was resumed.

We know that Richard Bishop, bailiff of Southwold in 1510, had at least four Iceland ships, and that by this time other Southwold shipowners like Robert Joye and Thomas Mower had sent ships across the freezing waters. When Southwold's benefactor, William Godell, made his will in 1509 he was expecting the arrival of his ships from Iceland, and much of his great wealth must surely have come from cod and ling.

In 1528, when the English cod fleet numbered 149, Southwold with Easton Bavents and Covehithe sent 32 ships, and in 1593 when the county of Suffolk sent 28 ships to Iceland 16 of them came from Southwold. These Iceland ships seem to have resorted

33

chiefly to Wood's End Creek, later renamed Buss Creek, where they had their quay, their blubber pans and tackle houses.

There was also coasting trade from Southwold harbour, carrying butter and cheese to feed the gaping maw of London; but it is startling also to find records in Newcastle showing that in the summers of 1508 and 1509 30 Southwold ships and many others from Dunwich and Walberswick came to fetch coal. We can only conclude that they were transporting coal to many places beyond their home port.

In 1609 Thomas Gentleman of Southwold, the owner of four Iceland ships, was buried at the age of ninety-eight. His son Tobias, fisherman and mariner, wrote in a famous pamphlet in 1614:

> In the Towns of Southwold, Dunwich and Walberswick is a very good breed of fishermen … but these men are greatly hindered and in a manner undone by reason that their Haven is so bad and in a manner often stopped up with beach and shingle stone … it is pitiful the trouble and damage that all the men of these towns do daily sustain by their naughty harbour.

His complaint about Southwold harbour was to be repeated endlessly over the years that followed, but aside from the haven problems, and well before the time when he was writing, the fishing industry was facing decline. The salt fish trade must have been seriously hit by the decline of fasting after the Reformation, but more serious were inroads into the local fishery by the Dutch, who used larger vessels and superior equipment. The Dutch, Tobias said, 'engrossed' the fishery. James I was sympathetic to Southwold's problems. In 1618 he allowed a collection throughout the kingdom for repairs and it was probably out of this money that the first quay at Blackshore was built.

But the 17th century was a depressing time for Southwold mariners. Their harbour remained at the mercy of drifting shingle and sand, and there were no piers so that the haven shifted about according to the wind. No wonder mariners complained bitterly:

> Dunwich, Soul and Walderswick
> All go in at a lousy creek.

Outside the harbour, East Coast boats were now being harassed by pirates and attacked by armed raiders from Dunkirk, so that the fishing fleets had to be provided with naval escorts which were not always available. The Dutch wars provided further disruption. Southwold Bay was one of the main watering places for the fleet, and the port was swamped with sick and wounded sailors while at the same time the press-gang was seizing local fishermen. In the mid-17th century the bailiffs wrote to Milton, secretary to the Protector:

'The town of Southwold [is] at present destitute … The causes of the decay of the town are the impairing of the harbour, the want of fishing, and the charges of many widows and fatherless, left upon them by several fights with the Hollanders.'

In 1659 the town was struck down by the disastrous fire and recovery from this was not helped by the renewal of the Dutch wars: the landing of 2,000 prisoners and a further contingent of wounded men in 1665-6, and the increasing ruthlessness of the press-gang. The wars culminated in the Battle of Sole Bay in 1672 when the Dutch were at least forced to retreat.

In 1688 the limits of the Port of Southwold were defined as from Covehithe to Thorpeness, and Blackshore quay was assigned as the legal quay at which goods brought from abroad could be landed, or goods could be embarked for export. The town, now struggling to emerge from poverty, appreciated that its economic prosperity was greatly dependent on its 'naughty harbour' and made great efforts to keep it open, despite lack of money.

By the mid-18th century, however, lucrative opportunities were opening for both fishing and trading vessels and merchants, and fishermen grew increasingly impatient with the hazards of the harbour. It was generally agreed that oak piers must be built to secure the wandering mouth, but this was work the town could not afford and so by an Act of 1746 Southwold Borough willingly relinquished the harbour into the control of a body of Commissioners drawn largely from neighbouring country gentlemen. The Act empowered the Commissioners to raise funds by issuing interest-bearing mortgages secured on the proceeds of the harbour dues. In 1749 the north pier was built, followed in 1752 by the south pier.

Almost immediately London merchants made Southwold the headquarters of the Free British Fishery, a company incorporated to compete with the Dutch fishermen. Busses were built on Dutch lines—about 45 to 80 tons and square rigged. The Society established their quay and premises at Wood's End Creek, from that day known as Buss Creek, and built warehouses at Blackshore and a net-house on The Common. In 1753, 67 busses made Southwold their port. This brought new life to the town, but the Fishery was short-lived and collapsed in 1772 partly owing to the weaknesses of the company itself but also because the harbour was still precarious, as indeed it continued to be in the years which were to follow.

Thomas Gardner, writing his great history in 1754, was enthusiastic about the Fishery but, leaving it aside, he also reported that there belonged to the town itself 15 small fishing boats in the home fishery and one brigantine and nine sloops engaged mainly in exporting 'Red Herrings, Red Sprats, Malt and Corn' and importing coals and cinders. It was the Southwold merchants with vessels involved in this trade who, until nearly the end of the 18th century, cared for the haven and themselves supervised the endless repair work as the vulnerable piers were devoured by sea worms and 'mashed' by the seas. These men had

thriving businesses in brewing and malting, salt, and timber, but they needed the harbour to carry produce to London and Rotterdam, to bring them timber from the Baltic, and above all to bring in the coal and cinders vital to their manufactures.

About this time two developments on the River Blyth swelled the number of trading ships passing through the harbour. In 1740 Reydon Quay was built and its accessibility encouraged merchants from Reydon and Wangford to export their barley and malt, peas and beans on a considerable scale. In 1757 the Act to make the river navigable to Halesworth was passed, and from the 1760s black-sailed wherries, laden with country produce, made their day's journey down to vessels at the harbour and returned to the quay at Halesworth with badly needed coal.

During and after the Napoleonic Wars, Southwold harbour was in all sorts of trouble, and between 1805 and 1818 it had to be dug out 13 times. Expert engineers were called in and for the most part blamed the trouble on the embankment of the river by landlords on each side, busy reclaiming the tidal saltings. Little was done till, in 1829, Lieutenant Francis Ellis was appointed Harbour Master. His strenuous efforts to clear the shoaling with the aid of a steam dredger brought results, and during the 10 years from 1831, 4,250 merchant ships passed in or out of the harbour. This gave a boost to ship-building. In 1833 two brigs were built at Blackshore, followed soon by two more, and ship-building continued here until about mid-century.

The improvement at the harbour was transitory and now the main trouble was a bar of shingle which formed across the mouth—so high in the winter of 1838-9 that carriages could travel across it. By now the lion's share of harbour dues was being paid by the Halesworth maltster, Patrick Stead, who angrily attacked the Commissioners and also embarked on a bitter campaign to have the landlords' embankments pulled down so that flooding waters could again scour the harbour on the ebb tide. Despite a strongly supportive report by the national Tidal Harbour Commission, Stead's efforts over this were frustrated. Nonetheless, by the time he sold up in 1852 his business, which was so dependent on shipping malt to London from Southwold, had done very well. A shrewd man, he sold his maltings in Halesworth and his shares in the river to Trumans, the brewers, at the right time for he was already convinced that soon the railways would take over the river trade. In this he was correct, and in 1884 the river navigation was closed.

The harbour also gradually lost its shipping to the railways, and as the traffic disappeared so too did finance for repairs. The harbour became a sad sight with piers tumbling to pieces and wharves desolate. In the 1880s the Commissioners threw in the sponge, but once again Southwold men fought stubbornly for their harbour which they claimed back amid much rejoicing. There was then evolved a great and optimistic plan to restore the harbour to glory, and appositely this scheme was based on North Sea herring. Why could not Southwold become, like Lowestoft, a main port for the thriving Scottish herring fishery?

E.R. Cooper, Southwold's Town Clerk, devised and engineered the scheme. Southwold won the approval of the Scots, and then sold the harbour for a token half guinea to Messrs Fasey & Son, developers, who with government aid restored and improved the structure, extending the piers and widening the entrance. Pickling plots and a central office were laid out. There had been some frustrating delays, and the port was not ready for the 1907 autumn fishing, but in 1908-9 about 300 drifters landed herrings which were speedily dealt with by the Scots girls who were lodging in the town. Southwold ships then transported the cured herrings, packed in barrels, to Germany.

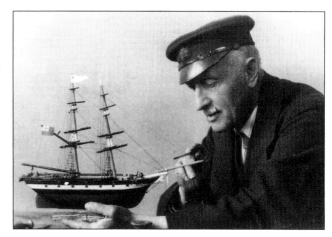

29 Ernest Read Cooper, Town Clerk of Southwold at the time of the harbour redevelopment, 1906-7.

30 Construction of the new concrete harbour wall, March 1907.

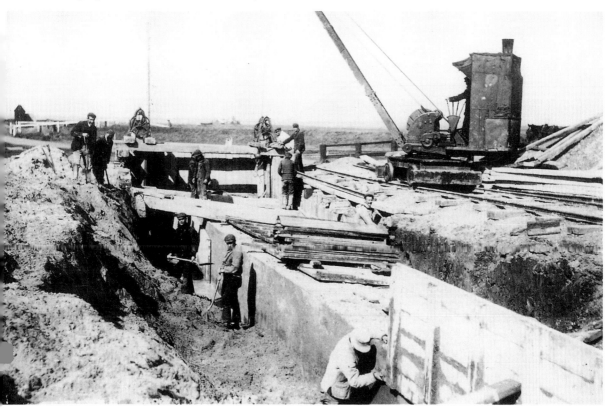

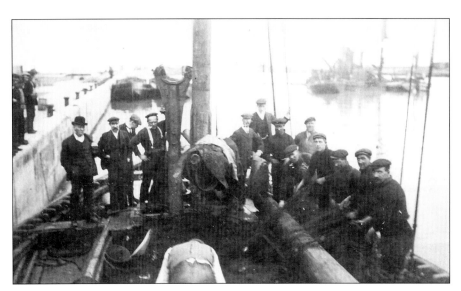

31 The first Scots fishing boat in Southwold Harbour, 26 October 1907.

Sadly, in the following years the scheme faltered owing to some bad fishing seasons and lack of co-operation by the Southwold Railway. By the outbreak of war in 1914 it was effectively dead. Nothing now remains of the buildings, but the harbour had been saved. Although once more it began to deteriorate, it was there for the local North Sea drifters, known as half-and-halfers, and for boats bringing coal. In 1932, 20 vessels entered with 3,000 tons of coal.

The harbour was uninviting to fishing boats by the latter half of the 19th century, but the sea was full of fish and Southwold fishermen with the same tough courage and enterprise shown by their forefathers turned to their beach and to longshore fishing. They launched their boats, often called punts, from the shore and hauled them back with the catch by means of capstans. They caught herring, sprats, shrimps, sole, cod, mackerel, and by 1900 some three hundred men and

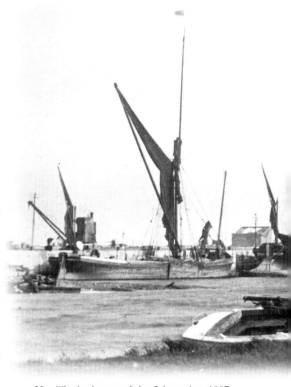

32 The harbour and the fish market, 1907.

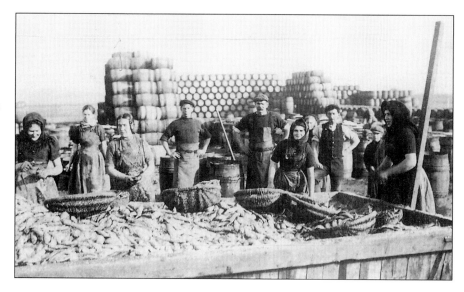

33 Scots fisher girls around 1908.

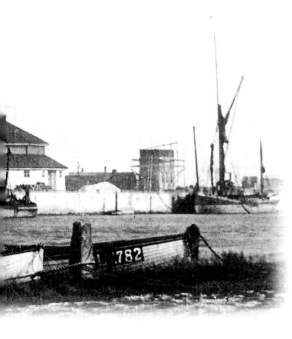

boys were making their living in this way. In 1907 there were about one hundred and twenty open boats working off the beach engaged in trawling and shrimping, and this fishing continued well into the 20th century.

These clinker-built boats were made locally by men whose names are still familiar—Critten, Ladd, Martin—boat-builders who were also making half-and-halfers and the famous beach yawls, used for piloting and rescue work. They had their workshops at Blackshore, along the river's edge and on the beach itself.

The longshore men themselves had their huts, black-tarred and tiled, on the beach above high water mark and in front of the town. Beside them were fishermen's cottages, a beach village which housed some 16 families in mid-Victorian times. Some of these buildings were still there after the turn of the century and some of the huts, although they were moved more than once,

can still be seen within the harbour on the north bank of the river. Longshore boats were all under sail in the 1920s, but gradually motors were introduced and for these the harbour was preferred, so that by the 1930s interest in it revived. Ownership had reverted to the town in 1931, and eventually in 1939 a new entrance was completed with piers of reinforced concrete and a bell-shaped mouth. The latter was never satisfactory, and the entrance was not helped by large gaps blown out of the concrete in the war years.

The post-war years saw the advent of powerful foreign trawlers, some of them belonging to Southwold's old rivals, the Dutch. These foreign factory ships swept the bottoms of the North Sea ruthlessly and indiscriminately, and this put paid to the rich catch of herrings which had meant so much to Southwold's development. The Blackshore men lost most of their herring fishing, but they did not lose the traditions and the seamanship which that fishing had nurtured over the centuries. In May 1998 there were about thirty-five registered boats fishing from Southwold, including four fast boats for long lining and netting.

Increasing numbers of pleasure craft and visiting yachts were also by now berthing in the harbour, and it was realised that something must be done to make it more viable. Scientific advice was called in, but the Borough Council could not obtain enough grants to carry out work till the mid-'60s. Then in 1974 the local government reorganisation finally removed the ownership from Southwold and passed it to Waveney District Council.

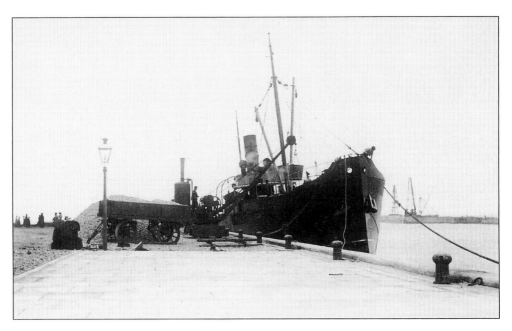

34 The first steamer to enter Southwold Harbour. The SS *Commandante* from Guernsey arrived on 17 April 1908 with a cargo of granite.

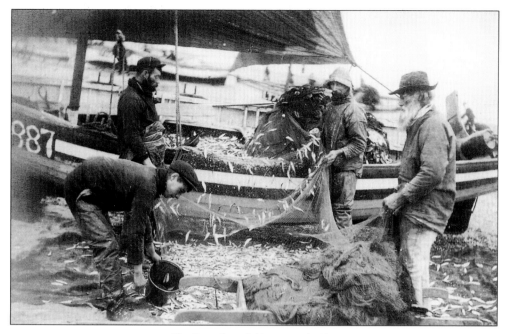

35 Longshore fishing around 1905.

36 The second chain-driven ferry, which operated from 1927 to 1939. The photograph was probably taken in 1936, after a larger boiler was installed on the ferry.

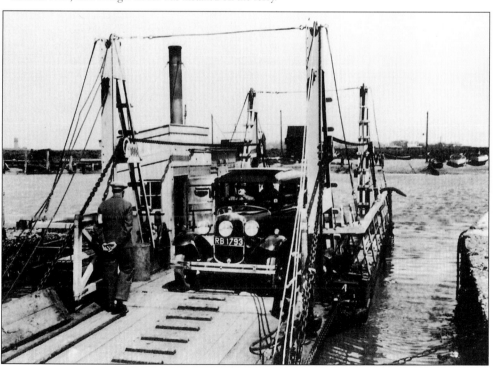

Southwold fishermen and inhabitants were, however, quite clear in their hearts and minds that the harbour was theirs. When in the '80s the District Council proposed to let it to a developer who planned to build a marina and a holiday village on the Town Marshes there was unanimous outcry. A public meeting was held in 1986 in St Edmund's Church, which was packed to bursting. As Simper records, 'the developer's words were drowned by a chant of GO NOW!, and go he went'.

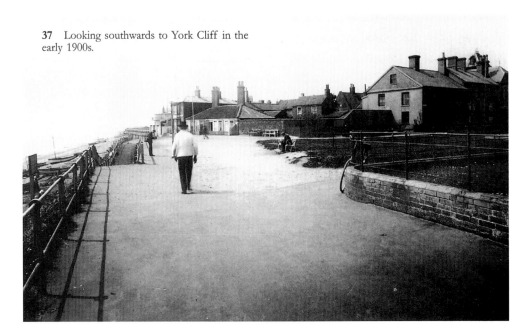

37 Looking southwards to York Cliff in the early 1900s.

Bibliography

Becker, Janet (ed.), *Story of Southwold* (Southwold, 1948)

Bottomley, A.F., *A Short History of the Borough of Southwold* (Southwold, 1974)

Bottomley, A.F., manuscripts in Suffolk Record Office, Lowestoft

Cooper, E.R., *A Brief History of Southwold Haven* (Southwold, 1907)

Gardner, Thomas, *An Historical Account of Dunwich, Blithburgh, Southwold* (London, 1754)

Lawrence, Rachel, *Southwold River* (pbk edn, Southwold, 1997)

Lawrence, Rachel, 'The Transformation of Southwold Harbour 1891-1914' in *Suffolk Review*, 29 (Autumn 1997)

Middleton-Stewart, Judith, 'Down to the Sea in Ships' in *Counties & Communities* (UEA, 1996)

Scarfe, Norman, *Suffolk in the Middle Ages* (Woodbridge, 1986)

Simper, Robert, *Rivers Alde, Ore and Blyth* (Creekside Publishing, 1993)

Simper, Robert, *Traditions of East Anglia* (Woodbridge, 1980)

Southwold Museum, *Southwold and the Sea* (booklet, 1996)

Williams, N.J., *The Maritime Trade of the East Anglian Ports 1550-1590* (Oxford, 1988)

The Harbour and the Fishing in 1998

JOHN WINTER

✧

After the trio of unrealistic schemes suggested to destroy our harbour and marshes during the mid-'80s there seems to have been a period of calm, although in reality much has been happening. One of the more important has been the building of a revetment of rocks to shore up the North Pier, which appears to work quite well and has the added advantage of allowing the waves to break on it, making it much calmer in the harbour itself. This has made it possible to have some moorings nearer to the entrance than before.

Boatbuilding on a commercial scale has returned in the shape of Harbour Marine Services, which builds in both fibreglass and wood and is run by a very enterprising young couple, John and Adele Buckley. Not surprisingly this has quickly become the centre of most activities at the harbour. There is another smaller yard run by another young man, Justin Ladd, so it would seem that the harbour's future is at least hopeful.

Fishing, despite quotas and masses of red tape, has adopted some more modern methods, although the traditional ways still exist. As at other ports natural materials have given way to man-made fibres. Drifting is still a wall of netting suspended from cork-like floats moving along with the tide to catch herring or sprats by their gills. Trawls are net bags, towed along the sea bed to scrape up ground-feeding fish like plaice, sole, dabs and flounder. There are two basic types. Beam trawls, which use a pole or beam between two iron hoops called luteheads to keep the mouth open, stem from the days of sail and today are used mainly for shrimp nets. The other, and more common type, uses two kite-like boards called otter doors to keep the entrance open. Trammel nets are also used. These are made up of three walls of netting, each with a different size mesh, into which fish swim and entangle themselves. There are also tangle nets, which work on the same principle but with only one wall of net. Long lines are another traditional form of fishing, with over a kilometre of line, with a hook every three or so metres apart baited with squid, sprats or herring, and shot at an angle to the tide, being hauled out at slack tide. Wreck fishing— anchoring over a wreck and angling—has been introduced; also jiggering, which is similar but with the hooks on a horizontal pole which is constantly moved up and down. These last two types of fishing are carried out from boats made of fibre glass and powered with engines up to 600 hp, enabling speeds of up to 30 knots to be attained. Sometimes these craft find themselves working nearer to the Dutch coast than our own, all a far cry from the

time that Jack May put the first engine in a boat in Southwold. This, I was told, was a Brit which had so much external pipework on it that it became known as 'The Brass Band'.

At present there are many varieties of fishing craft at our harbour, some in wood, others in fibre glass. There are traditional longshore punts, clinker-built with transom stern and with full sections, and rarely over 20 feet long; these open boats are direct descendants of the beach boats. There are several more which are slightly larger, both clinker- and carvel-built and sporting wheelhouses giving a little bit of comfort; a number of these are ex-Trinity House boarding boats. Then there are some between 30 and 40 feet long that fish for herring, and with trawl and lines. The high speed craft are mostly in this latter class.

The Southwold Railway, 1879-1929

DAVID LEE

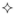

A Brief History

Railway projects in Suffolk during the 1840s and '50s, including some that never materialised, never took Southwold into consideration. Halesworth became the terminus of a line via Beccles from Haddiscoe, on the railway between Norwich and Lowestoft, in December 1854, which was extended to Ipswich via Woodbridge jointly by the East Suffolk and Eastern Counties Railways in June 1859.

Southwold thus came within nine miles of the rapidly expanding national railway network while the town was still a small fishing village attracting few visitors because of the poor communication. It was to be a further 20 years before a railway connected the town with Halesworth.

During the 1860s there were at least two horse omnibuses operating to Darsham, the principal one being run by Mrs. Jane Catton, proprietress of *The Swan Hotel*, whose bus left at 10 a.m. returning at about 1.30 p.m. daily, except Sundays.

Attempts to build a railway from 1855 and during the following two decades were backed by various local people who were in favour of such a scheme and initially made financial contributions, but failed to maintain their support or encourage others to contribute. Even Sir Morton Peto looked favourably on a scheme in 1860, but was unable to continue his association due to heavy financial commitments with the London, Chatham and Dover Railway, which ultimately led him into financial difficulties.

During the period 1855 to 1865 the Mayor of Southwold, Alfred Lillingstone, was actively engaged in the promotion of three early projects to build a railway from Halesworth to Southwold, but he died in March 1866. Between 1865 and 1867 two schemes were promoted by the Blyth Valley Railway, which surveyed potential routes and presented Bills to Parliament only to withdraw them because of insufficient financial support. In 1865 support was enthusiastic, and it was hoped that within 15 months 'the sound of the whistle will be heard along the valley of the Blyth'. A further attempt at promotion was made in 1875, to be overtaken by the Southwold Railway presenting its Bill to Parliament.

A scheme was projected by the East Suffolk Tramway Co., which obtained an Act in 1872 under the Tramways Act of 1870, to build a roadside tramway via Wangford, Brampton, Westhall and Holton to Halesworth. This was part of a project for a tramway from Yarmouth to Lowestoft and Southwold of 1870-1. However, the plans lapsed because of the usual

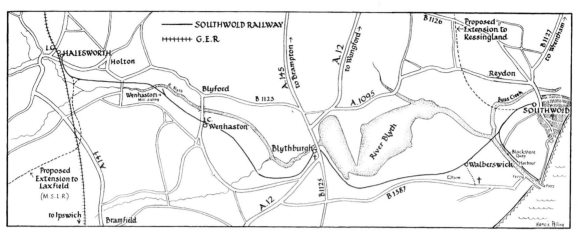

38 (*above*) The route of the Southwold Railway.

39 (*below*) The second Southwold Railway timetable issued in December 1879.

Stations.					UP TRAINS.—Week Days.							Sundays.	
	Morn	Morn	Even	Even		Even	Even	Even				Even	Even
Southwold ...dep.	8 30	11 8	..	2 37	..	5 0	..	6 30				1 46	6 0
Blythburgh (for Wangford) ,,	8 43	11 21	..	2 50	..	5 13	..	6 40	on			1 59	6 13
Wenhaston ... ,,	8 53	11 31	..	3 0	..	5 23	..	6 50	run as			2 9	6 23
Halesworth ...arr.	9 7	11 45	..	3 14	..	5 37	..	7 14				2 23	6 37
...dep.	..	11 47	..	3 21	..	5 41	..	7 53	will				7 14
Brampton ... ,,	..	11 56	..	3 30	..	5 8	..	7 27					7 27
Beccles ... arr.	..	12 6	..	3 39	..	5 55	..	8 18	Trains				7 36
Bungay ... ,,	6 25	the				
Lowestoft ... ,,	..	12 34	..	4 2	..	6 24	..	8 45	Day				8 5
Yarmouth ... ,,	..	12 45	..	4 20	..	6 55	..	8 55	Christmas				8 16
Norwich ... ,,	..	1 55	..	4 50	9 55					
Halesworth ...dep.	9 9	12 4	..	3 17	7 15	Sundays.				
Darsham ... ,,	9 19	12 18	7 25	On				
Saxmundham ... arr.	9 30	12 30	..	3 36	7 39					
Leiston ... ,,	9 43	1 2	..	3 17	7 50					
Aldeburgh ... ,,	9 58	1 13	..	3 30	8 19					
Wickham Market dep.	9 42	12 43	..	3 48	7 51					
Framlingham ... ,,	..	1 10	8 20					
Woodbridge ...dep.	9 55	12 57	..	4 1	8 5					
Bealings ... ,,	..	1 4	8 18					
Westerfield ... ,,	..	1 16					
Ipswich... ...arr.	10 14	1 25	..	4 8	8 30					
...dep.	10 15	1 35	..	4 26	8 40					
Manningtree ... ,,	10 35	1 53	8 56					
Colchester ... arr.	10 45	2 7	9 9					
...dep.	10 51	2 12	2 55	9 11					
Mark's Tey ... ,,	11 3					
Witham ... ,,	3 4					
Chelmsford ... ,,	11 30	..	3 24	9 52					
Liverpool Street... arr.	12 15	3 24	4 23	6 0	10 50					

The Trains will stop at Wenhaston and Blythburgh by Signal only, and Passengers wishing to alight there must inform the Guard at the starting Station.
An Omnibus meets all Trains at Southwold.
Conveyances can be obtained at Blythburgh.

Stations.					DOWN TRAINS.—Week Days.							Sundays.	
	Morn	Morn	Morn	Morn	Morn	Noon	Even	Even	Even			Morn	Even
Liverpool Street...dep.	5 10	7 20	9 0	10 0	11 0	12 0	2 30	3 35	5 0	on		3 0	..
Chelmsford ... ,,	5 57	8 32	9 57	10 45	12 8	..	3 15	4 45	..			4 15	..
Witham ... ,,	..	8 53	10 14	..	12 24	..	3 32	5 6	..			4 35	..
Mark's Tey ... ,,	6 21	9 14	12 48	1 10	3 47	5 25	..			4 53	..
Colchester ... arr.	6 32	9 24	10 39	11 16	12 55	1 20	3 56	5 35	..	run as		5 4	..
...dep.	6 34	9 29	10 42	11 19	..	1 24	3 59	5 39	..			5 8	..
Manningtree ... ,,	6 44	9 40	10 59	11 35	..	1 45	4 15	5 59	..	will		5 23	..
Ipswich... ... arr.	7 5	10 16	11 15	11 50	..	2 0	4 30	6 22	6 36			5 55	..
...dep.	7 12	10 25	12 0	1 6	4 31	6 45	..	Trains		6 0	..
Westerfield ... ,,	7 21	10 38	4 43	6 54	..			6 10	..
Bealings ... ,,	7 29	10 45	2 23	..	7 2	..	the		6 19	..
Woodbridge ... ,,	7 36	10 55	12 19	2 30	4 54	7 9	..			6 27	..
Framlingham ... ,,	7 20	2 10	..	6 50	..	Day	
Wickham Market ,,	7 55	11 10	12 30	2 45	5 7	7 34	..			6 41	..
Aldeburgh ... dep.	7 20	3 50	11 45	2 35	5 35	6 60	Christmas	
Leiston ... ,,	7 16	9 2	11 55	2 36	4 48	7 2		
Saxmundham ... ,,	8 6	11 26	12 45	3 0	5 21	7 38	..	On		6 56	..
Darsham ... ,,	8 18	11 36	12 55	3 10	..	7 48	..			7 6	..
Halesworth ... arr.	8 26	11 47	1 6	3 21	5 41	7 59	..			7 13	..
Norwich ... dep.	..	8 20	1 23	..	5 32
Yarmouth ... ,,	..	8 20	2 30	4 0	6 10	..			7 0	..
Lowestoft ... ,,	..	8 22	11 16	4 4	6 28	..			7 10	..
Bungay ... ,,	..	8 25	9 36
Beccles ... ,,	..	8 53	11 48	3 0	4 30	6 54	..			7 37	..
Brampton ... ,,	..	11 56	7 5	..			7 49	..
Halesworth ... arr.	9 9	12 8	3 17	4 46	7 15	..			7 57	..
...dep.	9 25	3 26	5 48	8 5	..			2 26	7 25
Wenhaston (for Wangford) ,,	1 11	3 36	5 56	8 15	..			2 36	7 35
Blythburgh ... ,,	9 33	..	1 29	3 44	6 4	8 23	..			3 44	7 43
Southwold ... ,,	9 52	..	1 21	3 36	6 23	8 43	..			3 3	8 2

Through Tickets are issued between all the above Stations.
Through Rates for Goods and Minerals to and from all Great Eastern Stations.
The Through Rates for Fish to London are the same as from Yarmouth and Lowestoft.

lack of finance, and in addition there were suspicions about the intentions of the East Suffolk Tramway Co., which was wound up in 1874.

Towards the end of 1875 well-attended public meetings were held at Halesworth and Southwold which resulted in an Act being obtained in 1876 authorising construction of a single line railway approximately 8¾ miles long between those towns, to a gauge of not less than 2ft. 6in. and with two branches. The narrow gauge option was at the instigation of the company's engineer, Arthur Pain, CE, who for some years had been advocating construction of 'light railways' for agricultural development in rural areas. Such railways were claimed to be cheaper to build and to operate, and finally 3ft. was the track gauge selected, unusual for England. During 1877 there was some uncertainty about proceeding with construction due to lack of finance, and the original board of directors resigned. However the contractor, Charles Chambers of

Westminster, was able to start work in May 1878, and the work was completed and inspected by the Board of Trade for opening to all traffic on 24 September 1879.

When the line opened the only intermediate station ready was Wenhaston. Blythburgh opened in December 1879, Wenhaston Mill Siding in November 1880, and Walberswick in September 1882. The two branches which had been authorised were never constructed.

The promoters originally intended the line to be a light railway with simplified signalling, reduced speed, and weight restrictions. However, the Act failed to provide this status, which after rectification was confirmed by a Board of Trade Licence dated March 1880.

During the 1880s traffic and revenue increased only slowly, and was insufficient to pay interest on the capital and outstanding debts. The authorised capital of the Southwold Railway Company was £53,000, but construction had cost over £60,000, making it necessary to raise a further £24,000 which was authorised by Board of Trade Additional Capital Certificates dated 1880 and 1888. In 1883 arrangements were made with the creditors to clear outstanding debts and to return an engine to the makers, but by 1893 matters had improved sufficiently to enable purchase of another engine. Ordinary shareholders did not receive any dividends until 1910, when two per cent was paid.

Until 1914 the company prospered, and during that time improvements were made at Southwold by extending the goods yard and station building, and installing electric light in 1905. In 1902 Walberswick station building was rebuilt. At Blythburgh a siding was converted to a loop line enabling two trains to cross, and in 1908 train operation changed from Train Staff to a Train Staff and Ticket system.

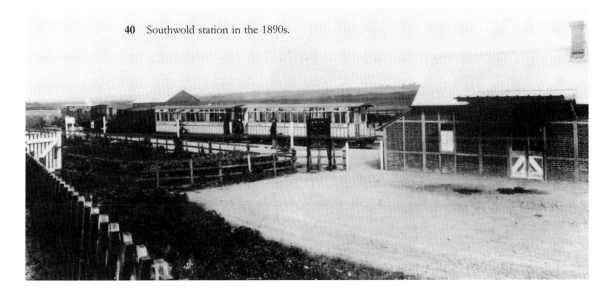

40 Southwold station in the 1890s.

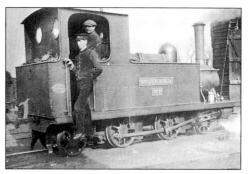

41 2-4-2T No.1 Southwold of 1893, photographed in March 1913. T. Moore on the footplate, with Porter Fisk.

Under the provisions of the Light Railways Act 1896 a Light Railway Order was obtained in 1902 to extend a line to Kessingland and convert the railway to standard gauge. The extension was never built, and after rebuilding four bridges, including the swing bridge over the Blyth, and completing sundry earthworks, conversion work petered out. Had the gauge conversion taken place and the proposed extension of the Mid-Suffolk Light Railway from Laxfield to Halesworth ever been built, it was intended that the new line would join the Southwold Railway by means of a triangular junction in The Quarry at Halesworth, with a terminus on the east side of that company's station, so that its trains could run direct to the coast, the intention being to develop Southwold Harbour into a commercial port in conjunction with the Midland Railway.

Following the reconstruction of the harbour in 1906/7, there was a long dispute with the owners as to who should build and operate the branch line, so it was not until 1913 that the Southwold Railway Company obtained a Light Railway Order for the necessary powers, including raising £2,700 (total capital £89,700). The branch was opened in the autumn of 1914, but the outbreak of war prevented any fish being landed, and it is doubtful whether the branch was ever an economic proposition. Another engine was bought and an engine shed built at Halesworth.

Following the end of the First World War traffic never regained previous levels, a steady decline in passenger traffic, the main source of revenue, resulting in the railway's eventual demise.

A Description of the Line

Passengers arriving at Halesworth Station via the Great Eastern Railway (London and North Eastern Railway after 1923) from Liverpool Street Station, London, proceeded to the Southwold Railway platform by the footbridge at the south end of the platforms. The Southwold train, waiting at a low platform with a small wooden office and shelter, consisted of two or more six-wheeled coaches with tramway style bench seats along each side and doors at each end, a van for luggage, mail, etc., and some goods wagons, the usual formation hauled by one of the railway's four engines. No trace remains of the station and sidings, which have become the site of a housing development.

Leaving Halesworth Station in a southerly direction, the line soon crossed Holton Road bridge (B1123), of which one brick abutment remains. It then ran parallel to the

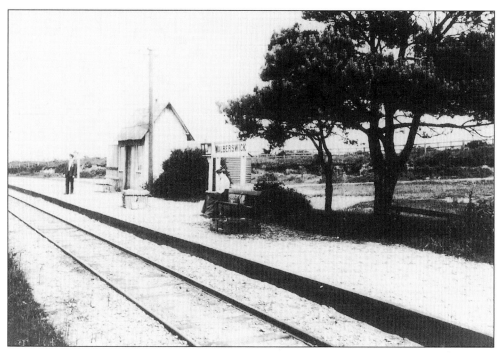

42 Walberswick station in 1900.

43 The down train to Southwold about to cross the original swing bridge over the Blyth, before 1907.

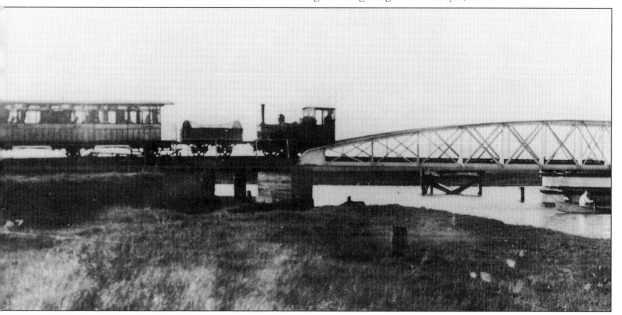

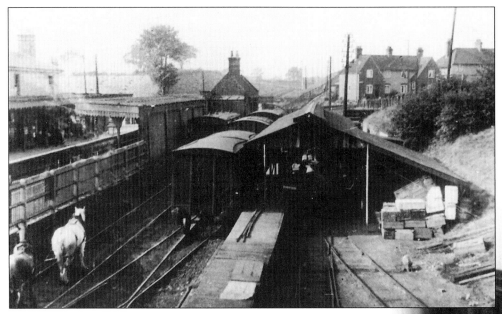

44 *(above)* Halesworth station in the early 1920s: goods being trans-shipped to the Southwold Railway.

45 *(right)* Southwold station, 1910. Guard Wright is standing at the extreme left.

Great Eastern Railway for 200 yards before turning eastwards to pass through The Quarry (or Bird's Folly), where there was an engine shed of which a few traces remain, and continued through meadows behind the *Cherry Tree* pub, past Corner Farm, under Mells Road where the bridge still stands, then followed the water meadows of the Blyth Valley and at 1 mile 63 chains crossed the river on a timber viaduct, for the first time amid rustic surroundings.

Next came Wenhaston (or Kett's) Mill with a siding at 1 mile 74 chains, a water-mill of ancient origin which is now a private house, and from this point for some five miles the railway closely followed the River Blyth along its southern bank. At 2 miles 52 chains came Wenhaston Station (an electricty substation is now on this site), approached over a level crossing on the Wenhaston-Blyford road.

The line then took a south-easterly course to pass through open countryside, approaching Blythburgh Station at 4 miles 70 chains,

then making a wide sweep north and then east round the rise on which the church stands. This station site remains undeveloped, with the remains of a former coal shed.

After Blythburgh Station the line went under the main road (A12); the bridge was demolished during the 1950s as part of a road improvement scheme. At the eastern end of the station a splendid view opened up of the River Blyth to the left as the journey continued for about a mile winding through reedy backwaters and on low embankments, until the river and the railway parted company. Then, climbing steadily, it entered the area called The Heronry, a picturesque and popular part of the journey. Part of this section of the formation has become a public footpath, providing a pleasant walk.

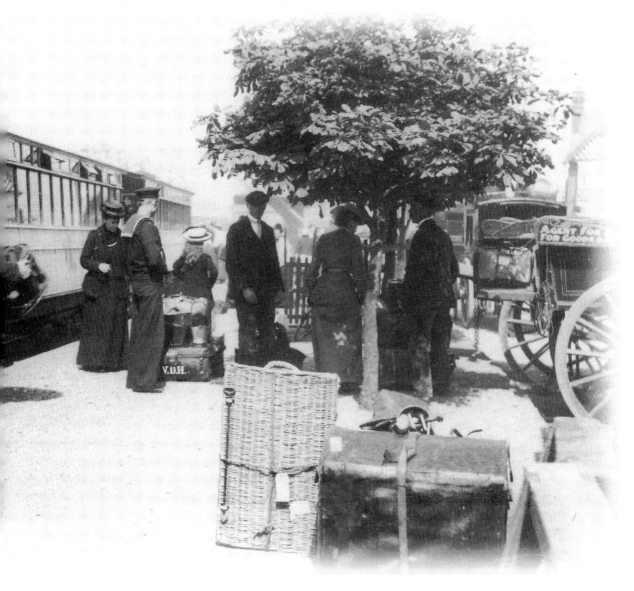

The climb continued steadily over embankments and through cuttings to emerge just beyond East Wood Lodge Farm in the gorse and heather of Walberswick Common, across which the line ran in shallow cuttings and over low embankments until reaching Walberswick Station, a distance of 7 miles 45 chains. The station was isolated, and connected with the village by a bridle-path with no houses within sight. Much of this section is now inaccessible or overgrown, though the station site remains and the concrete base of the station building has been exposed by a local society which provided a commemorative seat on the site in 1996.

Continuing the journey, the line dropped slightly towards the River Blyth, at 8 miles, which it crossed on an imposing wrought-iron swing-bridge, the major civil engineering work of the railway, which has been replaced by two Bailey Bridges, the second in 1977.

The line then crossed Woods End Marshes and entered a deep cutting on Southwold Common over which there was a footbridge giving golfers access to a part of the golf course which at that time was on the northern side of the cutting. Only the concrete bases and steps remain. The track from the site of Walberswick Station to the eastern end of the cutting is now a public footpath.

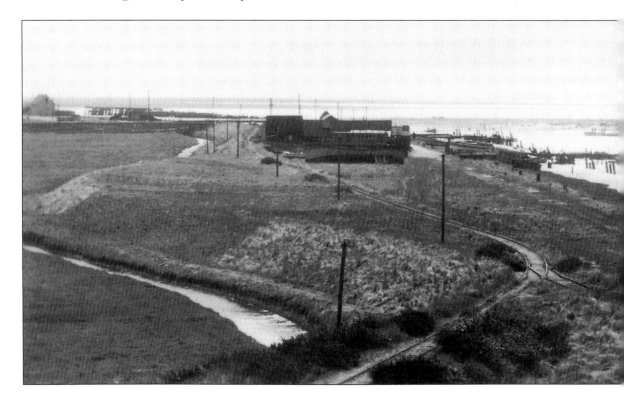

Finally, the line ran parallel to the rough road to terminate after 8 miles 64 chains adjacent to the road into town (A1095) opposite *The Station Hotel*, now *The Pier Avenue Hotel*. The site of the station building and the sidings is now occupied by the police and fire stations and two rows of houses along Blyth Road, while one of the three chestnut trees formerly on the platform remains.

The route of the branch line to the harbour can be seen curving away across the field to the south-east from a position near the Bailey Bridge, then over the road to Blackshore, behind *The Harbour Inn*, continuing behind the buildings and fishermen's huts to terminate on the quay, where there is now a car park. There was a siding on the quay at Blackshore, and some rails still remain in place at the water's edge.

The Southwold Railway made a considerable contribution to the development and the economy of Southwold, despite the imposed speed restriction of 16 mph and the break of gauge at Halesworth, where all goods had to be trans-shipped. Following the end of hostilities in 1918 motor vehicles were sufficiently developed to become a major competitor to the railways, and in 1928 Southwold Borough Council authorised the Eastern Counties Road Car Company to pick up passengers within its boundaries, which was a major setback to the railway and, despite a reduction in fares, resulted in its closure on 11 April 1929.

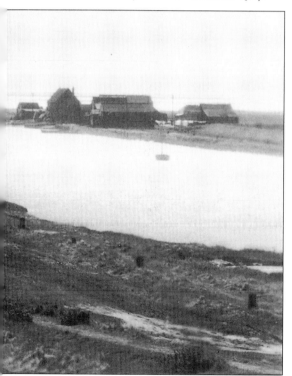

46 Looking seaward: the railway branch to the harbour and the junction to Blackshore Quay.

The Railway Equipment

When the railway opened in 1879 there were three locomotives built by Sharp Stewart & Co. Ltd. of Manchester. These were 2-4-0 side tanks numbered and named: No.1 Southwold; No.2 Halesworth and No.3 Blyth. Payment was partly in Debenture Stock, but as revenue was insufficient to service the interest payments the arrangement was terminated and No.1 returned to the makers in 1883, eventually being regauged and sold to the Santa Marta Railway, Columbia, in 1888, and withdrawn in 1932.

By the 1890s traffic and the company's finances had improved sufficiently to replace the displaced locomotive, which was ordered from the same firm's Glasgow works in 1893

and assumed the same name and number as the late No.1. This was a 2-4-2 side tank of the same principal dimensions as the originals, but was slightly longer. The livery of these locomotives was in maker's green on delivery, GER blue in the early 1900s, and finally black.

In anticipation of additional traffic arising from the Harbour Branch, a further locomotive was ordered from Manning Wardle & Co. Ltd. of Leeds in 1914. This was a larger and more powerful 0-6-2 side tank, being No.4 and named Wenhaston. The livery was in maker's green on delivery, and remained unaltered.

Most repairs to the locomotives were effected at Southwold in a small workshop joined to the engine shed, and included fitting new boilers, while other major repairs were done at Stratford Works GER, when engines were returned in that company's blue livery.

After closure in 1929 the engines were cut up, No.1 at Southwold in May 1929, Nos.2 and 4 at Southwold in January 1942, and No.3 at Halesworth in December 1941.

Throughout the railway's 50-year existence the coach fleet consisted of six vehicles—three composite (first and third class) and three third class. These coaches were about 36 feet long, carried on six wheels with a veranda and door at each end, and fitted inside with bench seats along each side in tramway style for about forty passengers. Lighting was by an oil lamp at each end; heating in first class was by hot water foot warmers, while in the third class straw was strewn ankle-deep on the floor. Curtains were fitted on the south, or platform, side as a sunshade. Between 1919 and 1923 five coaches were rebuilt, eliminating the verandas and most of the side panel moulding, while doors were fitted on the sides at each end on the platform side only.

Photographs of the coaches on delivery show a dark-coloured livery, possibly maroon, with gilt lettering. During the 1890s this was changed to white, or possibly pale cream after varnishing, with black lettering, and early in the 20th century the livery became maroon with black, later white, lettering. Roofs are thought to have been white.

At the opening of the railway there was a fleet of four-wheeled wagons—ten Open and two Bolster wagons—each of four tons carrying capacity and about 10ft. long, to which in 1885 were added two Vans for luggage, mail, parcels, etc. At various times between 1892 and 1914 further four- and six-wheeled Open wagons were added, bringing the total fleet to 36: 32 Open wagons, two Bolster wagons and two Vans. The six-wheeled wagons were about 20ft. long, carried about seven tons, and were built by Thomas Moy & Co. Ltd. The only alteration made was to lengthen the Vans in 1918. The livery of the original stock, as observed from photographs, was black with white lettering. At some date this became grey with black or white lettering. The Vans were painted maroon, probably retaining that colour throughout, with white lettering.

Until 1939 privately owned wagons, mainly for collieries and coal factors, were a common sight on the railways, with some being brightly painted. Thomas Moy & Co. Ltd.

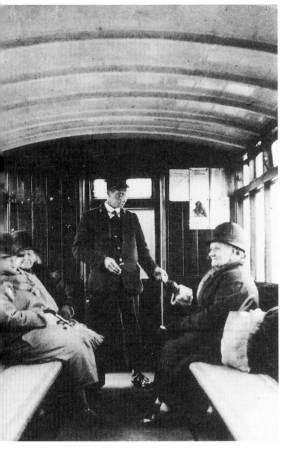

47 A carriage interior around 1927. Guard 'Peely' Palmer standing.

of Peterborough were owners of a fleet of their own wagons, which included some six-wheeled vehicles of superior design which the firm ran on the Southwold Railway, a unique feature for an English narrow gauge railway. Initially there were three wagons, replaced by two of identical design in 1922, the Southwold Railway purchasing the three which had been displaced, thus increasing their fleet to thirty-nine. These wagons were painted red oxide with white lettering shaded black.

All six-wheeled vehicles—coaches, wagons and Moy's wagons—were fitted with Clemenson's Patent Flexible Wheelbase, patented in 1876, which gave lateral movement when negotiating curves and crossings. All vehicles were fitted with a combined centre buffer and coupler, the original coupling hook being of the 'chopper' type, but following an accident at Walberswick a 'figure of eight' coupling was substituted on the recommendation of the MOT in 1921.

After closure in 1929 all vehicles, except for one Van, were stored at Halesworth. One coach was burnt out in the 1930s and all the stock, except for a Van, was broken up for scrap metal in 1941. The Van body which survived was ultimately restored and is on display at the East Anglia Transport Museum at Carlton Colville.

Further Reading

Information on the technicalities of the engines, etc, can be found in *The Southwold Railway* by A.R. Taylor and E.S. Tonks (new revised edition, Ian Allen Ltd., 1979). Much of the early history of the railway can be read in contemporary issues of the *Halesworth Times* and other county newspapers between 1858 and 1876.

In Peril on the Sea:
The first hundred years of the Southwold Lifeboats

JOHN GOLDSMITH

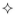

The Southwold Lifeboat Society was formed at a meeting convened by the following announcement:

> ### LIFE BOAT
> The expediency of a LIFE BOAT at the Port of SOUTHWOLD having been made obvious, not only by frequent Wrecks on the Barnard Sand, of Vessels to which no assistance can be given by the Pakefield or Lowestoft Life Boat, when the tide is ebbing and the wind adverse, but also by the recent loss of several Lives from a Vessel which foundered between Walberswick and Dunwich. A general Meeting of the inhabitants of Southwold and the Nobility, Gentry and others in its Vicinity, will be held at the TOWN HALL on Friday, the 18th of December instant, at 2 o'Clock in the afternoon, to take into consideration the means to be adopted to establish a Life Boat at the said Port. The Right Honourable the Earl of Stradbroke has obligingly consented to take the Chair.
>
> <div align="right">Southwold, 12th December 1840</div>

A committee was proposed, consisting of Dr. Robert Wake, Mayor of Southwold (Chairman); Jas Jermyn of Reydon (Honorary Secretary); members were J.B. Edwards, J. Shrimpton, Jn. Gooding, Richard Crisp, Capt. Sayer, Capt. Wayth, Capt. Magub, Capt. Walsh, Mr. Montague and Mr. Jn. Lilley.

At this meeting 'it was unanimously agreed that the several members above named should form a local committee for the purpose of soliciting subscriptions in the town'. The subscribers' list numbered 117, and the sum of £385 7s. 2d. was raised, which enabled the committee to order a boat from Teasdel of Great Yarmouth. The total cost of the gear was £400. The Society started in debt!

The station became active in August 1841, when the boat was named *Solebay. Solebay* was 40ft. in length by 11ft. beam, pulling 12 oars, and of the Norfolk and Suffolk type. This type of boat is not self-righting, but relies on introducing water ballast for stability.

The sail plan is a dipping lug foresail and a standing lug mizzen. Yawls and fishing boats on the Norfolk and Suffolk coast favoured this method of sailing.

Between November 1844 and November 1852 the *Solebay* gave assistance to the brig *Cleofrid* of Newcastle, the barque *Mary Bulmer*, the schooner *Ury* of Sunderland and the collier *William Cook* of Great Yarmouth, as well as to Southwold and Walberswick fishing punts.

In 1852 the *Solebay* was found to be in need of extensive repairs. Rather than repair her a subscription was opened for a new boat. The Society ordered the new boat to be built by Beeching of Yarmouth, on the same design as the boat with which Beeching won the Duke of Northumberland's competition at the Great Exhibition of 1851. She was 38ft. long, 10ft. beam and rowed 14 oars. She was a self-righting boat, and with her two lug sails cost £280. She was christened *Harriett* on 8 October 1852.

On 29 November 1853 the brig *Sheriton Grange* was seen drifting towards the town in a strong gale from the SSW flying a flag of distress. As the fishermen were about to launch their yawl *John Bull*, a report says, 'they were deterred from doing so by a large body of females who, apprehensive of danger, created a panic'. The lifeboat was thereupon launched, rescuing the crew of nine who had taken to their long boat. Presently the brig struck and became a total wreck.

The crew expressed their dissatisfaction with the *Harriett*, as there was no confidence in a self-righter, compounded by the loss of life through capsizing of two similar boats on the north-west coast.

The Southwold Society were in a dilemma. They had two boats, one unseaworthy and one the men declined to go out in, and no funds to purchase a new boat. Under these circumstances, at a General Meeting of the Southwold Lifeboat Society on 21 October 1854 the Society accepted an offer from the renamed Royal National Lifeboat Institution to take over the running of the station. So, after 14 years of struggling with finances, the Society bowed out and became the Southwold Branch of the RNLI.

On 31 December 1855 the first boat from the Lifeboat Institution was delivered. A Norfolk and Suffolk type, 40ft. long by 13ft. beam and with 12 oars, she was built of oak by Beeching of Yarmouth for £215. A 'wet' boat like the *Solebay*, she was destined to do good service, and was also named *Harriett*.

On Saturday 27 February 1858 the lifeboat was out on exercise when, running through breaking waves on the shoal while still under sail, the rudder, which hung two feet below the keel, struck the ground causing the remains of the pumped out water ballast to run to the bow of the boat. In that condition, with all the weight in her bows, the next wave caused the boat to broach to broadside onto the seas. The seas breaking over her and into the sail caused her to capsize onto her side; the masts broke off after about five minutes and she capsized completely throwing the crew into the sea. The crew, who were all wearing

their cork lifejackets, were saved, but there were three visitors on board who had declined to wear lifejackets. One, the Rev. Hodges, who was Curate of Wangford, was found under the boat with his legs entangled in the gear. The son of Capt. Ellis of Hill House and a Mr. Ord were also drowned. Five of the crew swam ashore, and the rest of the crew were saved by the yawl *Reliance*.

As a result of this accident, alterations to enhance the qualities of the *Harriett* were carried out by improving the bulkheads with solid chocks of wood weighted to the specific gravity of the water. The boat was tested in the harbour by 32 men standing on one gunwale and 36 men pulling on a rope from the masthead. This capsize test restored the crew's confidence.

A good service was rendered on the morning of 28 January 1862, when after a blowing night the men on lookout in the cliff-houses observed a boat drifting outside the outer shoal. The lifeboat was launched at 7.30 a.m. and rescued the crew of five men and a dog from the boat of the Ipswich schooner *Princess Alice* which, it appeared, had struck on Sizewell Bank at about 1.30 a.m. and had almost immediately filled and sank. The crew took to the boat and drifted through the night in the greatest danger until rescued. A print of this rescue can be seen in the Southwold Lifeboat Museum.

The lifeboat shed in front of the town was partly washed away in March 1862, and a new shed was built on the South Denes in that summer.

13 January 1866 was a day of strong gale from the south west. A brig was observed with a distress flag in her rigging. The lifeboat was launched, but not before the brig struck on the outer shoal, following which her masts went overboard. The lifeboat anchored and veered down on the wreck. Owing to the violence of wind and sea, the anchor would not hold so she missed and had to be brought back again into position for veering down again. This happened three times. All the crew of the brig were drowned. The brig was the *Billy* of Whitby, and the crew are buried in a marked grave in Mariners Corner of Southwold churchyard.

Following this tragedy a deputation of pilots approached the Committee and represented the need for a surf boat that could be taken by carriage along the shore and launched under the lee of a wreck. Following an enquiry the RNLI decided to place a small carriage boat at Southwold, and a new house was built on the Denes next to the existing boathouse. Funds for this boat were raised by members of *Quiver* magazine, and appropriately it was named *Quiver*. She was a self-righter. The lifeboat was conveyed free of charge by the Great Eastern Railway Company to Halesworth, where it was received by crowds of people and caused much excitement. The next morning, Thursday 23 August 1866, the boat was taken to Wangford on its horse-drawn carriage. It stayed there for four hours to the 'great delight and astonishment of the rustic population'. Meanwhile in Southwold it was declared that after 1 p.m. the shops would close. At 2 p.m. the church

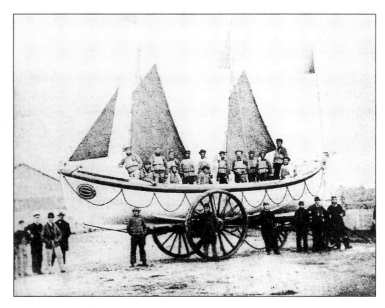

48 The self-righter *Quiver* at Halesworth station in the course of her delivery to South-wold, 22 August 1866.

bells from St Edmund's tower announced that the boat was in sight and immediately a large assembly arranged themselves into a procession. This went through the town to the accompaniment of the bells, a band, and ladies waving their handkerchiefs. They went through the flag-decorated High Street to the south of Gun Hill where the tide was full. The *Quiver* was christened by Miss Sheriffe and launched to the cheers of the assembly and the band playing 'Rule Britannia'. After rowing out to sea, the crew capsized the boat to display her self-righting qualities.

In April 1869 it was announced by the Institution that the Coal Merchants of London had presented to the Institution £700 to defray the costs of a lifeboat establishment, and they chose Southwold. The lifeboat *Harriett* was rechristened *Coal Exchange*, by which name she was known throughout the remainder of her career.

In December 1882 the surf boat *Quiver* was replaced by a smaller carriage boat of the Norfolk and Suffolk type. This boat was named *Quiver No.2*, being number two of three boats which were paid for by *Quiver* magazine subscribers. The self-righting *Quiver* was returned to the Institution, having been on station for 16 years and only off once on service.

Quiver No.2 was launched on 2 May 1887 to the Norwegian barque *Nordhavet* and on 15 August 1890 to the brigantine *Vectis* of Harwich. In launching the boat off the carriage she was thrown by the sea against the carriage and stove in four planks as well as breaking all the spokes in one of the wheels. Afterwards she was launched the same way as the larger boat, off ways on the beach.

On 15 February 1892 strenuous efforts were made to assist a vessel in distress when, during a strong gale at SE, a schooner was observed in the bay. It was considered impossible

for her to get off the lee shore, so the *Quiver* was brought out, horses were obtained and, with the aid of the floaters on the drag ropes she was taken through the town and kept abreast of the schooner along the shore and up on Easton Cliff, over hedges and ditches, for two miles, nearly to Easton Broad. At that point the captain, seeing it was impossible for him to get out of the bay, put his helm up and ran the vessel ashore straight for the lifeboat. She came quite to the main, and the men were got ashore by ropes, so that the lifeboat was not required. The schooner was the *Elizabeth Kilner* of London and carried five hands. She was sold and broken up where she lay.

On 27 December 1886 the *Coal Exchange* was launched in a terrible gale and snowstorm and rescued four men of the schooner *Day Star* of Ipswich, abreast of Sizewell Buildings, and being unable to get back to her station she went ashore at Aldeburgh and was brought home on 30 December. While at this wreck Cragie was washed overboard but, his leg being entangled in some of the gear, his comrades were able to haul him on board again without damage beyond the loss of his souwester. This breeze put three vessels ashore in Sizewell Bay: the *Day Star*, from which all were rescued, the *Magnet* where all but one were drowned, and the *Trixie V*.

This was the last successful service performed by the *Coal Exchange*, formerly *Harriett*, although she was subsequently launched three times without result, and at last after an exercise in the spring of 1892, when the boat was being swivelled, it was noticed that she set her back up and showed signs of weakness. The crew

49 The Norfolk and Suffolk *Quiver No.2* coming ashore. In service 1882-1897.

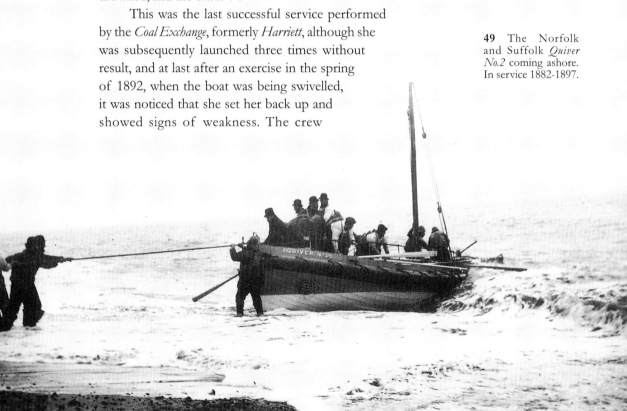

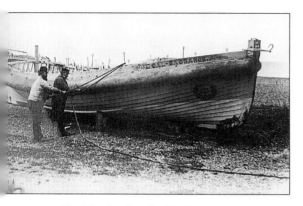

50 The derelict *Coal Exchange* née *Harriett*, in service from 1855 to 1893. Sam May and John Cragie in the foreground.

expressed their opinion that her time was up, she having been placed on station on 31 December 1855 and seen 37 years of active service during the course of which she had saved 76 lives.

A new boat was ordered with design features suggested by the men. Built by Beeching of Yarmouth and costing £800 she was an improved version of the Norfolk and Suffolk type, with confined water ballast and scuppers as well as relieving valves, and was rigged like the former boats with dipping fore-lug and standing mizzen. She carried a crew of 18 hands. The boat was formally handed over on Easter Monday 1893, and was christened *Alfred Corry* by Mr. J.E. Grubbe, in memory of the donor.

On the morning of Sunday 13 January 1895 after a heavy SE by S gale all night with snow squalls, the brig *James and Eleanor* of Shields was seen at daybreak by a man returning from duck shooting, aground on the shoal with a fearful sea breaking over her. The *Alfred Corry* was launched and reached the wreck in half an hour, finding the crew in the fore-rigging. The anchor was let go with a spring on the cable and as the boat was veering down the ship's foremast went overboard, carrying the crew with it. One man was rescued and the cable was then slipped, and the boat sailed into the raffle and rescued another man. One of the crew had hold of a third man but could not break his hold, and while he was

trying to get him the grapnel gave way and the lifeboat was driven broadside onto the beach. Two other men were rescued from the shore but the captain and two others were dead when they were washed ashore. So heavy was the sea that the brig was soon all to matchwood and her planking was washing along in front of the town. A salvaged section of the ship's wheel is on display in the Sailors' Reading Room on East Cliff.

In 1897 the second *Quiver* was condemned, and a new boat was built at Lowestoft by Reynolds. This boat was of the Norfolk and Suffolk type, 32ft. long and 9ft. beam, rowing 12 oars. She was christened *Rescue*.

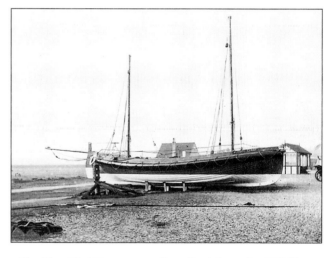

51 The *Alfred Corry* at rest at Ferry Road. In service 1893-19

At daylight on 27 November 1905 the Coastguard reported something ashore at Covehithe, and as soon as it was light enough the masts of a sunken vessel could be seen with a glass. The *Alfred Corry* was launched, the wind then being WSW, a moderate gale and sea after a heavy gale at SSW most of the night. The wreck was seen to be a smack completely sunk with the crew hanging on the foremast-head in the greatest peril as the vessel rolled from side to side in the swell. The cries of these poor fellows as the lifeboat approached were most piteous and not an instant was lost in laying the boat alongside the mast, whence the men dropped into her without difficulty. They turned out to be four men of the French trawler *Joseph et Yvonne* of Dunkirk, which had stuck on the Barnard about four o'clock in the morning and sunk in deep water inside the sand. Some of the men were only partly dressed, as they turned out when she struck, and had suffered much from exposure in their desperate position. The lifeboat was towed back to Southwold by the tug *Lowestoft* and landed the men safely there.

In 1908, owing to the beach in front of the lifeboat shed being scoured out and too steep to launch and retrieve boats, the *Alfred Corry* removed to the harbour to a position east of the steam ferry. Haul-off anchors were set off the harbour mouth to allow the boat to be manually hauled clear of the piers against adverse winds and flood tide.

A very heavy gale at SE by E occurred on 17 January 1912. Information was received from the Coastguard that a schooner was ashore at Minsmere with the crew in the rigging. The *Alfred Corry* was launched in record time, towed down to the pier head, and sailed out in a most splendid manner through a very heavy sea. In about an hour she was at the wreck, just after dark, and let go the anchor to veer down, but the sea was tremendous and no

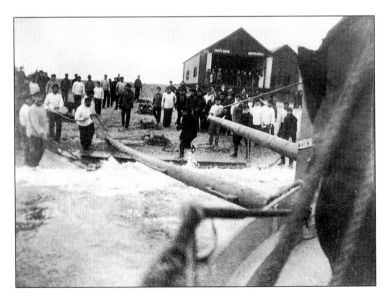

52 The sett pole being used to launch the lifeboat.

sooner did she come to her anchor than the cable snapped and the lifeboat was in the greatest danger of being swept ashore. With incredible smartness sail was set again, and the boat sailed off to sea and round outside the vessel, finally letting go the second anchor inside the ship and taking out the crew of four men and the captain's wife from the lee quarter. The lifeboat was then sailed back and into the harbour by soon after 7.30 p.m., having been six miles out and six miles home in a very heavy gale, and taken out a crew, in a little over three hours. The lifeboat was thrown against the North Pier by a heavy sea when entering the harbour, but fortunately no very serious damage was sustained. The schooner was the *Voorwaarts* of Groningen in Holland, bound from Emden to Southampton with loam. This rescue took place almost at the exact spot where, 53 years before, the *Harriett* rescued the crew and the captain's wife of the Prussian brig *Lucinde*.

While the *Alfred Corry* was away tremendous excitement was aroused in the town by a large Norwegian barque coming ashore at about 7 p.m., exactly opposite the lighthouse. The lifeboat gun was immediately fired, the *Rescue* was quickly got out and dragged by hand up the hill, through Pinkney's Lane, Trinity Street and North Parade to *The Grand Hotel*, where she was got over the breakwater and afterwards launched from the carriage near the Steamboat Pier, a heavy sea breaking on the shoal at the time. Contrary to orders, the men put the boat's mast on shore so that they could row better, and when, owing to an error of judgement, they missed the wreck they were unable to fetch her again against tide and sea and were obliged to anchor and wait. Had the mast been on board they could have sailed back into position again. Meantime, the Rocket Brigade had fired several rockets over the vessel, which was now within hailing distance. Eventually getting communication,

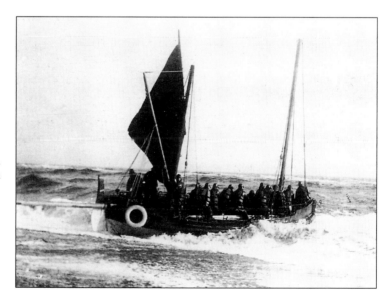

53 The *Rescue* launching into a rough sea. In service 1897-1920.

63

the whole crew of nine was saved by the apparatus. This barque was the *Idun* of Christianssand, bound to Cadiz in ballast, and she became a total wreck. Her hull was sold for £65 and broken up where it lay.

The First World War took many of the Southwold fishing community into service, bringing back into the crews older, retired members and sometimes those at home on leave. An outstanding test of endurance was the occasion of the brigantine *Carmenta*, aground at Thorpeness on 23 February 1916, and the crew of the lifeboat *Alfred Corry*. A report by the Honorary Secretary, E.R. Cooper, reprinted in the *East Anglian Daily Times*, reads:

> The call was received at 5.45 a.m. and at 6.15 the boat was under weigh in a ENE gale of such severity that few remembered worse. The seas were running very high, and were continually crossing over the boat, so that the crew were always waist deep in water. However, as the wind was favourable she made the journey in good time and was in hail of the distressed vessel in an hour. The vessel was found to be lying in the very worst position possible having been driven straight on to the shore. There was no shelter to be obtained from the ship. The coxswain took the only course possible, and endeavoured to get under the port bow, so that the ship-wrecked crew could drop on to the lifeboat. Anchor was dropped, and the weight of the seas told heavily. The lifeboat was skilfully manoeuvred close to the vessel, and in response to a call a small line was thrown by the crew of the distressed vessel attached to a lifebuoy, and secured by the lifeboat. A heavy rope followed, and this in turn was secured.
>
> All the time this was going on the crew of the lifeboat were continually under water. Wave after wave raked the boat from stem to stern, washing the crew about in nearly helpless confusion. Two of them, Edward Denny and J. May, were washed out of the boat but they had the presence of mind to grip the ridge rope and hold on, just having time to clamber on board again before another sea swept the decks. Another of the crew, J. Palmer, who is home on two days' leave from the Navy after eighteen months' service, was struck by a wave, and would have been overboard but that he struck S. May, the coxswain, on the shoulder, knocking him down. As he fell May realised something was passing over his head and he instinctively clutched hold of what proved to be Palmer's trousers and held on, at the same time grabbing the ridge rope with the other hand to prevent them both being carried over.
>
> Another member of the crew, J. Ashmenall, also had a narrow escape from drowning. He was all but washed under the ridge rope. The experiences of the crew in the face of these seas were beginning to tell, the biting wind and driving sleet and snow adding to the strain. After nearly one hour's struggling

and fighting against overwhelming odds, they got closer and still closer to the vessel till they were within ten feet. All the time their efforts were being watched with extreme eagerness by the crew of the brigantine huddled in the bows, but they for the time were not being subjected to the fury of the sea as were the lifeboat crew, as at times when the second coxswain (who was working in the bow of the lifeboat) looked round he could see nothing but one or two heads struggling in the water, the lifeboat being covered with water, but as the water ran through the valves she freed herself every time. As the lifeboat got closer to the vessel the seas told even more, and in between the waves she bumped the bottom till at last the strain was too great and the rope parted, and with it all hope of getting the crew away by the lifeboat. The lifeboatmen were completely exhausted physically and badly bruised, almost incapable of looking after their own safety, but in one last endeavour managed to get the sail up, and just avoided being driven ashore themselves, which would have meant death to all the gallant band.

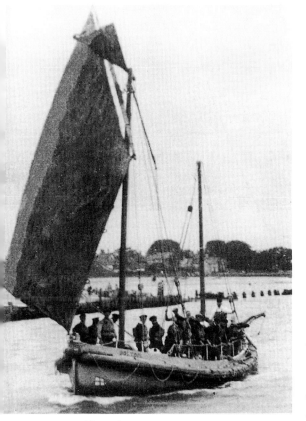

The coxswain of the *Alfred Corry*, Sam May, says that in all his experience, extending over twenty years as coxswain and five years as second coxswain, he has never been in a sea under circumstances so trying or when the strain had been so great. The crew were very relieved when a message came through later in the evening that the rocket apparatus had succeeded in bringing the distressed mariners ashore.

In September 1918 the *Alfred Corry* was condemned. Coxswain Sam May took her to Lowestoft and all her gear was transferred to the reserve boat *Stock Exchange*. This boat served from 19 September 1918 until replaced by the *Bolton* from Kessingland on 1 November 1919.

54 The *Bolton*, ex Kessingland, leaving Southwold Harbour. In service 1919-1925.

On 19 April 1920 the No.2 station was closed. The *Rescue* was in no condition to be repaired, and there was no necessity to retain a second boat as a new motor lifeboat was soon to be on station.

The arrival of a new motor lifeboat on 20 June 1925 caused great excitement in the town. The new boat was 46ft. 6in. in length and 12ft. 9in. in beam, fitted with a Monobloc petrol engine. She was of double diagonal build and of the traditional Norfolk and Suffolk type sail plan with a drop keel; the cost of £9,000 was met out of a legacy from Mary Scott who, after a life devoted to unostentatious charity, fulfilled her ambition with the giving of this lifeboat which was called after her. The crew now had both sail and motor power. This boat was the last of her design used by the RNLI.

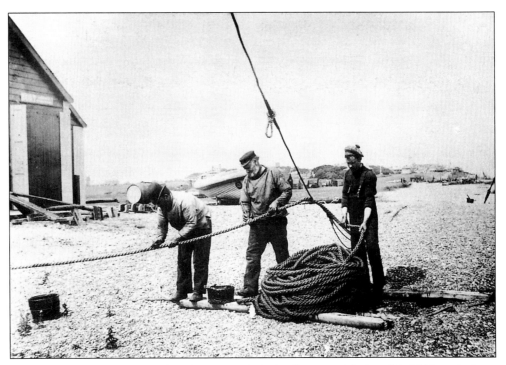

55 Sam May, John Cragie and another tarring the haul-off warp outside the original lifeboat shed.

An outstanding service of the *Mary Scott* was to the SS *Georgia* caught on the Haisboro' Sands off Cromer on 22 November 1927. The *Georgia*, an oil tanker of over 5,000 tons, had struck the sands, broken her back and parted amidships, one half remaining firmly aground, while the other half with 16 men on it drifted away until it finally went ashore at Cromer. Aided by the searchlight of HMS *Thanet*, the crew of the *Mary Scott* fought their way through seas which broke right over the boat to reconnoitre the wreck. Four times they

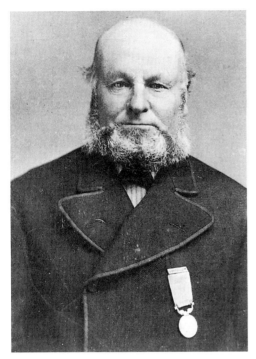

56 John Cragie, coxswain 1879-1898.

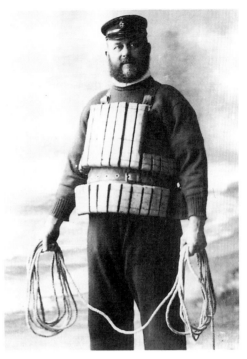

57 Sam May, coxswain 1898-1918.

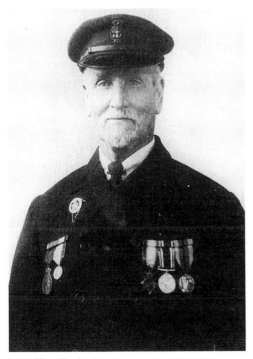

58 Charles Jarvis, coxswain 1918-1922.

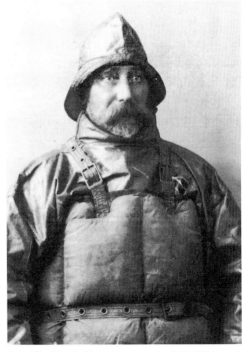

59 Frank Upcraft, coxswain 1922-1934.

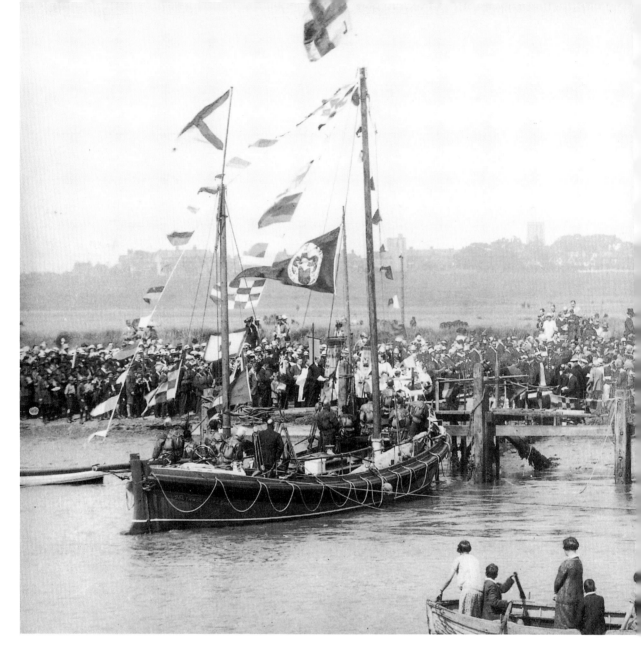

got within hailing distance but no response was forthcoming. Around midnight a message reached *Thanet* that the Cromer boat had been successful in getting the men off but had returned direct to Yarmouth without notification en route. The service was a most gallant one and the fact that the *Mary Scott* did not actually effect the rescue does not detract one bit. To cruise round the wreck four times with such a sea running and on so bitterly cold a night speaks volumes for the courage and determination of the men to render all the assistance possible, to say nothing of a splendid piece of seamanship, and is a glowing testimony to the deservedly high place held by East Coast fishermen for their self-sacrifice on behalf of others when they are in danger.

The naming ceremony of the *Mary Scott*, 11 July 1926.

The evacuation of troops from Dunkirk was taking place when, on 20 May 1940, 19 lifeboat stations received a telephone call from London to take their boats to Dover. The *Mary Scott* was taken by the Southwold crew. When they got there the boat was taken over by the Royal Navy and the Southwold men were given railway warrants to get back home. This was not welcomed by the crew, who were prepared to go to Dunkirk, but the Navy would have no argument.

One of the inspectors of the Lifeboat Service, now in the Navy, Sub-Lieutenant Stephen Dickinson, found himself in command of the Southwold lifeboat. He had already made two trips to Dunkirk, and on Saturday 1 June he went over for the third time on board a paddle-steamer, the *Emperor of India*. She had the lifeboat and two other boats in tow. At 11 o'clock that night she anchored off Dunkirk and Mr. Dickinson was sent ashore in the lifeboat towing two of the ship's boats. High explosive shells and shrapnel were bursting all along the beach and it was empty of troops. The first lieutenant of the *Emperor of India* landed and went in search of them, while the three boats waited in the surf under fire. They waited for two hours. It was one o'clock in the morning when the men arrived, and in two journeys the lifeboat, and the two ship's boats in tow of her, brought off 160 men. Shortly before dawn the commander of the *Emperor of India* decided to return to Dover, but Mr. Dickinson remained with the Southwold lifeboat, went ashore for the third time, and took on board his third load of 50 men. It was now dangerously near dawn. He tried to push the lifeboat off the beach, but she was fast. Then a soldier in her bows called out, 'Hoi, mister, you're pushing against a lorry.' It must have been run out into the sea to make a pier until it was almost submerged and the lifeboat had passed it unseen in the darkness. She worked clear of it, unloaded her 50 men onto a ship and returned for the fourth time, but her engine

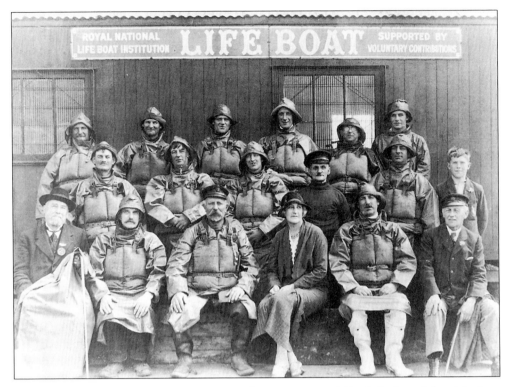

61 The crew of the *Mary Scott* in 1931 with some of the committee and friends. Back row, left to right: Joe 'Satan' Palmer, 'Popeye' Palmer, 'Bludgeon' Palmer, 'Worky' Upcraft, Johnny Critten, K. Albany; middle row: 'Capt. Bar' Stannard, Albert 'Shall I ' Stannard, 'Chrissy' Stannard, 'Erno' May, Jack 'Snooks' Palmer, John C.P. Wells of Woodbridge; front row: John Herrington, 'Slummy' Ashmenall, Frank Upcraft (coxswain), Mrs. Horsfall of Dunwich, Fred 'Mobs' Mayhew (coxswain 1934-40), Major Ernest Read Cooper.

stopped and could not be restarted. It was now day and she was helpless on the beach, but the Great Yarmouth and Gorleston lifeboat, making for England with troops on board, came within hail and took off her crew.

What happened after that is not clear. One account is that a Royal Navy boat towed the *Mary Scott* off the beach later in the day. What is known is that the lifeboat was found in St Margaret's Bay, Dover, by the Lowestoft lifeboat crew who were returning to their home port. She was drifting, abandoned. It was thought she may have been floated off the Dunkirk beach by the tide and drifted over the Channel. It is also possible she was towed home by the Royal Navy boat that reputedly got her off the beach. Whatever, the *Mary Scott* took part in the biggest lifesaving operation ever and lived to do reserve service on all stations between Gorleston and Torbay. She finally came out of service in June 1951.

The Southwold lifeboat station was permanently closed in December 1942, but after several requests to the RNLI by the Southwold Branch Committee the station was reopened in July 1963.

In the first 100 years of the Southwold lifeboats the two stations made 120 effective launches, which saved the lives of 192 seamen. The crews of these boats were awarded 13 medals from the Institution: 11 Silver and two Bronze. Forty-two other medals were also awarded to them.

62 The former Cromer Lifeboat Shed arriving in Southwold Harbour on 24 April 1998. The Victorian structure was purchased by the Alfred Corry Trust to use as a Maritime Museum and to house the ex-Southwold lifeboat *Alfred Corry*. The *Alfred Corry*, converted to a houseboat, had been discovered on the River Blackwater by John Goldsmith and Terry Oddie in 1972. In 1976 the owner contacted John Goldsmith to enquire whether he wanted the boat, otherwise she would probably have to be cut up and burned. He passed the message on to John Cragie, great grandson of her first coxswain, who bought her, restored her to seaworthy condition and sailed her for another 12 years before she was returned to Southwold where she is being restored to her original layout and will form the centrepiece of the Alfred Corry Museum.

63 The crew of the Atlantic 21 class Southwold lifeboat *Quiver* in September 1998. At the end of October the boat was replaced by the larger Atlantic 75 class *Leslie Tranmer*.

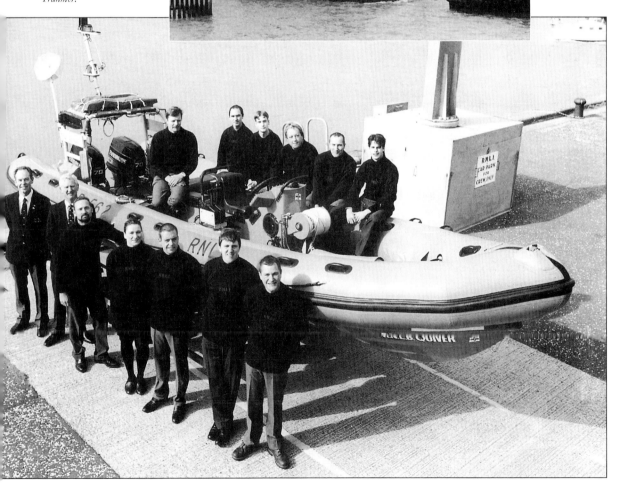

The Southwold Lighthouses

DAVID LEE

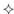

The establishment of a lighthouse at Southwold is connected with the demise of Orford Ness Front, or Low, Light. A grant to erect two lights there was given to Sir John Meldrum, a Scottish patriot, in 1634, who immediately sold the right to Alderman Gerard Gore of London, a merchant.

The two lights were built on the most eastward point of the Ness and were in a line with each other to indicate a safe passage between Sizewell Bank and Aldeburgh Napes, being known as the High and Front, or Low, Lights respectively.

The Low Light was located almost on the beach and consequently suffered from being overcome by rough seas on four occasions, and was replaced because of other reasons the same number of times. The lights were taken over by the Brethren of Trinity House in 1837. In 1887 the most severe storm that there had been for many years scoured out the foreshore in front of the Low Light resulting in it going the way of its predecessors. It was not replaced, and Trinity House decided instead to establish a new light further up the coast, where it could be seen more easily by shipping approaching from the north. The next

salient point north of Orford is Southwold, which due to the lie of the land is about four miles further east, and the higher ground gives Southwold a commanding view across an extensive seascape.

At the Trinity House board meeting in November 1887 the opinion was that proposals for a new light at Orford were not considered suitable, and 'that a light somewhere in the vicinity of Southwold would meet the object in view'.[1] At the following meeting recommendation was given to removing the Low Light to Southwold,[2] leaving one light at Orford, and the various committees concerned were called upon to select a site for building the new lighthouse.[3]

At the request of the Wardens Committee[4] the Examining Committee made their recommendation to the Board as to the location,[5] and at the same meeting recommended that 'arrangements suggested by the Engineer for a temporary light be at once put in hand'. The temporary light was on the beach at the southern end of Southwold known as California Sands, near the former Lifeboat Shed and roughly opposite the Dutch Barn Restaurant. A conventional lantern was placed on a stout timber structure, and reported as being first lit on 1 August 1888.[6] Great interest was shown by the press, who stated that the character of the light was an occulting light twice in twenty seconds, showing white to sea and red sectors along the beach.[7] The report continues: 'Considerable interest was exhibited by the inhabitants and visitors in the exhibition of the light. Mr. Harding obtained subscriptions so that the band should play the National Anthem at the time, and this attracted numbers onto the Gun Hill. The band afterwards played selections of new music.'

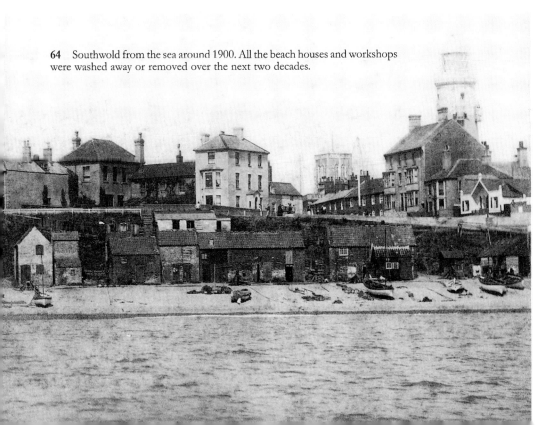

64 Southwold from the sea around 1900. All the beach houses and workshops were washed away or removed over the next two decades.

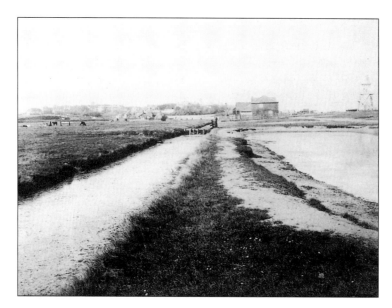

65 The temporary Southwold light south of the town on California Sands, seen from beside the model yacht pond in Ferry Road, 1889 or 1890.

The location for the permanent light was described by a local newspaper as 'appears to be the plot … adjoining the Coastguard Station. This is very advantageous … the smoke from the town will not obscure the light, and its nearness to the cliff must make it very prominent all along the coast. The land belongs to Mr. F.H. Vertue.'[8]

The cost of the new lighthouse, together with some alterations to the High Light at Orford, was estimated at £6,700.[9] The appointment of Mr. Williams as Superintendent of New Works at £3 per week was sanctioned,[10] but sanctioning of Messrs John Shillitoe & Son, of College Lane, Bury St Edmunds, as contractor for the permanent lighthouse was not given until September.[11]

By May 1889 work was under way, the *Halesworth Times* reporting on 21 May 1889 that, 'The new lighthouse, the dimensions of which may be judged by the extent of the excavations for its foundations … Its height … will be upwards of 90 feet, and it will contain a million and a half bricks …'[12] This was followed by an announcement that the Mayor, Eustace Grubb, laid the first brick on Tuesday 28 May.[13] In another report it was stated: 'The locality of the Works was gay with bunting, and the occasion was full of interest to workmen and contractors, but very little was known of it by the townspeople generally till all was over.'[14]

The bricks were not of local origin but came by train, being trans-shipped into Southwold Railway wagons at Halesworth, causing problems in maintaining a sufficient supply of wagons from the fleet of 12 vehicles and the three private coal wagons owned by Thomas Moy & Co. The stationmaster at Halesworth wrote to Wenhaston and similarly

to Blythburgh on 7 June 1889: 'We have several thousands of bricks coming for the Southwold New Light House I expect hundreds of thousands 4 G.E. wagons will be in tonight please do your best to have our wagons unloaded & returned here when you have any at your Station & oblige. Yours truly, W Calver.'[15] In March 1890 the lantern, weighing eight tons, arrived from Harwich and was conveyed to Southwold in two sections by two of Thomas Moy's wagons.[16]

Construction was completed for the first lighting and arrangements were made for Trinity House officials 'to proceed in *Argus* to inaugurate the new light on the night of Wednesday 3rd September'.[17] That, however, was not the end of the story. On 9 September of the same year there was a fire in the lantern which destroyed the burner.[18] This was due to the inexperience of the keepers in the use of the original Argand oil burners, but after further instruction they were considered competent to manage the six wick burner.[19]

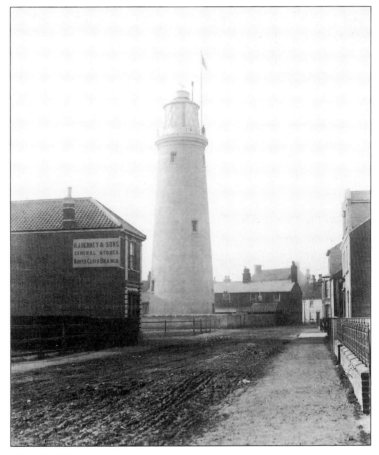

66 Southwold lighthouse from Stradbroke Road, 1910.

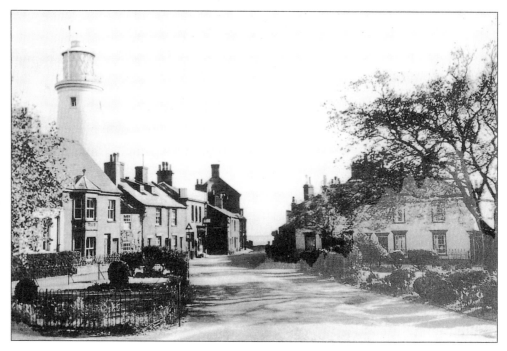

67 East Green and the lighthouse in the early 1930s.

Statistics

The tower is 101 feet high, and 120 feet above mean high water. It was electrified with a 1,500 watt lamp and automated, being de-manned, in 1938. The lighthouse is a listed building.

Character: The main light is white, visible 18 sea miles with red sectors over the land north and south which are visible for 15 sea miles. Originally the light was group occulting two every 20 seconds. On 23 February 1938 it became group flashing six every 20 seconds. Finally from 3 August 1965 it changed to group flashing four every 20 seconds.[20]

1 Trinity House Board minute 15.11.1887.
2 *Ibid.*, 29.11.1887.
3 These Committees were: Wardens, Examining, Light and Visiting.
4 Wardens Committee, 6.3.1888.
5 Examining Committee, 20.3.1888.
6 *Ibid.*, 7.8.1888.
7 *Halesworth Times*, 7.8.1888.
8 Not identified, but from a cutting in Maggs' Diary Vol.V, Southwold Museum.
9 Wardens Committee, 6.3.1888.
10 *Ibid.*, 22.6.1888.

11 *Ibid.*, 4.9.1888.
12 *Halesworth Times*, 21.5.1889.
13 *Ibid.*, 4.6.1889.
14 Probably *Ipswich Journal*, early June 1889.
15 Southwold Railway Halesworth Letter Book, p.335.
16 *Ibid.*, p.353 (quarterly return).
17 Trinity House Board minute 2.9.1890.
18 *Ibid.*, 9.9.1890.
19 *Ibid.*, 16.9.1890.
20 Trinity House pamphlet and Admiralty chart.

Brewing and Pubs

BERNARD SEGRAVE-DALY

The earliest record of brewing in Southwold is in 1345 when Johanna de Corby, an ale wife of notorious repute, was taken before the Manorial Court and fined 3d. for breaking the Assize of Ale. She made regular appearances before the court for the next 20 years for almost every conceivable offence relating to the retailing of ale, including selling in unmarked measures at too high a price, and selling ale of poor quality. She was also in repeated trouble for breaches of the peace. *The Swan Hotel*, which dates back to medieval times, may once have belonged to Johanna and her husband Robert, a baker. There was certainly an inn on this site in the 16th century because a chimney in the present building was constructed from Tudor bricks, discovered during recent renovations.

The brewery was originally part of the inn but probably moved to its present location in East Lane or Back Street (now Victoria Street) after the great fire in 1659. The cellars of the present brewhouse have been dated to the mid-17th century.

Immediately before the fire *The Swan* was run by Goodman Wiggins, and after the fire it was rebuilt by John Rous. His family owned the inn and the brewhouse until the end of the 17th century, and built a business which supplied several pubs and which, with their interests in malting, fishing and general merchandise, made them the most prosperous family in Southwold. For most of the 18th century it was owned by the Thompson family, who were the great trading rivals of the Nunns of the Victoria Street Brewery. In 1806 *The Swan* was sold to its sitting tenant, Henry Meadows, who in turn sold it to Thomas Bokenham in 1818, together with 'all that Billiard Room, all those Stables, Coach houses, Brew Houses … and also a right of Common or Commonage upon the Common pasture of Southwold'.

Bokenham spent large sums of money on *The Swan* and then, when he married his second wife, built a grand house next door—the present Town Hall. To pay off some of his debts he sold the brewhouse to a local maltster, William Crisp, for £350. From that date, 1825, the Sole Bay Brewery operated as a separate business.

In 1872 George and Ernest Adnams took over the Sole Bay Brewery. Subsequently George left and Ernest set up in partnership with Thomas Sergeant. By 1890 Ernest had built up a sizeable estate of some 20 pubs and wished to expand his brewhouse to meet future demand. He was by now brewing some 5,000 barrels a year including the famous Tally Ho as well as mild, stout and pale ale. He also brewed AK, whose initials remain a mystery.

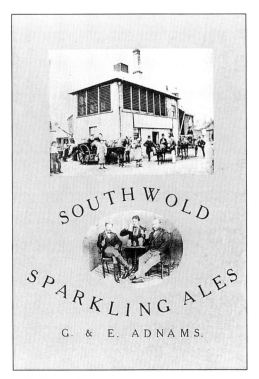

68 The earliest Adnams advertisement, showing George and Ernest Adnams enjoying a glass of ale with their father George.

The brewery was enlarged and rebuilt to the designs of Messrs Inskipp & Mackenzie in 1896, incorporating the earlier brewhouse which probably dates back to the time of William Crisp. On the roof of the new building was a 5,000-gallon Braithwaite tank with a decorative cast-iron balustrade. Over the next few decades 43 and 45 Victoria Street were incorporated into the brewery, but their original roof heights were retained, enabling us still to identify these old cottages.

Ernest spent far too much on his brewery, and as trade was slow during the recession of 1900 to 1902 he was forced to bring in a partner who could inject some capital into the company.

In 1902 Pierse Loftus qualified as a brewer. In order to gain further experience in brewing and microbiology he went to Copenhagen, Pilsen, Berlin and finally to the Castle Brewery at Durban before being transferred to the larger sister brewery in Johannesburg where he worked as junior brewer to Paul Adnams. Through this contact he became aware of the dilemma facing Paul's cousin Ernest, who after the departure of brother George in 1880 and his subsequent death in the Zambezi (he was eaten by a crocodile) was in need of fresh blood, more capital and new ideas. I think Ernest got more than he bargained for.

Pierse Loftus set about raising capital and paying the bills, but he too saw the need for expansion and the brewery grew with the acquisition of C.J. Fisher & Co. of Eye in 1905, E. Rope & Sons of Orford in 1922 and Flintham & Hall of Aldeburgh in 1924, each bringing precious new outlets and even more precious barrelage to justify the enlarged production capacity of Ernest's new brewhouse. Output at the Sole Bay Brewery grew over the next few decades to 17,000 barrels.

Post-war change was signalled by Watney's Red Revolution in the 1960s, which threatened to replace traditional ale with characterless keg, and stimulated the formation of the Campaign for Real Ale. This in turn benefited Adnams. Production volumes trebled in 10 years, creating a capacity shortfall which was only fully remedied by a major expansion

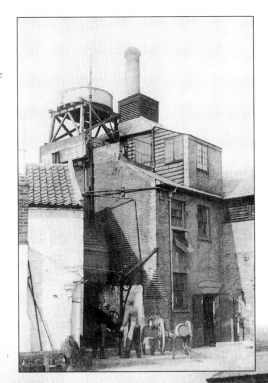

69 The rear of the Sole Bay Brewery in 1895.

70 The employees of Adnams and their families being taken to Great Yarmouth for the annual Company Holiday in 1895.

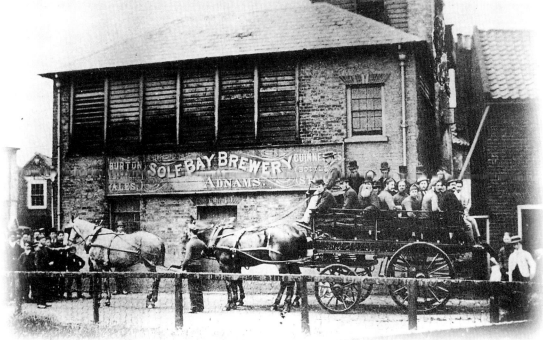

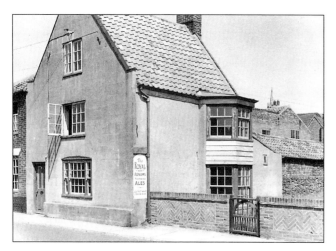

71 *(left)* The *Royal* in Victoria Street, 1956.

72 *(below)* The Sole Bay Brewery seen from Victoria Street in 1959. The cottages on the left were being demolished to make room for *The Swan Hotel*'s Garden Rooms.

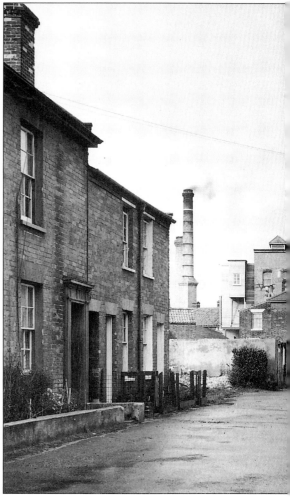

of the brewery in 1984 which incorporated a number of cottages in Church Street, including the former *Brickmakers Arms*.

Throughout the 18th century there was a brewery and maltings in Victoria Street based around the *White Lion* inn, which was owned by the Nunn family. The brewery yard was bounded at the front by what are now 20-26 Victoria Street and at the rear by Hope Cottages. The White Lion Brewery was absorbed into the Sole Bay Brewery, and the brewery office subsequently became the *Royal* inn, which was sold off in 1958. The White Lion maltings was located in a very old building in Victoria Street, part of which pre-dates the fire of 1659, and which has recently been converted into additional offices for Adnams. The *White Lion* itself briefly rivalled *The Swan*, but was 'silenced' in 1796.

A brewery and maltings called the Home Maltings was owned by William Crisp, who lived in the brewer's house, on the site of the present Barclays Bank. This may well have been the site of a much older brewery which had belonged to the Warren family in

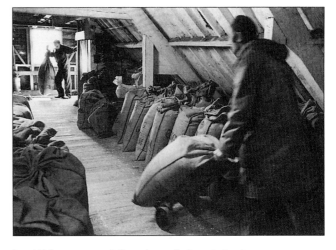

73 *(right)* The inside of the Victoria Street Maltings in 1978. It was built on the site of the *White Lion* inn, which was demolished in 1792, and in 1998 was converted to offices.

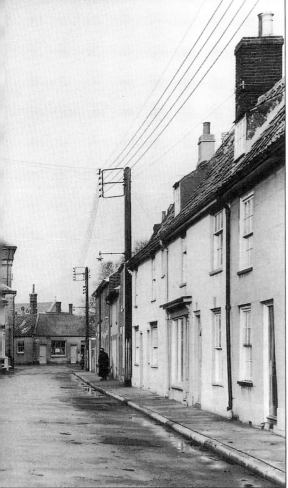

the 17th century. The site of the United Reformed Church was the brewery yard. Crisp's son was a 'dissenting' minister, to whom he donated the land for the erection of the Congregational Church, but it seems that John Banham Woodley—who acquired the Sole Bay Brewery—also purchased the Home Maltings in 1866, and the lane from the High Street through to The Common is named after him.

Brew Pubs

As well as the breweries mentioned above, Southwold boasted three others which never expanded beyond supplying the pubs of which they were part.

The *White Horse* (1792) at 19 High Street, opposite the now-closed *Marquis of Lorne* (which was previously named the *Wagon and Horses*), survived until the turn of the century when Adnams transferred the licence to *The Station Hotel*, now *The Pier Avenue Hotel*.

The *Sole Bay* inn, with its very extensive cellars, was built on land purchased in 1839

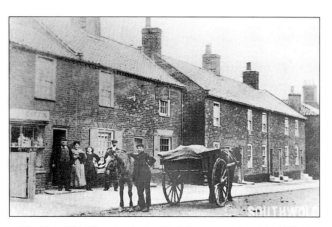

74 The *White Horse* inn in the High Street was closed in 1898. It was a beer house where Charles Newby brewed his own beer.

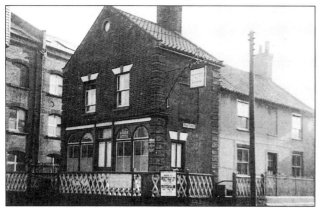

75 Opposite the *White Horse* was the *Marquis of Lorne*, which closed in 1956.

76 The earliest photograph of the Sole Bay Brewery showing Samuel Haydn Fitch in front of the brewery, which he acquired from John Banham Woodley in August 1866.

by a local builder as 'two tenements for the sum of £400'. In 1868 the cottages were acquired by Samuel Hayden Fitch who converted them into a pub and installed a complete brewing plant in it some years later, after he had sold the Sole Bay Brewery which he owned from 1866 to 1872. Fitch extended the pub by incorporating 2 and 4 Stradbroke Road, and remained there till he died in 1910 when he left the pub in his will to provide an income for his two daughters. His executor Reggie Pepper must have been a very young man, as he lived locally until the 1960s.

The *Brickmakers*, 38 Church Street, is now the Tun Room for Adnams Brewery. Until 1876 it had been a builders' yard and home, which were cleared for the erection of a public

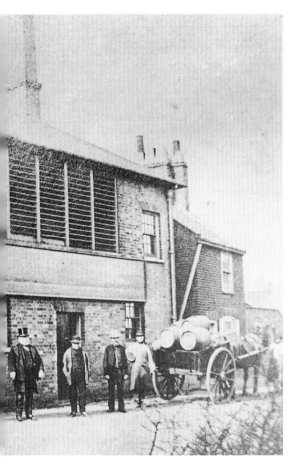

house by William Blowers. As well as being a beer house—it did not have a licence to sell wines and spirits—the deeds also refer to its as having 'one fourth part of the Drawwell and the brewhouse, stables, shed, carthouse and Fish Office'. It was closed in 1958 and demolished to make way for further development in 1984.

No.28 Church Street was the home of John Magub. He was the captain of a three-masted sailing ship named the *Guardiana*, which foundered in a gale on the Winterton Ridge on 15 December 1866 while carrying 317 tons of malt from Cromer to the Sole Bay Brewery. The Inland Revenue summoned the brewer, Mr. Fitch, to Beccles Court to prove that this 'sinking' was genuine. He had to make sworn affidavits and produce bills of lading from the maltster before he could reclaim the duty which he had paid on the consignment. Adnams continues to use the three-masted sailing ship as one of its registered trade marks, and John Magub's great-grandchildren still hold shares in Adnams today.

Subsequent tenants of this property included 'Bastin' Bullen, 'Rocky' Mortlock, Frank Mortlock—twice Mayor of South-wold—Bill Burrage and myself. Frank Mortlock worked as an electrical engineer and foreman at Adnams. He recalled his grand-father returning from work in the brewhouse pulling from his pocket the much prized 'sugar mouse'. The brewer used hundred-weight blocks of sugar which had a couple

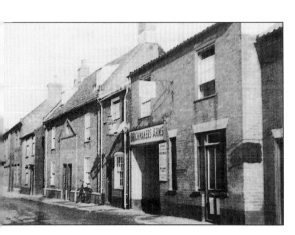

77 The *Brickmakers Arms*, a beer house in Church Street where Arthur Davy brewed in the 1880s and 1890s. The *Brickmakers* closed in 1958 and was demolished in 1984.

of heavy strands of string through them to prevent them from breaking up when lifted. The solid block of sugar was then broken by a sledgehammer into the brewer's boiling copper, but pieces of sugar stuck to the string (old man Mortlock made sure of that!) and these were pocketed and taken home as a treat for the children.

Other Pubs

Earliest records suggest that the *Lord Nelson* was two properties, one being a dwelling house and the other part fish merchants, both in the ownership of Benjamin Simonds. By 1795 John Petiford had inherited the property; he was a naval officer on board the *Majestic* and was injured in battle off Martinique. He died at the age of 38, leaving the property in trust for his infant son. Later, it was leased to a dissenting minister named Rev. William Henry Gardener, and the address of the property was The High Street, 'Near the Sea'.

In 1803 the buildings were knocked into one and converted into a pub. The first landlord was Samuel Le Strange, and the pub was named after Lord Nelson. After 25 years he sold it to Dowson & Rathbone, who owned a fine large brewery on the site of the Wherry Inn at Geldeston. In 1860 the Geldeston brewery was taken over by Cobbolds of Ipswich and the Nelson was transferred to them, but was immediately sold off to a local fish merchant, Hugh Lawrence, who had earlier deserted his wife Rhona. He was successful in acquiring the pub despite an attempt to purchase it by the Norwich brewers Youngs & Crawshay, which failed with considerable acrimony and attempts to sue the seller. Hugh Lawrence made major alterations to the front of the building in East Street.

When he died in 1877 his deserted wife made a claim on his estate, and succeeded in getting a share. The dispute was so bitter that the judge directed that the property should

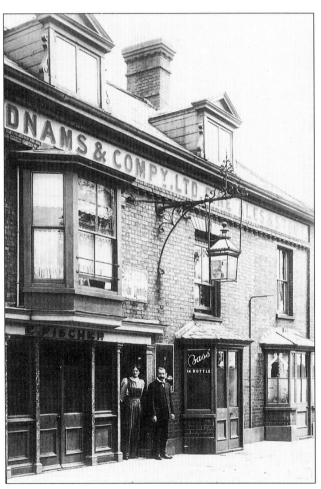

78 The *Lord Nelson, c.*1910

be sold by a nominated estate agent, and the court administer the estate. Ernest Adnams and Thomas Sergeant were the highest bidders at £1,175.

There is little information in the deeds of the *Red Lion*. It was first purchased for £70, as the *Queens Head*, from Benjamin Harrington by Robert Thompson, who no doubt added it to his collection of public houses which he operated from the Victoria Street brewery. The deeds contain the wills of three owners, the earliest of whom was James Martin who died in 1844. Martha, the eldest of his 10 children, married Joseph Arthy, the druggist, who in 1841 purchased the building next door to the *Red Lion*, now the Adnams Wine Shop. There is a plaque in his memory in St Edmund's Church.

Benjamin Chandler succeeded him, followed by James Jillings who sold the *Red Lion* to Walter Harrison, innkeeper. That was in 1872. Later in the same year it was leased to John Lee Barker leaving Jillings as tenant. In 1876 Walter Harrison sold the pub with its two associated shops to James George Tomasin who came from the same village in Essex as George Adnams, Ernest Adnams' father. I suspect he was the financial backer who put up the money for the Adnams' investment in the Sole Bay Brewery. He owned a lease on the brewery from 1872 until Adnams became a limited company in 1890.

The Harbour Inn has one of the most attractive locations, overlooking the Town Marshes on one side and the river front on the other. Next to it was the coal bin and granary built by Francis Wayth in 1816. It benefited greatly from the harbour trade, and imported coal and grain for the three breweries and maltsters of the town. The branch line of the Southwold Railway ran to the harbour, and the sleepers can still be seen at low tide at the water's edge. The building was neglected for many years, and in 1998 was converted to a fish restaurant.

The Harbour Inn has wonderful records detailing ownership when deeds were written in relation to the kings of England and George II was described as 'by the Grace of God King of Great Britain France and Ireland' (North *and* South!). In 1743 William Munn, yeoman, entered into a lease with William Milbourne, Beer Brewer and Maltster of the Black Shore Ale House, for 5s. As the deed is dated 1743 it is possible that the previous tenants had been there since the early 1700s.

In 1766 the property was acquired by John Thompson of the Southwold Brewery. He leased it to Charles Barnett who changed the name back to the *Nag's Head*. Later that year the tenancy was passed to William Clarke of Bungay, Beer Brewer. After John Thompson died his estate was sold piecemeal by auction at *The Swan*. One of the lots was the *Nag's Head*, known by now as the *Fishing Buss* and described as 'comprising a Tap room, Bar, Parlour, two Chambers and Club room, together with recently erected Stable for ten horses'. The Halesworth brewing partnership of Samuel Paget, Dawson Turner and William Jackson Hooker acquired it.

In 1855 the *Fishing Buss* was valued for insurance at £150, and in the same year sold for £250 to George Butcher of Wenhaston. He got into financial difficulties and had to

raise a mortgage: he sold the *Fishing Buss* in 1874 to R.F. Hinde for £150, who renamed it *The Harbour Inn*.

In 1743 *The Crown* was known as the *Nag's Head*, and was renamed the *New Swan* in 1756. In 1829 it was renamed *The Crown*. It was a commercial hotel and posting house with extensive stables, and since it did not belong to any of the Southwold brewers it went through the ownership of a succession of brewers from outside the town. The Cobbold family acquired it in 1865, and in 1881 it was sold to the Halesworth Brewing Company which was bought out in 1894 by the Colchester Brewing Company. It was then sold on to Lacons Brewery of Great Yarmouth, who sold it to the licensee, who sold it to Adnams in 1927. A note in the Adnams property ledger records that on 20 March 1936 '2 timbers in roof found marked NL 1604'. Did it survive the Southwold fire, or were they just re-used secondhand ships' timbers?

The *King's Head* was the residence of Southwold diarist, teacher and auctioneer James Maggs before it became licensed premises. The earliest records go back to 1799 when the property was sold by the Southwold historian Thomas Gardner to John Bedingfield. It was further conveyed in 1817 to James Jerman for £150, and by 1838 William Crisp had acquired it. On his death, the pub was in the tenancy of John Crowford who paid £20 a year for the privilege. He had to share the well with his four neighbours. In the sale details, we are told that the *King's Head* 'is doing a good trade'.

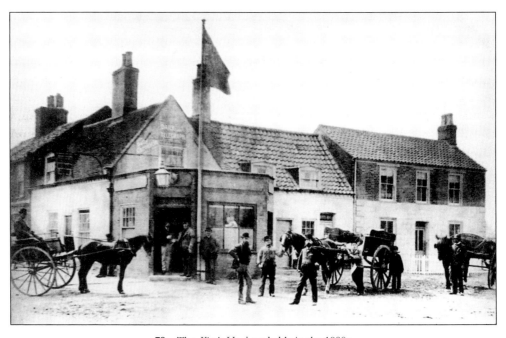

79 The *King's Head*, probably in the 1880s.

No records exist for the *Southwold Arms*; they were lost in the 1980s. All we know is that it was previously named the *Joiners Arms* and the *Green Man*. In 1820 it formed part of the Thompson Brewers tied estate. The *Victoria*, recently converted into a wine bar and restaurant, was owned by the Norwich brewers Bullards, and had several previous names including the *Star*, the *Nag's Head* and the *Pilot Boat*. The *Two Brewers* stood on the corner of Church Street and the High Street, where there is now a chemist's shop. It was demolished in 1834. The *Bear* public house, at the corner of Bridge Road and Lowestoft Road on the Reydon side of Mights Bridge, with a malt house and coal warehouse adjoining, was in the ownership of Crisp and Thompson. The tenant in 1820 was John Magub. The *Tom and Jerry*, on Constitution Hill, now a private house named Tamarisk, was one of a number of other beer houses in Southwold. One Henry Garrod was licensee in the mid-19th century. He bought the old sounding board, which had been removed from the pulpit in St Edmund's Church in 1825 and stored for some years in the church tower, as an inn sign. This is recorded in Maggs' diary.

The arrival of the Southwold Railway in 1879 enhanced Southwold's popularity as a seaside resort and attracted the development of two large seafront hotels. Not to be done out of the business of travellers, Ernest Adnams decided to erect two hotels, one at the edge of the town and one in Reydon. In June 1898 two plots of land were acquired for £650, one opposite the railway station bought from the Coast Development Company, and the other in Reydon bought from Mr. Keen. Each site was to be purchased on the condition that it would be licensed.

The architect, Mr. Key of Aldeburgh, was commissioned to draw up plans for *The Station Hotel* and for *The Randolph Hotel* in Reydon, and he sent in two practically identical ones. In 1904 consternation was expressed by the board of Adnams: the managing director stated that he believed that 'Mr Key had no other plans available but those overgrown suburban Villa-like Inns', and the board feared that 'these two hotels constituted a drag on the Company and at the present moment it seems likely that both will be left on our hands, as unwieldy white elephants, quite impossible to let. We would be glad to get even £30 per year Rent with a suitable tenant.' It took many years before either hotel really came into its own.

The Station Hotel was renamed *The Pier Avenue Hotel* after the closure of the Southwold Railway, and *The Randolph* was substantially altered in the 1990s and renamed *The Cricketers*, from which time it took its place as a community pub.

* * *

At the close of the 19th century there were some 7,000 breweries in operation in Britain: today there are fewer than 60 of those still in production. Southwold enjoys fame for many reasons, not least of which is the Sole Bay Brewery, which has preserved its independence, integrity and its identity with its town. Brewing may only be thought of as the second-oldest profession in the world, but the Sole Bay Brewery, with its roots going back to 1345, can lay claim to being Britain's oldest brewery.

Visitors to Southwold

DUDLEY E. CLARKE

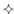

Southwold has attracted visitors for centuries despite being off the beaten track, well away from the main A12 some five miles to the west. One of the things that has made the town so popular is that, even today, journalists pour into *The Swan* and *The Crown*, spend a couple of days meeting the 'locals', go away and persuade their editor to include yet another article on the delightful unchanged town situated on the Suffolk Heritage Coast.

Southwold cannot be commended for its climate, although a brisk walk along the

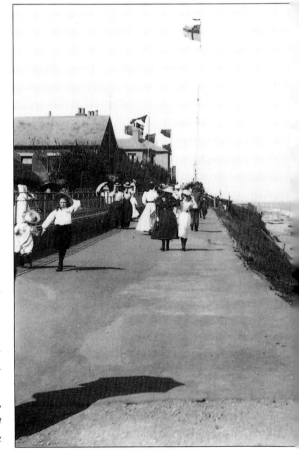

seashore on a windy winter's day can be an invigorating experience. The beaches are mostly covered in pebbles, public transport facilities are poor and the nearest railway station is nine miles away. Could it be that Southwold is a bastion of tradition? Over the centuries change has been minimal compared with other towns of similar size and location. Maybe visitors still travel to Southwold because there is so little change that it reminds them of yesteryear.

From around 1750 wealthy families began to view Southwold as a place to build second homes, hence the large houses around Gun Hill and South Green. This practice continued for a hundred years, creating an industry where the wealthy families had to be catered for. This in turn led to a large influx of new blood into the town—servants, service providers and professionals: doctors, lawyers and businessmen.

Hotels flourished, *The Crown*, *The Swan*, *The Grand*, *Centre Cliff*, *Marlborough* and *Station* hotels were all extended and refurbished. The

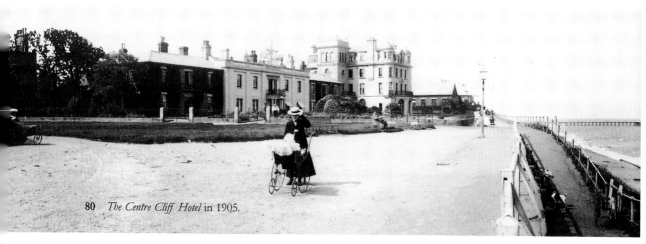

80 *The Centre Cliff Hotel* in 1905.

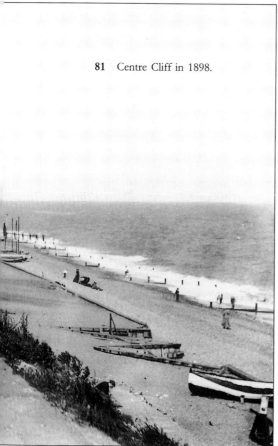

81 Centre Cliff in 1898.

pubs provided a very good service to the visitors. Bed and breakfast establishments (then called boarding houses) sprang up around the town, with a concentration around North Parade and Stradbroke Road. Sea bathing added to the charm of the town. Victorian bathing machines appeared on the beaches, remaining there until 1939. Subsequently the beach hut has replaced the colourful four-wheeled cart.

Towards the end of the 1800s the lighthouse was built and a golf course completed, now one of the oldest in East Anglia, attracting more visitors to a town still very much at ease with itself, with its unrivalled charms and well clear of the noise and bustle of neighbouring towns. With the advent of the motor car, Southwold became more accessible yet retained its charm and civility. The railway from Halesworth to Southwold continued to bring in visitors for holidays up to 1929 when it was closed down, suffering loss of business through increasing road transport.

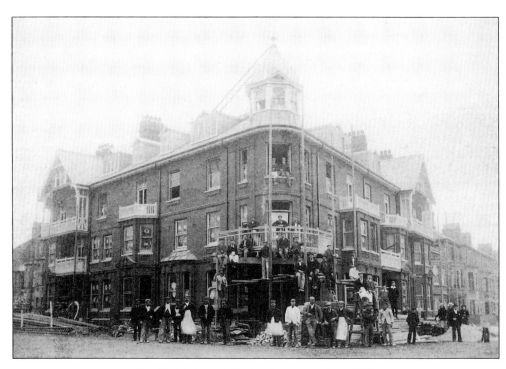

82 *The Marlborough Hotel* under construction, *c.*1900.

83 *The Centre Cliff Hotel* decorated for Queen Victoria's diamond jubilee, 1897.

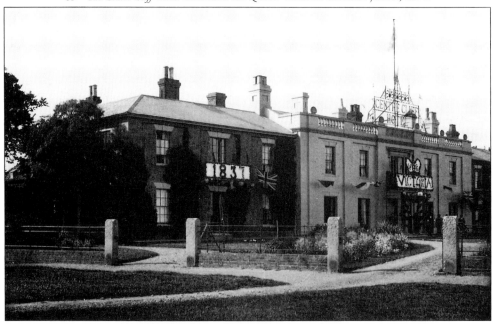

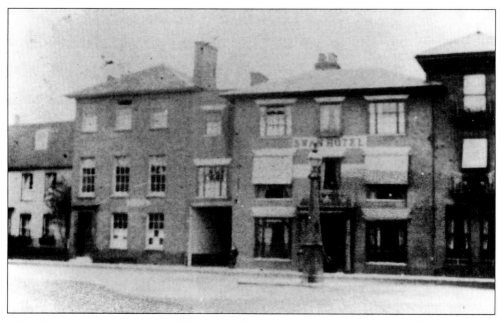

84 The Market Place in the late 1870s or early 1880s, before the bay windows were added to *The Swan* hotel.

It was at this time that *The Swan* was extended, taking in what is now the dining room and the two floors of bedrooms above. The stables were gone; at the far end of the yard was a garage with petrol pumps and an attendant. Guests would be offered the opportunity of garaging their cars for a small charge.

Visitors also arrived by steamer from London, tying up at the end of the pier and being met by staff from the hotels. *The Grand*, only 100 yards from the pier, was considered the ideal resting place by many. Belle Steamers promoted *The Grand*, for it was built in an ideal location with excellent views of the sea from the dining room.

Even the start of the Second World War did not dampen people's enthusiasm for Southwold. *The Grand* and *Centre Cliff* hotels were requisitioned for billeting troops, and women and children were evacuated by boat from London, staying with local householders. Winston Churchill visited Southwold and stayed at *The Swan*. *The Marlborough Hotel* was destroyed by a direct hit during the war and after the war the *Grand* and *Centre Cliff* hotels also ceased to exist. The cost of returning *The Grand* to its former splendour was too great and in the late 1950s it was demolished. *The Centre Cliff* had also suffered damage, and was turned into houses and flats. Southwold started to come alive again.

The past 50 years has seen Southwold change considerably. In the late 1950s the town's bowling green at the rear of *The Swan* was closed and 'garden rooms' built on the site,

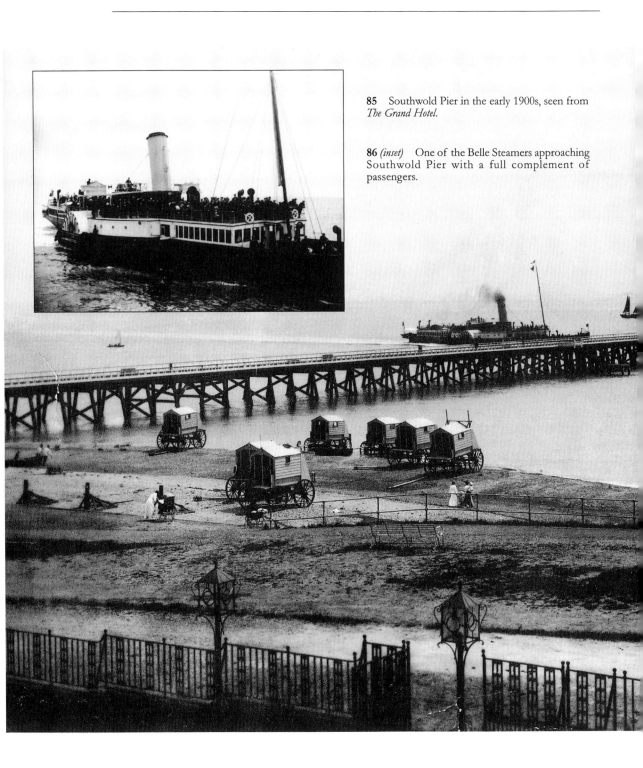

85 Southwold Pier in the early 1900s, seen from *The Grand Hotel*.

86 *(inset)* One of the Belle Steamers approaching Southwold Pier with a full complement of passengers.

extending accommodation for even more guests. The formation of Sole Bay Hotels in the early 1960s gave prominence to *The Swan* and *The Crown*. Selective advertising brought in guests to sample the peace and tranquillity of this jewel in the crown.

With tedious monotony, the A12 continued to be upgraded over many years, providing an invasion of visitors as the dualling of the carriageway reached Wickham Market. Fortunately the upgrading has never taken place beyond that stretch of road, keeping the north-eastern part of Suffolk relatively quiet and free from traffic pollution. Nevertheless one can reach Southwold from the centre of London in three hours on a good day.

The past 14 years have probably seen the most change of all, which has maintained the town as a vibrant community, mixing business and pleasure to create an ambience that is still much sought after by all ages. Although changes have taken place, they have been designed to have the minimum effect on the town but at the same time create a better atmosphere for the visitor.

In 1986 Simon Loftus installed the headquarters of Adnams Wine Merchants at *The Crown*, at the same time completely redeveloping the hotel, providing a hostelry with 12 simply-furnished bedrooms, a busy wine bar selling over 20 wines by the glass, and a small restaurant serving a style of food never seen in Southwold before. This was a major innovation that caused waves of anxiety from the inhabitants and considerable curiosity from the national press. Add to it the provision of classical music evenings

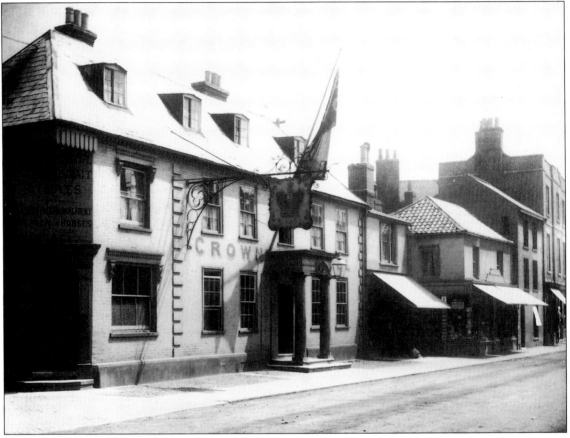

87 High Street and *The Crown*, 1930.

followed by a dinner; Jill Freud arranging lunchtime theatre at weekends; winemakers from around the world attending 'meet the winemaker' dinners—the scene was changing and steadily drawing an influx of visitors who had never heard of Southwold but could not resist the temptation of the widely acclaimed Loftus innovation. Remember that these were the heady days when 'recession' was not a word found in any business news column.

At this time, too, second homes were being purchased in great numbers, and prices were rising rapidly; many of these homes were subsequently let for holidays, increasing the number of holidaymakers. The caravan site close to the harbour mouth was crammed with visitors and the small camp site adjacent was packed every weekend. Southwold had been well and truly 'found'.

Guest houses were very busy indeed; many more opened to take advantage of the growing demand for beds. It was around this time that plans were submitted to build a

marina at the harbour. The opposition was intense and the project never got under way, but once again the name of Southwold was splashed across national dailies, bringing yet more people into town. Shops and businesses flourished, estate agents were overwhelmed by the volume of lettings for holiday houses and beach huts.

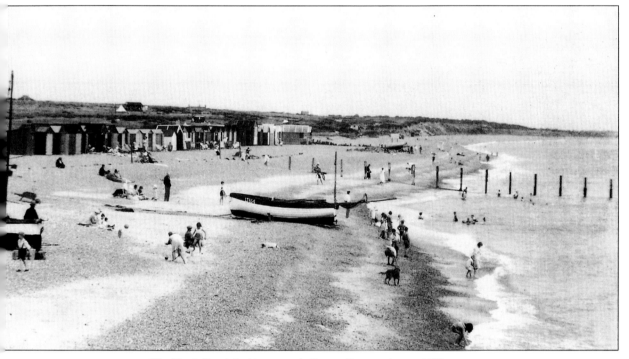

88 North Beach looking towards Easton Bavents, August 1933.

In early 1989 Adnams the brewers secured Sole Bay Hotels and invested nearly £1 million in refurbishing *The Swan*. This hotel, which stands majestically in the Market Place, has been the town's principal hotel throughout the centuries, having been rebuilt in 1659 following the great fire.

Regrettably recession did arrive, and at that time Southwold had not mastered winter trading, November to March being very quiet periods. Indeed, a few retailers could not sustain their businesses and one or two empty shops appeared along the High Street. However, visitors continued to come to the town, in the majority of cases applauding its facilities, quaintness and location. Even the mention of its closeness to Sizewell 'B' did not deter them. Recession took its toll on Southwold, but not nearly so savagely as in other areas of the country. Locals invested in their town by using the shops, the hairdressers, the banks and other facilities. Visitors were made to feel welcome. Standards were maintained;

it was as if the town realised that failure was not a word it recognised. Everyone united to maintain the quality of life.

In the early '90s *The Swan* gained national recognition from a major style magazine, Adnams Wine Merchants won prestigious awards, and Adnams beer was widely acclaimed. Life was not so bad. Visitors were much encouraged to find such vitality in the community. The regular visitor was now the norm. Houses were on the move again, prices hardly touched by the recession.

A new lifeboat station was built at the harbour; guest houses were filled as their owners advertised them nationally. Cars with continental number plates were becoming common-

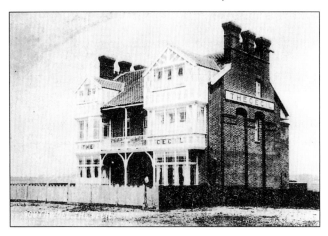

89 *The Cecil Hotel*, Pier Avenue in 1904: now Lancaster Court.

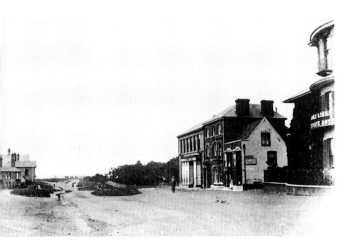

90 South Green around 1890: *The Golf Links Hotel* is now Regency House.

place. It was not just the visitors from London and the Home Counties, many of whom made regular trips to their second homes, favourite hotel or guest house, but a more cosmopolitan group of visitors. Parties came from Italy and America. A group of dignitaries from the British Tourist Authority made a special visit to see for themselves what Southwold was all about. Their subsequent efforts to promote the area have paid off.

Naturally there was an undercurrent of concern from local inhabitants that Southwold was becoming far too popular, with the possibility of all that was dear to people's hearts being destroyed. Parking was becoming very difficult, shops enjoying excellent trade demanded more deliveries, often in larger vehicles. Coach companies placed Southwold on their itineraries, disgorging their bewildered passengers in a town where lunchtime and half-day closing still exist. No amusement arcades, no burger bars. Bewildered they arrived: bewildered they departed.

The Town Council has set its heart on maintaining Southwold as it was, adjusting slowly but discreetly to modern-day trends, continuing to observe the pageantry of yesteryear: delighting the visitor who may

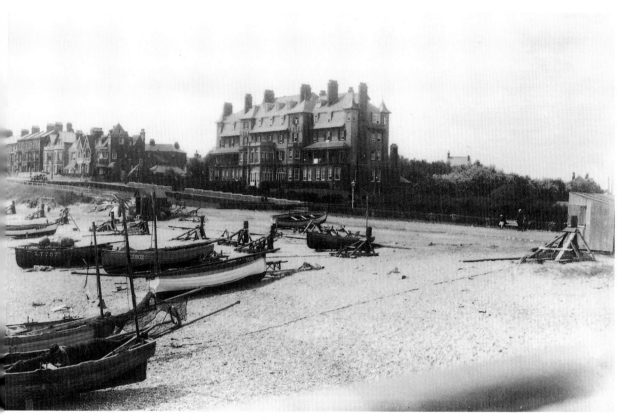

91 *The Grand Hotel* seen from Southwold Pier.

have never seen a Town Mayor in full regalia walking alongside the Serjeant-at-Mace and the Bellman resplendent in their uniforms and followed by the councillors, ladies dazzling in their wonderful hats, the males bowler-hatted and with silver-knobbed sticks. This is still the Southwold that visitors to the town 50 years ago will remember.

Adnams continue to dominate the scene in Southwold. They provide employment, they own and run the two main hotels along with *The Cricketers* in Reydon. They own many successful pubs in the town and continue to invest heavily in their properties and business. The visitor to Southwold can be forgiven for asking if Adnams actually own the place! They don't, but their input has without any doubt helped to keep the town 'alive'. Businesses are today thriving, property prices remain buoyant, buildings are maintained to a high standard, the streets are clean and welcoming, and the press continues to heap praise on a town and community that work well together to preserve its spirit.

These same people are the very ones who serve on the countless committees that provide so much for the visitor. With just 1,800 inhabitants, it is quite spectacular that so

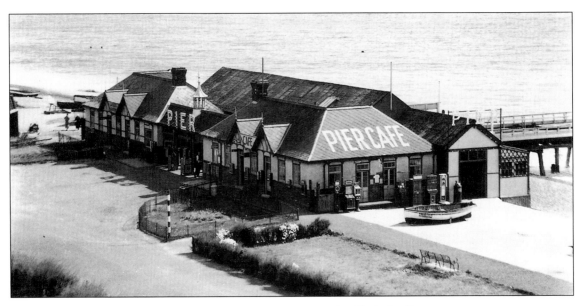

92　The original Southwold Pier Pavilion.

much money is raised. Never a weekend goes by without someone collecting money for a good cause, be it the lifeboat, Southwold Christmas lights, Rotary Club, local nursery schools and countless more.

The visitor gains so much from these worthy causes. Christmas lights cost over £8,000 each year; monies are all raised locally. By the end of July there is hardly a bed to be booked for that remarkable weekend in December. The Southwold Summer Theatre box office is inundated with calls; bookings are at an all-time high. Concerts, talks, and special dinners are all sold out well in advance. Visitors to Southwold not only have the benefits of a delightful town, pleasant beaches and a friendly community, they also benefit from the hard work and dedication of a community that puts so much back into the town it so obviously loves.

So what can the visitor to Southwold expect today when they divert off the A12 towards a town steeped in history, unwilling to catch up with modern times yet benefiting from technology well hidden behind the architecture of our forebears? The visitor can expect to be treated as a friend, to receive smiling service, to feel safe in the community, and depart understanding just why so many people are so bowled over by one of England's least spoilt towns.

How many visitors first came to Southwold as a child with their parents, revisited as young married couples with their own children, and continue to visit with their

grandchildren? If someone enjoys their first visit to Southwold, they will return. It has that effect on everyone.

Not all visitors to Southwold are on a leisure trip. Since the early 1960s film companies have used the town and its environs for filming. Recently a P.D. James story starring Roy Marsden and an episode of 'Kavanagh QC' with John Thaw and Geraldine James have been shot in the area. 'Death by Drowning' with Joely Richardson was filmed in the late '80s, preceded by 'East of Ipswich' with Michael Palin. Southwold attracts fashion editors, who consider the harbour and shingle beaches to be an ideal backdrop for the clothing they wish to feature. In 1995 one national magazine used locals as models, a most successful venture.

Writers and painters make their way to Southwold to take advantage of the relaxing atmosphere and stunning views. The Southwold Literary Festival is well established, attracting some of the best writers around today. Many have returned to take a well-earned rest away from the stresses of the modern world. People with famous names have settled in the area, enjoying anonymity in a community that takes an inordinate interest in everyone else, but observes one's right to be free from public intrusion.

In conclusion, it has to be said that Southwold is now a year-round resort. Apart from a quiet period in January, hotels and guest houses continue to trade all year round, and the shopkeepers are happy in the knowledge that they are serving visitors throughout the year. Long may Southwold remain as it is.

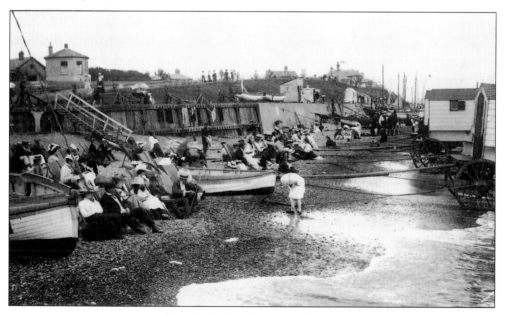

93 The beach under Gun Hill, 1910.

Southwold Common:
William Godell's Bequest to Southwold

GERALDINE BRYANT

✧

North of the River Blyth is a wide area of marshes, and then the land rises to The Common. Southwold Common is not, and never has been, common land. It is part of the land left to the town by William Godell in 1509 on trust to the inhabitants for ever, and it has inevitably had a great effect on the way that the town has developed over the centuries.

It is possible, with the help of historical facts and a good imagination, to picture what Southwold was like in the time of William Godell. But how totally impossible it would have been for him to imagine how the town, its people and its needs would develop over the years into what we are today.

When we read his will we see him as a man of property, a God-fearing man and, I suspect, a person to be reckoned with. He bequeathed 'my place called Skylmans' and 'my heaths and marshes' to 'the bailiffs and commonalty of Southwold for ever to give and sell'. As with all the bequests made in his will there were conditions to be adhered to, but ultimately he gave the land to the future inhabitants of Southwold to do with as they wished.

Today it is difficult to identify exactly the inheritance he left us. Skylmans was probably a manor house, and not necessarily on the present-day Skilmans Hill. Over the years the heaths and marshes have remained largely unchanged, but certain areas on the periphery of the land have been built on.

Southwold's earliest extant record, The Dole and Common Book, includes rules and regulations laid down in respect of The Common and the marshes, the animals which might or might not enter onto them and, from 1741 onwards, the rate of payment for their pasturing there. The diary of James Maggs records the charges for pasturing cattle, and the fact that townsmen who did not pasture

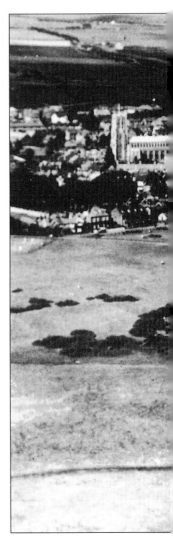

stock on The Common were allowed a 12s. a year discount on their rates, so that everyone benefited from the land. Providing pasture for stock was The Common's main function until 1939, although there are records of horse racing, sports, and linen being draped there to bleach in the sun. Because The Common was used for pasture, the grass was always cropped short throughout and could be walked on easily everywhere. After the Second World War costs rose, and although a few sheep may have grazed The Common, cattle and horses were no longer pastured there. The grass was still cut, though, and at no expense to

94 Aerial view from the south, 1934.

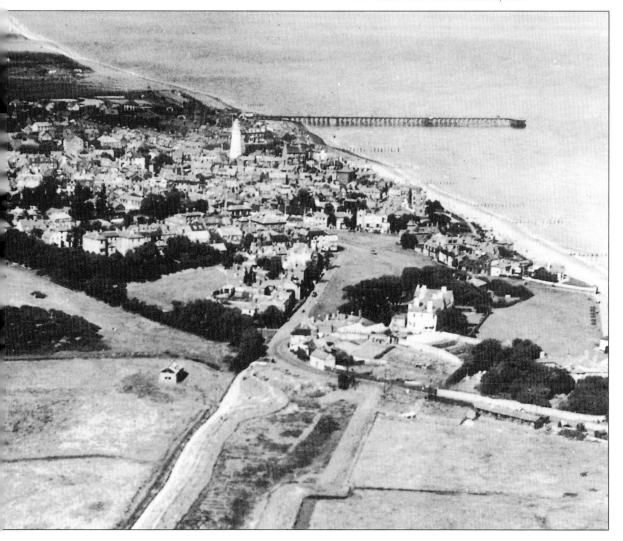

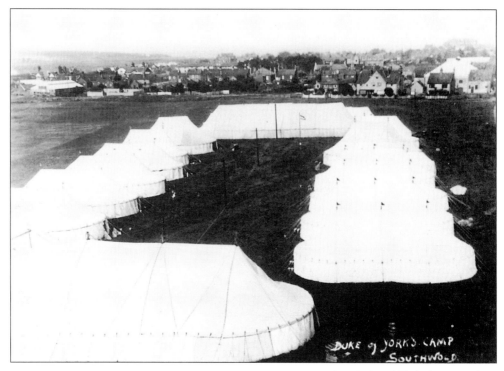

95 The Duke of York's Camp in August 1931. King George VI, when Duke of York, inaugurated a camp for boys during the week of August Bank Holiday each year. The first was held in 1920, with the 400 'guests' drawn from public schools and factories all over the country. The great feature of the week was a 24-hour visit from the Duke himself, who joined in all the fun and games, and the only difference between himself and his guests was that he was accorded an iron bedstead in his tent instead of a sleeping bag. On the initiative of Councillor Mrs. Hope, later Southwold's first woman mayor, the camp was held on Southwold Common from 1931 to 1938. In 1939 the king decided that in future the camp should be held at Balmoral, so that he could spend the maximum time with his guests as well as being with the Queen on her birthday, 4 August.

Southwold Corporation because it provided excellent bedding for animals and local farmers were happy to cut it and take it away. By the late 1950s the grass was no longer usable for bedding because it had become more and more fouled by dogs, and as the Borough Council at that time had little money the cutting and carting ceased.

As structured sport came into being a golf club had been established on The Common, and ever mindful of the changing needs of each generation the 'bailiffs', or 'council' as they had by then become, executed certain changes. A sports pavilion was built, and pitches for football, cricket and rugby were laid out. It would have amazed William Godell to see women's football teams playing a match on the land he had bequeathed. How could a 16th-century man possibly imagine such a thing?

96 James Braid, a professional golfer who advised Southwold Golf Club when the course was extended from nine to 18 holes in the early 1900s, driving from the 7th tee during his match against W. Aveston of Cromer, 13 September 1898.

97 The original swing bridge over the Blyth with golfers on the 6th green: the photo was taken before 1907 when the bridge was rebuilt.

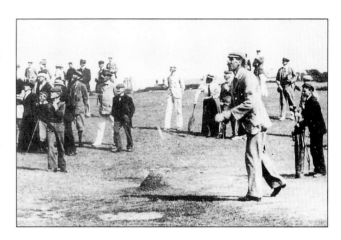

Today we still have the pleasure of seeing cows and sheep graze the marshes. But in 1971 the Town Council felt concern about the future of The Common and registered it with the Charities Commission. The council has always been very conscious of the appeal of our town, and takes a great pride in its appearance and character. We treasure our green spaces, of which The Common and the marshes form a large part.

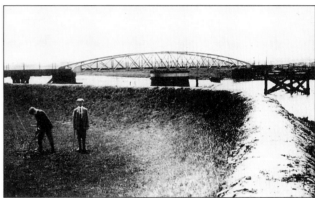

In the light of the pressure put on society today for even more land development, we are indeed grateful for William Godell's foresight in giving 'my land and marshes for the bailiffs and commonalty forever', and to the council for making sure that Southwold's inheritance was legally secured.

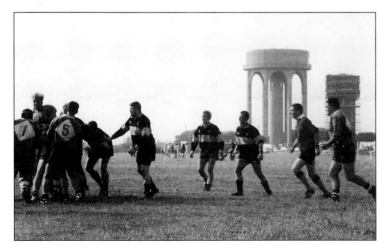

98 At Home on The Common: Southwold Rugby Football Club (wearing hooped jerseys) meet Mersea Island in Eastern Counties League Two, 26 September 1998.

Reading William Godell's will is to step back in time. His main preoccupation in drawing up his will was to secure the safe passage of his soul to his God, secondly to secure the future of his wife, and finally to leave a permanent memorial of himself to his town. His business interests ranged from France to Iceland; he dealt in every sort of merchandise. There would have been hundreds of other businessmen of like substance in England at the time, but few records of them remain.

The Will of William Godell Esquire
E. Reg. Cur. Prorogative Cant. Extract William Godell's Will

IN THE NAME OF GOD AMEN. The year of Our Lord God 1509 the 22 day of May. I, William Godell the Elder, of Southwold Merchant, in whole mind and good memory make my Testament and last Will in this wise following. First I bequeath my soul to Almighty God, our blessed Lady Saint Mary, Saint Edmund King and Martyr, myn Advowry; and to all the holy Company of Heaven. And my Body to holy Sepultre within the Church of Saint Edmund King and Martyr at Southwold aforesaid before the seat where I am bound to sit in. Item. I give to the High Alter of the said Church &c. Item. I will have a priest to Rome to sing for me the space of one whole year, at five places in Rome, that is to say at Saint Peter, Scala Cieli, Saint Sebastians, Saint John Lateraneus, and Saint Gregory. So provided that the said priest shall continue all the said year at Rome at the Churches beforesaid except the space that he may easily go thither and the year so forth there continue and easily come home again into England and I will that the said Priest have for his labour fourteen pounds, and if that Sir Thomas Lane Vicar of Southwold would have the said service I will that he have it afore any other Man. I give to the reparation of the Church of Southwold twenty pounds. Item. I give to the four orders of Friers within the limitations every order ten shillings Item. To the Black Friers of Yarmouth ten shillings for a trental Item. I will have Mass of requiem said for me in Southwold Church during thirty days after my decease and my wife to offer for me every day at the said Mass in the worship of the Holy Trinity three pence Also I will have at the said Mass during the said thirty days twelve poor men or women and my wife to give to every one of them dayly one penny during the said term Item. I will that mine Attornies or Executors shall keep my year-day yearly during the space of twenty years and to beware of expence of twenty shillings about my said years-day during the aforesaid term Item. I will that Margarett my wife shall have my place that I dwell in during her life keeping it in sufficient reparation and after her decease to be sold by mine Executors to the performance of my Will Item. I give to the said Margaret my wife all my Stuffs of Household implements and utensils with all manner of ware and Merchantdise within the said house to give and to sell at her own will Item. I give to my said wife one of my two ships the *Cecilly* or the *Andrew* whether of them she will Item. I will that all mine other ships be sold by mine Executors as well as those that be in Iceland as

those that been at home And also those that I have part in except that ship that Margaret my wife shall have And also I will that all the fish that God shall send me out of Iceland be sold by mine Executors in performing of this my last Will Item. I bequeath unto Symond Hathe an house called Ordymers to give and to sell Item. I will that all my houses at the Town's end with all the Salt and Merchantdize within them and my house at the Wood's End which I hold by Copy of the Manor of Southwold be sold by mine Executors to the performance of my will Item. I will that Margaret my wife shall have my place called Skylmans with all that the lands tenements rents and services heaths and marshes both free and copy with all their commodities and appurtenances thereto belonging and four hundred sheep pasturing upon the said lands and marshes during the life of the said Margaret my wife upon condition that the said Margaret shall find a secular priest to sing in the Church of Southwold for my soul during her life aforesaid and after the decease of the said Margaret my wife I will that the said four hundred sheep whether they be more or less be sold by mine Executors then living and then I will that after the decease of the said Margaret my wife the said place called Skylmans with all the premises before rehearsed be in the hands of the Bayliffs and Commonalty of Southwold aforesaid by the span and term of sixteen years then next following and the Bayliffs and Commonalty shall also find by all the span and term of sixteen years beforesaid a secular priest to sing for my soul and the souls of my friends in the said Church of Southwold And I will that the said priest have for his stipend yearly during the said term nine marks And if the said Bayliffs and Commonalty fail and make default in keeping or finding the said priest in any year of the said sixteen years that then it shall be lawful to mine Executors or the Executors of them to re-enter into the said place called Skylmans with all the premises and other appurtenances and to every parcel thereof And thus to have and hold the said place and other premises during the term of the said sixteen years unserved and they to find the priest by all the said term unserved And after the span and term of sixteen years I will that the said place called Skylmans with all the premises above rehearsed wholly remain to the said Town of Southwold for ever to give and sell and further more I will and desire all them that be seased and enfeoffed of and in the said place called Skylmans with other the premises that they shall stand and be seased and enfeoffed thereof to the use of the said Margaret my wife for the term of her life and after her decease to the use and performance of this my last Will and Testament and they shall make and deliver all such estates of and in the said house with other the premises as shall be devised betwixt mine Executors and the Township of Southwold aforesaid and their Councell for the surer performance of this my last Will whensoever they shall be thereto required Item I will that the said Margaret my wife have all my corn growing in Southwold and Reydon to the sustenation and keeping of her household and all my horses carts and ploughs and a Cow And I will that all my other neat be sold by mine Executors Item I will that the said Margaret my wife have my nets and all

manner of nets with the ropes belonging to them Item I give to Margaret my wife a Boat called the *Platfole* Item I give to Richard Howlett of Walberswick ten marks of lawful money of England Item I bequeath to the Nuns of Braisyard twenty shillings Item I bequeath to each of my God-children six shillings and eightpence Item I bequeath to Harry Godell ten pounds Item I bequeath to Robert ten marks Item I bequeath to William Godle the Elder five marks Item I bequeath to Thomas Godle five marks Item To William Godle the son of William Godle thirteen shillings and four pence To William Godle the son of Robert Godle thirteen shillings and fourpence Item to John Godle the son of the same Robert thirteen shillings and fourpence Item I will that the tenement called Cokks be sold by mine Executors Item I will that all my Wools at Calais be sold by mine Executors and Factors Item I bequeath to the Parish Church of Reydon six shillings and eight pence to Wangford Church six shillings and eight pence Item to Uggeshall Church six shillings and eight pence Item to Stoven Church six shillings and eight pence Item to Brampton Church six shillings and eightpence Item to Redisham Church six shillings and eight pence Item to Frostenden Church six shillings and eight pence Item to South Cove Church six shillings and eight pence Item to Wrentham Church six shillings and eight pence To Covehithe Church six shillings and eight pence Item to Benacre Church six shillings and eight pence Item to Easton Church six shillings and eight pence Item to Blythburgh Church six shillings and eight pence Item to Wenhaston Church six shillings and eight pence Item to Kessingland Church six shillings and eight pence Item to Walberswick Church six shillings and eightpence Item to Blythford Church six shillings and eight pence Item to Holton Church six shillings and eightpence Item to Westhal Church six shillings and eight pence and to Sotherton six shillings and eight pence The residue of all my other goods and chattels not bequeathed I put to the Disposition of mine Executors whom I do ordain and make Margaret my wife beforesaid Robert Hawe and Robert Godle that they may dispose for my soul as they shall think best to please God and most profit to my soul These men being witnesses, Henry Joye Henry Page Baylliffs of the said Town of Southwold Sir Thomas Coppyn Clerk, Richard Bishop, Robert Joye, William Godle and William Sparhawke and others the day and year above written.

PROVED at Lamehith the twenty sixth day of June One thousand five hundred and nine.

THOMAS WELHUM, Reg. Dep.

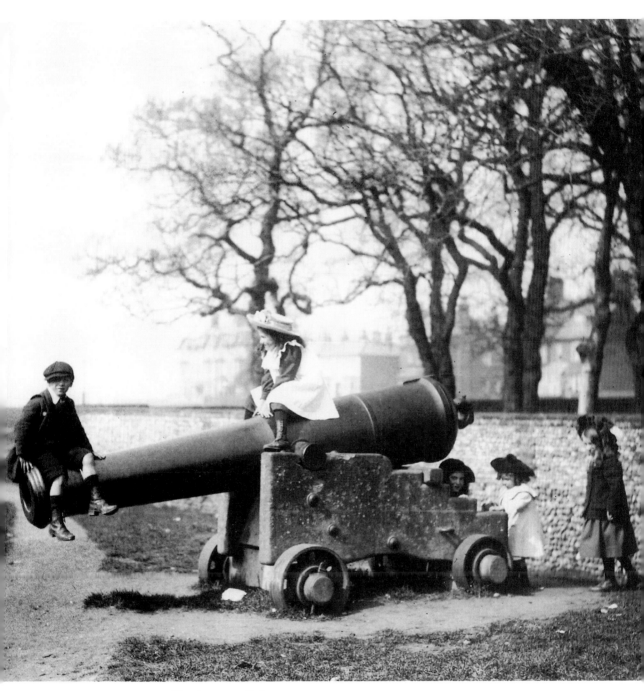

99 A corner of The Common near the Paddock.

In Pursuit of the Southwold Vernacular

JOHN BENNETT

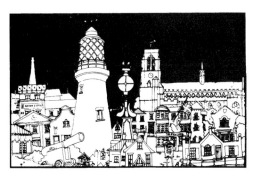

No one would doubt that, whilst the town has important liquid assets in the form of sea and ale, it is not exclusively these benefits that generate affection and cause holidaymakers to return year after year. Important, even essential, though they be (especially the latter), it is rather the pot-pourri of old buildings and greens, alleys and streets, pantiles and pediments, which generates that ambience of quiet quality and timelessness that is the Southwold attraction. And all within the compass of a single square mile.

There are many buildings to enjoy. No visitor should leave without seeing St Edmund's Church, the Sailors' Reading Room on East Cliff, the Museum in Victoria Street and the lighthouse in Stradbroke Road. But the spirit of Southwold is found as much in the less remarkable buildings and places in between as in these landmarks. What is it that defines this spirit? And is there, in fact, a Southwold Vernacular?

The term 'vernacular' is used to describe buildings produced without aid of architects by local builders using local materials, to provide shelter and protection for local activities. Professor Brunskill has described nearly all buildings produced prior

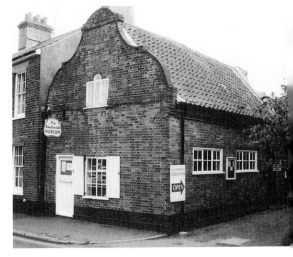

100 Southwold Museum in Victoria Street, September 1998.

108

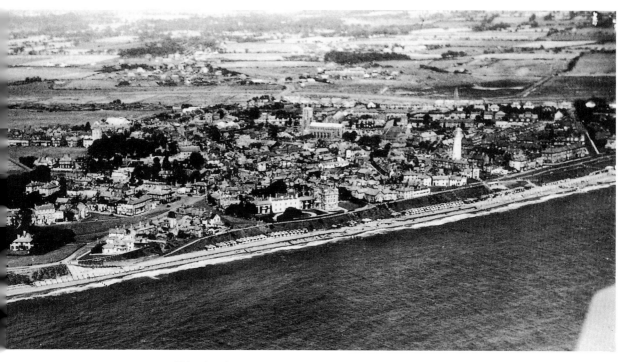

101 Aerial view showing Centre Cliff, August 1934.

to about A.D.1100 as 'vernacular' and distinguished them from what he termed 'polite' buildings, those where some level of sophistication and conscious design was introduced. These would have been larger houses and buildings increasing exponentially in number, and similarly decreasing in scale, from that time until the present day.

Southwold is an immensely 'polite' place, of course, and many buildings deserve this label. *The Swan Hotel* on the Market Place with its imposing pedimented bays added in 1907 is one such; the Manor House in the High Street, with its spectacular Gibbs carved-acanthus doorway, another. Centre Cliff, where the north wing, even without its two upper floors, still grandly faces the sea, is yet another. At the more vernacular level we might identify simple fishermen's cottages such as those on the north side of St James's Green (nos.2 to 8), and on the west side of Church Street. Eventually vernacular and polite elements combine by design or accretion; the small-scale cottages with classical doorways and details which thus emerge taking on a character all of their own, unassuming but genteel, quiet yet elegant; and all very English. Elizabeth House, 24a High Street, would typify this third category, one which would not only include the Georgian style, as this example, but the Victorian and Edwardian villa styles that followed. Houses in Stradbroke Road and Field Stile Road

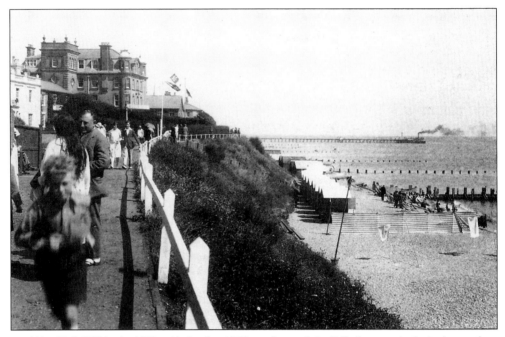

102 York Cliff in the 1920s with Southwold Pier and one of the Belle Steamers in the background.

would be typical of these. So three main categories of building—the Polite, the Humble and the Polite-Humble—in the form mainly of houses, shops and inns, are stirred up randomly and cast, cheek by jowl, into the ancient crooked street pattern and sprinkled around the greens. It has been argued that Southwold's famous Greens exist because of a replanning following the Great Fire of 1659, which sought to provide firebreaks between the buildings. There may well have been an element of this, but one likes to think that Southwoldians just preferred to pepper their town with open space and lawn; it is a more likely truth.

As with other parts of Suffolk the local Southwold materials were timber—Southwold is south of the 'wold' or forest—clay, reed and flint cobble. No stone, of course, and the 15th-century builders of St Edmund's Church imported from elsewhere—possibly Normandy, possibly Yorkshire. Thus we would expect to find brick- or cobble-built cottages with thatched or pantiled roofs. And so we do, but Southwold's Fire ensured that very little thatch survived. There is certainly none now, apart from a rather more recent house (with fetching feline finial) in Pier Avenue, but we may still see some of the more steeply pitched roofs, now bearing pantiles, which would once certainly have been reed-thatched. The cottages in North Green, nos.7, 8 and 9, are typical of these. Now, at roof level, slate and pantile jostle for prominence, with slate often set to the seaward side for better resistance

to weather. Plain clay tile is used sparingly—the Manor House being one of the few buildings thus covered. There is an uncertain number of cottages with walls constructed entirely in flint cobbles. These are hard to spot, being mostly rendered over to keep dampness, a hazard of cobble construction, at bay. Cobblestones, a restored cottage (or more accurately a pair) at the end of Snowden's Yard, is one such.

The Fire also ensured that most of the building stock may be dated after this time. There remain, however, some very old buildings and very old bits of buildings. Besides the fine St Edmund's Church (completed *c.*1450) with, amongst other wonders, an excellent medieval rood screen, there is Oak Cottage on Bartholomew Green, parts of which may pre-date this, and which certainly contains very ancient brickwork with clay mortar in places. As with many other such cottages the eaves have been raised by several feet. No.16-18 Park Lane has Tudor brickwork and clearly dates from the 16th century. The Old House, 51 High Street, may date externally to about 1750 but the interior has a pedigree going back another two centuries. The Crooked House, 82 High Street, is, despite its 1662 plaque, a good century older and was part of a larger building with a symmetrical and identical wing on the site of what is now the Card Shop. Buckenham House, at one time the Vicarage, was owned by one Richard Buckenham in 1571, and Sutherland House may date in part from 1455.

Whilst a number of buildings are of historical or architectural interest for one reason or another, it is the details of construction, the form of the bits and pieces that make up a building, and the manner in which the junctions and abutments are fashioned, that engender charm and a particular character. Until fairly recent times it was never enough to solve a problem (and preferably two problems), it was *de rigueur* to extract some artistry and some entertainment value as well.

Take, for instance, the 'squinches'. There are a number of these around the town. Here the problem is to protect the busy corner of a building by rounding or chamfering the wall on plan at ground level. This, however, would give rise to a technical difficulty at the eaves unless the wall could return to a right angle before getting there. Brick squinch arches were the original answer, but there are a variety of brick details. Stepping and carving create a visually rich sculptural effect and are a recital of skill by the tradesman. We can see one on 13 East Street on the corner of Pinkney's Lane, or a rare double version, almost hidden by a layer of porridge-like pebbledash and a municipal sign, at 12 Victoria Street, on the corner of Bartholomew Green.

SQUINCH

Most of the old brickwork came from local brickworks, one of which still exists. The predominant bond is Flemish Bond, where alternate headers (the short end) and stretchers (the long side) make a visual texture sadly lost in modern cavity walls. There is certainly a

Flemish flavour in the brickwork of several buildings, notably the Dutch-gabled Museum. Elsewhere there is evidence of Monk Bond (two stretchers and a header) and Rat Trap Bond where the bricks are laid on their sides forming off-set cavities, presumably like a rat trap. There is a good example at the Victoria Street end of Bank Alley. Delightful bits of bricklaying skill

RAT TRAP BOND

FLEMISH BOND (TOP)
MONK BOND (BOTTOM)

abound: typically, the fine arched niche on the *Sole Bay* inn on St James's Green, and an excellent elliptical oculus window and eaves ogee dentil course on 24-6 Church Street, dating back to 1760. A glimpse of conveyor belt indicates the presence of brewery operations internally.

Traditionally, the visual quality of any building component would follow rules, established in some cases over centuries, for the purpose of creating an eye-friendly effect. Windows, the eyes of a building, would for instance contain panes of equal size and usually fine proportion. The box sash window is a common and excellent type much seen about the town. Set nearly flush with the outside face of the brickwork prior to about 1709 and set back elegantly behind it later on, this clever type of fenestration, invented by C. Wren, Archt. for the Queen's Toilet, contains two vertical sliding frames or sashes which would

VENETIAN WINDOW.

have perhaps six identical lights of 2:3 proportion in 'portrait' format. Two hybrid versions are worth looking out for. The Palladian, or Venetian, window is in evidence in several locations. A triple sash window with central arched section is a particularly attractive form, and may be seen at Montague House, next to the fish and chip shop in the High Street, and 21 Market Place which is on the site of the old Town Gaol. The other interesting type is the horizontally sliding, or Yorkshire, sash. Here, a window which can only be three lights high is split vertically rather than horizontally to maintain equal sashes. There is one in the flank wall of 58 High Street (until recently the *Southwold Arms*). Many of these have disappeared over the years, but one or two have now returned in recent conversions. Dormer windows, sometimes with sidelights to pinch a sea view, adorn many an attic bedroom. Oriel windows, bays cantilevered out from a first floor room, serve a similar purpose. There are some three dozen of them.

YORKSHIRE SASH

ORIEL WINDOW

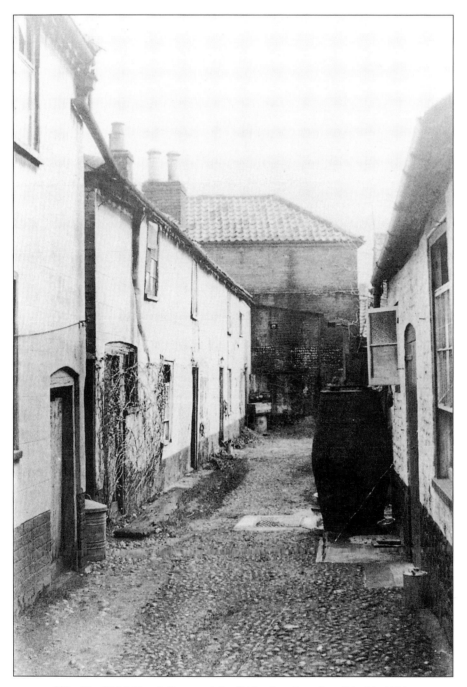

103 Nos.32-36 Church Street and the *Brickmakers Arms*, demolished in 1984.

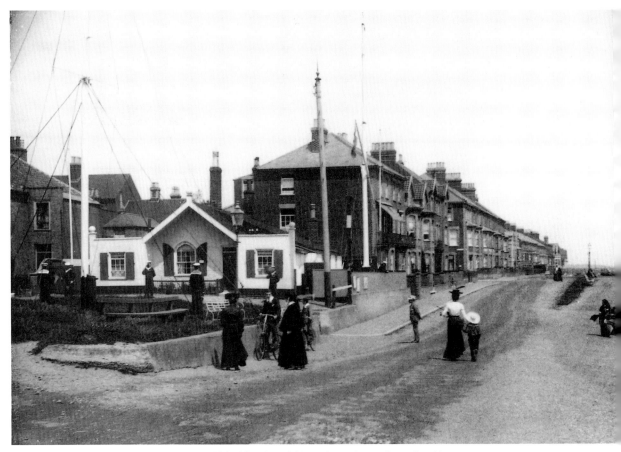

104 The Guardship and North Parade, mid-1890s.

In seaside locations finials, those rooftop exuberances that catch the eye, are particularly important parts of the skyline. The stone ball-and-pedestal features of Guardship, that delightfully odd confection with a single Gothick window at the seaward end of St James's Green, come to mind. There is a similar, but tiny, crimson ball over the octagonal Casino on Gun Hill, another interesting construction built in Regency times to house, before the Coastguard and then the Lifeboat Museum, a small library. Finials serve no useful purpose other than as a convenient seat for a sleepy seagull, but as an aesthetic device in certain situations they are invaluable.

CASINO FINIAL

Valances, or decorated canopies like those over Victorian railway platforms, work similarly to create a silhouette. Both *Swan* and *Crown* hotels possess one, and there is a very

unusual type to be found on South Cliff Cottage. This clifftop dwelling has recently been restored and extended with an upper storey and a turret, the design of which was borrowed from those that once graced the sadly demolished *Grand Hotel*, now the site of three bungalows in North Parade.

VALANCE ‑ SOUTH CLIFF COTTAGE

For a town said to be resistant to change there have, in fact, been constant changes throughout its history. Each century brings its new agenda and the shift from a fishing-based economy to one

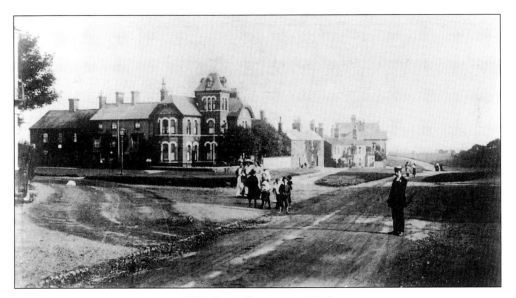

105 South Green around 1910.

built on holidays is this century's contribution to the changing pattern. From 1898-1915 the Coast Development Company, an energetic organisation set up by one Abel Penfold, undertook a series of projects along the East Coast. It ran the wonderful Belle Steamers and was responsible for whatever works enhanced this operation. In Southwold this meant constructing the Pier in 1900, laying out Pier Avenue from the railway station to the Pier in 1899, and erecting *The Grand Hotel* in 1901. The Town Farm Estate was purchased to provide the necessary land, and on 19 August 1899 a number of superfluous building plots were auctioned. Thus was established the road pattern of the area north of the lighthouse and genteel villadom was extended via housebuilding in Pier Avenue, Corporation Road and Hotson Road. Thankfully, the Harbour and Blackshore remain, for the most part, in delightfully unkempt and unspoiled condition, but the Fish Market (or 'Kipperdrome') which housed herring-gutting activities and rollerskating, though not,

one imagines, at the same time, is replaced by public conveniences. Gone too is the narrow gauge railway and the station, although *The Station Hotel* survives as *The Pier Avenue Hotel*.

There has to be a fire station, a police station and a telephone exchange. Shops have disappeared. Others arrive. A mattress factory transmogrifies successfully into flats. A grim new water tower overshadows a charming old one. Overhead cables proliferate. Scaffold tubes replace oak bollards and concrete lamp-posts replace the elegant cast iron. Plastic creeps in. But somehow Southwold remains Southwold. And provided that enough of the new development follows the grain of the existing, and uses the local materials and idiom, the essential Southwold quality can, as history indicates, be maintained.

So what is the 'essential Southwold quality'? The answer is in the beauty of its buildings and the spaces between them, in the roof rhythm of the beach huts, in the absence of overt commercialism, in the juxtaposition of Town and Common, in the resistance to the fashionably modern and in the seasoning of idiosyncratic, but always tasteful, small-scale details and features. Our eye is drawn irresistibly to the parapet shells of Centre Cliff, the Jubilee Clock, the golden weathervane on the lighthouse, the Town Hall noticeboard, the Wine Shop lettering and the Reading Room mermaids. George Child's triumvirate of herrings atop a triangularly planned cast-iron water pump supporting a slightly off-balance spherical glass luminare capped with a golden crown and arrows marks the centre of gravity of the Market Place, and of the Town. It also conveys a touch of humanity. This is the Southwold Vernacular.

PUMP.

106 Christmas lights switch-on with the mayoral party and a distinguished visitor on the Town Hall balcony.

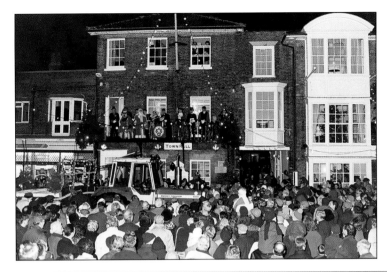

107 A winter beach scene.

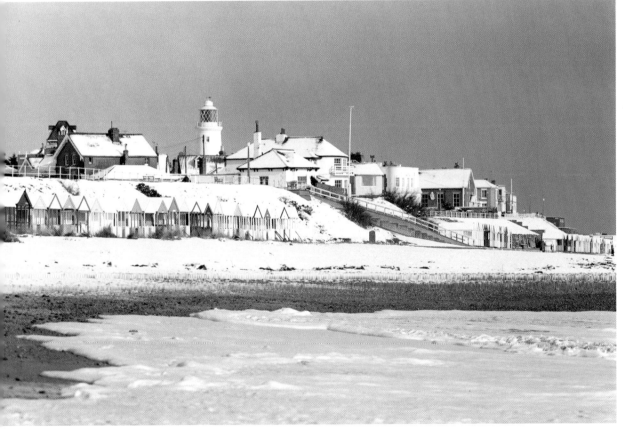

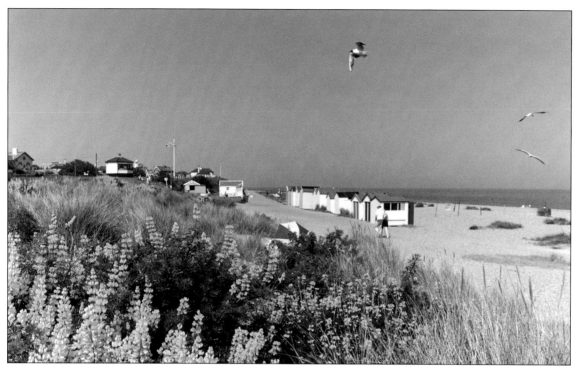

108 Gun Hill and the Casino seen from the Denes.

109 Adnams' dray horses at pasture on the marshes.

St Edmund's Church: An Appreciation

FELICITY GRIFFIN

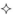

The parish church of St Edmund, King and Martyr, stands in the centre of the town. Over five hundred years ago it was built from local flint and imported stone, its tower standing 100ft. high. Around it there is a generously large churchyard now crowded with memorials and criss-crossed with pathways. There is always someone coming and going; this is no isolated graveyard. Four Greens adjoin it to north, south, east and west: Tibby's where the children play, Hospital to the north, Hollyhock next to the primary school, and to the south St Bartholomew's, under which lay once the market square of the Borough.

Fire made the St Edmund's we see today. It destroyed the small chapel early in the 15th century. Two centuries later, the church was saved by its graveyard from damage in the fire that devastated the town, and the subsequent rebuilding left it the legacy of the

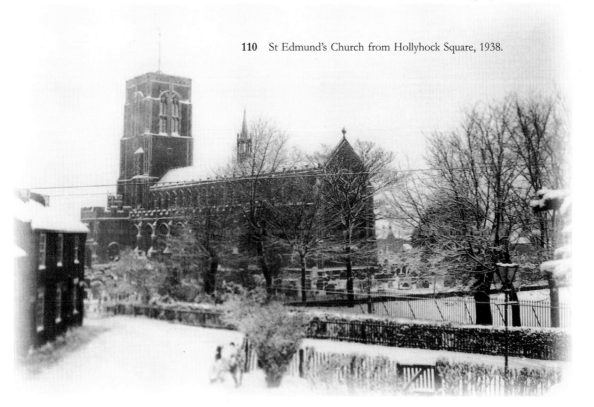

110 St Edmund's Church from Hollyhock Square, 1938.

surrounding Greens. Fire of a different kind, that of a wartime bomb, destroyed the Victorian stained glass in the windows. Again good came out of evil: following the replacement by clear glass, the interior of the church now has the light and lofty beauty that is so much admired.

Among Suffolk's many magnificent medieval churches built in the 15th century in the Perpendicular style, St Edmund's ranks high. See it floodlit in winter. See it on a summer's evening, preferably approaching by the old high road (now under the pathway by the children's swings) which led directly to the west face of the tower; the sunshine lights up the flint flushwork, clearly showing the successive stages of laborious craftsmanship on its great walls, and picks out the plea worked in capitals over the great west window: SCT EDMUND ORA PRO NOBIS.

The abbot and monks of the Benedictine Abbey at Bury St Edmunds owned the small manor of Southwold in the year 1202 when John de Grey, Bishop of Norwich, acting on instructions from the Pope in Rome, decreed that a chapel should be provided for the community of fishermen. Ecclesiastical supervision was given to the Cluniac Priors of Thetford and Wangford, who already had charge of St Margaret's Church at Reydon. Two hundred years later, when that first chapel burned down, the size and prosperity of the town had altered dramatically. Nothing now remains of that first building, unless it be the great doors in the south porch. It may be that the extreme weathering on the outside of those doors argues long exposure to Suffolk storms without the protection of a porch. The carved head of St Edmund portrayed between the paws of a wolf could once be made out in the spandrels, a reason for believing that the dedication to its patron saint dates from those earliest years.

The details of the creation of the Borough of Southwold are told elsewhere, but in recording the story of St Edmund's it is necessary to emphasise how close were the ties between borough and church. The town in the 15th century was growing to the height of its prosperity, its merchants having become rich from fish and shipping. The manorial rights had devolved to the Crown, and towards the end of the century, when borough status was granted, the town owed its natural duty and loyalty only to the king. It was in this period of confidence that the new church was planned, built, and paid for. Built to the glory of God in an age of Catholic piety and mercantile pride, its great tower has always been a beacon to ships at sea and a rival to the three neighbours at Covehithe, Walberswick and Blythburgh. The new borough took as its badge the three crowns and crossed arrows of St Edmund, with its motto 'Defend They Right'. In the newly completed church the 12 portmen and the 24 of the commonalty, led by the two Bailiffs, took their appointed places in the chancel for the celebration of the mass. During the reign of Queen Elizabeth I they could even be fined for being absent. Custom established their authority in the town and their rights to seats in the church, rights which have been defended down the centuries.

What can we know about the men of those times, whose lives spanned the building years, the years of Reformation and decay, and the years of repair and renewal? Just one memorial brass remains from the century of the church's building, that to Robert Byshopp and his wife Helena. Dying in 1456, he could have been present when fire burnt the first chapel, and as a wealthy merchant would have been involved with the plans for a new building. Another Robert Byshopp, his son or a close relative, is one of the names in a list of trustees on a deed dated 1458. It was for a grant of land to extend the churchyard, made by the prior and monks of Thetford in exchange for the annual rent of a rose payable on St John the Baptist's day, Midsummer Day, 'for all services, rights and demands'. The custom of placing a rose on the high altar is still honoured today.

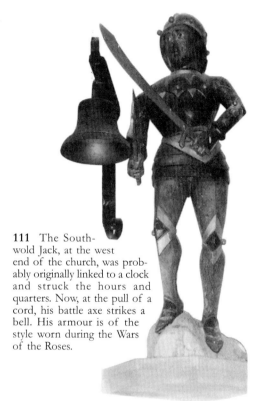

111 The South-wold Jack, at the west end of the church, was probably originally linked to a clock and struck the hours and quarters. Now, at the pull of a cord, his battle axe strikes a bell. His armour is of the style worn during the Wars of the Roses.

Robert Byshopp and William Godell were the first two Bailiffs of the borough and must surely have had memorial brasses, now long since gone. William Godell, a great benefactor to the town, died in 1509, the same year as his king, Henry VII. He left instructions in his will that he should be buried in the church 'near the seat which I was used to occupy'. He also left money to pay a chantry priest to sing masses for his soul.

There are no existing records to tell the story of the years of the Tudors, the Reformation, and the despoiling of the furnishings of St Edmund's. No doubt its fate was similar to that of other churches more completely documented than ours. In the reign of Edward VI the pace of reform accelerated: Cranmer's first Prayer Book was sanctioned, all Catholic forms of devotion were forbidden, and missals and breviaries were to be burnt. In Southwold money from the sale of church goods was used to repair the harbour. The Faith of the Fathers seems to have become a political football.

In 1602 there was an order that all churches should keep a register of christenings, weddings and burials. St Edmund's register begins in that year, Parson Robert Selby signing the first entries. Christopher Youngs was vicar from 1611-27, a graduate of the extreme Protestant college, Emmanuel in Cambridge, as was his son John. The story of John's

journey to America is briefly recorded on the perpetual curates' board in the north aisle of the church.

John Goldsmith is the next name signing the register. His handwriting continues with meticulous entries up to the year 1644. There is no record there of the visit to St Edmund's by Parliament's Commissioner for East Anglia, William Dowsing, on 8 April 1643. His infamous diary of journeys through Suffolk lists 150 churches he visited, with the destructions ordered. In St Edmund's he records, 'broke down one hundred and thirty superstitious pictures, St Andrew and four crosses on the four corners of the vestry and gave orders to take down thirteen cherubims and to take down twenty angels and to take down the cover of the font'. John Goldsmith was to continue as vicar for another five years but, interestingly, the entries cease or are missing, as several pages in the register book have been cut out. Entries do not begin again in a regular way until the middle of the 18th century.

There is one man who could have told the story of those years. There is a memorial to him, in Latin and now almost indecipherable, which records that James Petrie, born in 1619, died in Southwold aged 81 in 1700. His memorial reads, 'Here lies James Petrie, once Vicar of this Parish, an upright man whose learning few could equal. During his life he endured heavy trials for his King and for his true faith and at length full of days and very weary he changed this miserable life for the life eternal on the 27 August, A.D. 1700'. His name does not appear among those perpetual curates on the board. He was, no doubt, a Royalist. As a young man of 24 he would, perhaps, have seen the day when William Dowsing rode into town and set about ordering the final destruction of the ornaments of the building. He would have been living in the town at the time of the devastating fire that destroyed so many houses. He would have rejoiced at the Restoration of King Charles II and been relieved to see a Book of Common Prayer once more in use for all services. The church bought a beautifully simple silver chalice and patten in 1661 to replace those that had been sold. James could well have been at its service of consecration. It is still in use. The time was coming, though still far in the future, when beauty and holiness would again go hand in hand.

Thomas Gardner, salt officer and historian, provides much information about 18th-century Southwold. He it was whose delving into old wills of the townsfolk left us evidence of how many bequeathed money to the buildings and furnishings of St Edmund's. He writes vividly of the state of the church fabric, which had become deplorable, and blames the 'blind zeal' of the iconoclasts who destroyed so much. He claims to have discovered and opened the stairs to the rood loft; they would no doubt have been blocked up when the rood itself was taken down. He also records that the chamber over the porch was 'the arsenal for the warlike stores of the town'. These comments are the first rumblings of criticism which would lead to the start of a major restoration in the next century.

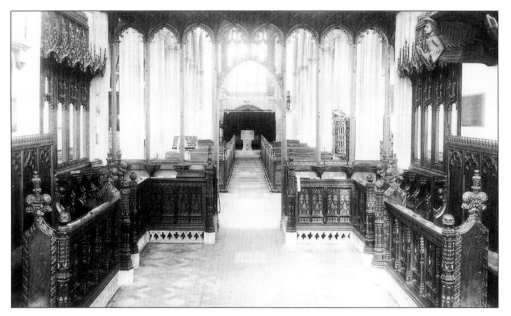

112 Interior view of St Edmund's taken from the Sanctuary steps looking to the west, early 1930s. The only significant difference from the same view today is the absence of F.E. Howard's magnificent font cover, installed in 1936.

In 1829, with the appointment of Henry William Rous Birch as vicar, the first incumbent actually resident in Southwold, work began on the renovation and repainting of the church roof. After his death in 1873 the livings of Reydon and Southwold were separated, with the patronage of the latter allotted to the Simeon Trust. The whirligig of time brought in its revenges, and by the end of the century the interior, which had been a 'preaching box', the chancel and side chapels long since disused, would be restored to its traditional use and order.

The present century has seen the continued care for and adornment of the church building. Between 1929 and 1935 the presiding genius of the decoration and furnishings was F.E. Howard of Oxford, a pupil and associate of Sir Ninian Comper. Comper's last work was the east window, installed after the Second World War. The spirits of the townsfolk of the past might well nod with approval at the present appearance of their parish church, though they might be surprised at the lively copper roof! Some might miss a sanctus bell in the hollow fleche, think that a modern St Edmund usurps Our Lady's niche over the south door, and look in vain for any representation of a crucifix.

The people of the place flow in and out and round about; they are one of St Edmund's sources of wealth. This wealth of voluntary help supports its maintenance, its security, its daily housekeeping. The bells are rung, the choir sings, the children are cherished, the

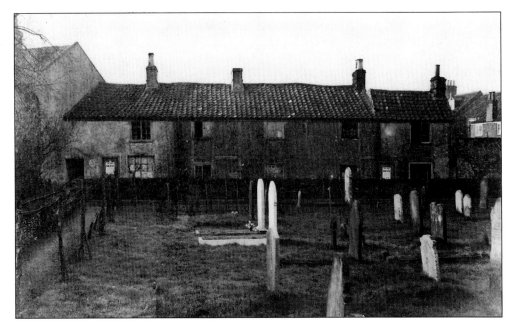

113 Hollyhock Square from the churchyard, 1938.

flowers are abundantly arranged, all by a steady stream of helpers. All are joyous chores that the glorious church deserves and expects. Wealth of another sort is its pride. Just as the first townspeople left legacies for the building of the church so to this day grateful donors leave money for the care of its fabric. St Edmund's is able to pay for its maintenance and give generously to many charities.

Writing in 1948, the vicar, Canon R.N. Pyke, sums up his description of St Edmund's like this:

> There is a vigorous church life in Southwold … as things go in these churchless days the congregations are distinctly good all the year round. In the winter the very capacious church is on special occasions crowded out, and in the summer we used, before the War, to duplicate the Sunday service … A very pleasant feature of Southwold life is the harmony that obtains between the Church of England and the other denominations … United services are held in the parish church on outstanding occasions.

For today, this is a goodly inheritance indeed.

What, then, of today? Southwold is a seaside town, accustomed to the rise and fall of the tides, tides which can devastate the beach in one season and in another kinder one leave

a margin of sand for children's play. The history of this church of St Edmund has had a similar flow; as, seemingly, does the liturgical year.

There is the high tide of Christmas. The town fills with visitors, there are lights and decorations, and excitement mounts until in full blaze the Eve reaches its gaudy climax. Midnight Mass is celebrated in the magnificently restored chancel of the church. The long low tide of Lent comes when the biting wind blows from the north east and the faithful few brave the dark mornings for the comfort and consolation of the 'eight o'clock'. Easter comes at last, and another high tide fills the church. There are blossoms in neighbouring gardens, red and white may bloom in the churchyard, there is a riot of gorse on The Common, and soon the first swallows are seen.

May brings the Civic Service. Though Southwold is no longer a borough, there are still a Town Mayor and Councillors who process to church where they claim their rightful

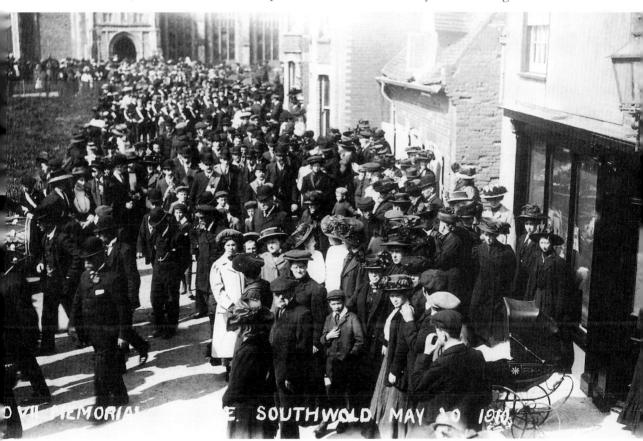

114 Crowd leaving St Edmund's Church via Bartholomew Green after the memorial service for King Edward VII, 20 May 1910.

seats with pomp and circumstance. We are reminded of the long-standing unity of town and church. Not so many years ago this unity gave rise to an occasion none who were present will ever forget. There was standing room only, not for a service but for united resistance to a plan that would have exploited the harbour and marshes. Rights were defended with one voice.

St Edmund's has many beauties, but to see it in all its perfection you must go to evensong in summer when the sun is setting. Sit near the screen, and you will see the gilding lit by the sunlight through the west window, outshining any artificial illumination. It is a delight for the eyes, while the familiar words of the office delight and comfort the heart. Autumn and harvest festival bring for Southwold the harvest of the sea, the fish that provide a livelihood and the lives that are risked and saved. In the church fishing nets drape the screen; a trawl net is suspended over the heads of the congregation. Who can fail to be moved at that service, as the lifeboatmen wearing their simple navy blue jerseys bear bundles of rolled-up nets to be laid on the altar? There is thanksgiving indeed, and the eternal prayer for those in peril on the sea.

The long tide of Sundays after Trinity ends with winter's approach, and with memories of the beloved dead: All Saints', All Souls' and Remembrance Sunday prompt us to face our own mortality while remembering the deaths of others. The town flows to fill the church for an ecumenical service. The war memorial is wreathed with poppies and traditional respect is paid. Each heart will have its own roll call.

Many who lived here in Southwold served this town and church faithfully and well. Their heritage has now passed into present hands; it is our responsibility and our right to defend it. One memory remains, of a grief which was shared by the whole town and which cast a pall over Advent one year. Two white coffins stood in the nave before the screen; two devoted and devout sisters had been killed together in a traffic accident. All their lives they had known and been loved by the people of the town, and men, women, and children wept at their passing—children for whose care and true nurture they had done so much.

Deo gratias for all who love and strive to keep St Edmund's Church as its creators intended, a glory to God.

NOTE: The guidebook to St Edmund's, Southwold, written by the late Alan Bottomley, M.A., historian and headmaster of Eversley School, was published in 1991. It is available in the church and is commended to all, inhabitants and visitors alike.

Southwold Hospital

BARBARA DAVIS

✧

At a meeting held by the mayor on 20 April 1897 it was decided that, to commemorate the Diamond Jubilee of Queen Victoria, a cottage hospital should be established. An influential committee was formed to act with the mayor on this project.

In July of that year it was proposed to open a Home for the nurses working for the Nursing Benefit Association in the Southwold district. A house was taken on St Edmund's Green which as well as providing accommodation for two nurses also had two rooms where patients could be nursed for a small weekly payment. The committee appealed for donations and annual subscriptions, with any surplus to be put as a deposit towards either building or purchasing a house as a permanent Jubilee Memorial in the future.

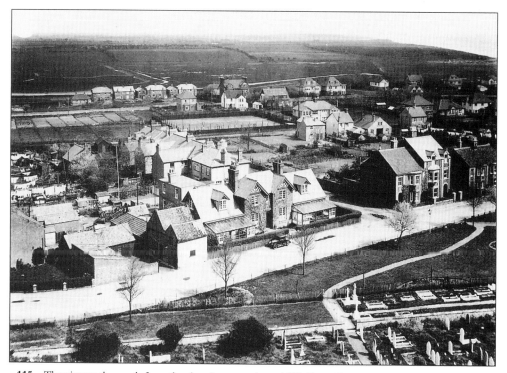

115 The view to the north from the church tower taken c.1930. Town Farm can be seen to the left of the Hospital.

The Home was duly opened in August, and many annual subscriptions had already been received. It had two two-bedded wards, and according to records looked most attractive. After three years and many fund-raising events, the committee felt that the Home had more than proved its usefulness to the community but that the present building, which was rented from Southwold Corporation, was not suitable for a hospital. The committee therefore felt justified in making a strong appeal to raise funds to build a hospital on ground which had already been purchased.

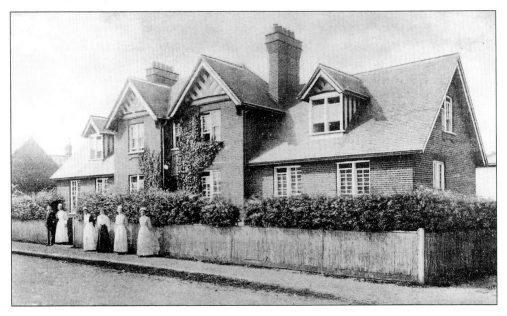

116 Southwold Hospital and staff around 1910.

On Friday 28 June 1901 the Countess of Stradbroke laid the foundation stone. The hospital was to consist of two wards for four patients and two single wards, together with the necessary accommodation for nurses, etc.

On 11 April 1903 the Southwold Cottage Hospital was decorated from end to end with flags suspended on poles, ready to be officially opened by the Bishop of Ipswich after the Corporation, Ambulance Corps, National Schools and members of the Friendly Societies had marched to the band of the 1st NVA for a service in St Edmund's Church.

By May 1904 it was reported that the balance sheet showed the committee was able to pay off the money borrowed for the building—a great achievement in so short a time. It was also felt that operations could be performed at the hospital, and an operating room was built.

After the Second World War the hospital was taken over by the NHS, and initially was part of the Norwich group of hospitals. Later, owing to changes in boundaries, it was linked with Ipswich, and then in 1974 another change took place and it became part of the Great Yarmouth and Waveney Health Authority.

In 1991 the Priority Health Services of Great Yarmouth and District Health Authority applied for and achieved Trust Status, and Southwold Hospital became an integral part of Anglian Harbours NHS Trust. Another change took place in 1997 when Anglian Harbours Trust was dissolved and Southwold Hospital was taken over by the Allington NHS Trust.

Throughout the past 50 years there have not only been many changes in the structure of the NHS and the management of the hospital, but also changes to both the fabric of the building and the services which are provided. In 1982 an extension was built with monies from a legacy and donations from the League of Friends to provide a physiotherapy department and out-patient clinic facilities. Then in 1987 the occupational therapy department was built with donations from the League of Friends, and in 1989 the west wing was renovated to provide a new administration office, treatment room and a quiet room/relatives room, once again funded by legacies and the League of Friends.

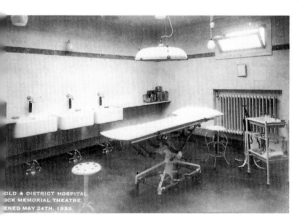

117 The Mullock Memorial Operating Theatre, opened on 24 May 1933.

Further changes are planned: to develop three single-bedded rooms to replace a three-bedded ward; to build a shower room; to create a reception area at the entrance of the hospital, and to develop office and meeting room accommodation. These changes are being progressed once again with the financial support of the local community, with completion planned for late 1998.

At the present time the hospital includes 17 in-patient beds, with medical care provided by GPs from Kessingland and Southwold, out-patient clinics, a 24-hour minor injuries unit, and a base for community staff. The hospital works closely with community care staff, social services and many voluntary groups.

There have been changes over the years. Southwold Hospital has changed and developed, and will continue to do so, with the support of the local community to meet the needs of the local population.

Southwold At War

✧

It perhaps comes as something of a surprise to the casual observer to find this chapter in the book. In fact over the centuries Southwold has found itself in the front line on a number of occasions, and while every small town in Britain has tales to tell of Nordic invaders, medieval skirmishes with neighbouring settlements and bombardments during the wars of the present century, Southwold's involvement has been greater than most. Its position near the mouth of one of East Anglia's unpredictable rivers and its location at just about the most easterly point of the British Isles, making it among other things the closest landfall to the Dutch coast 100 miles east-south-east, has ensured that.

118 Drawing, *c*.1790, artist unknown, of South Green and Gun Hill. 'There was an earthwork in front of the guns whose muzzles pointed over it. The shot was piled up near. The Powder Magazine stood on The Common near Skilman's Hill. There were also two guns on New York Cliff, and two 4lb guns on Kilcock Cliff near the present Coast Guard Station.' (D.R. Gooding, 1900)

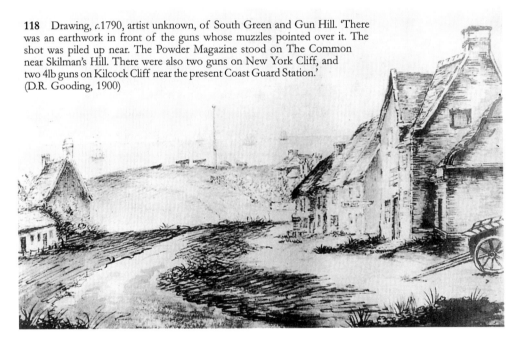

Disputes in the Middle Ages
RACHEL LAWRENCE

There were endless wrangles with Dunwich over nearly three centuries. The root cause was the shifting mouth of the River Blyth as its outlets to the sea moved away from Dunwich and each time closer to Walberswick and Southwold, often with active encouragement by

the men of these two towns. Dunwich attempted with dwindling success to keep a realistic entrance to its harbour and to preserve its once great market. At the same time it obstinately reiterated its right to dues from shipping on the Blyth until nearly the end of the 15th century. The arguments were conducted in a typical medieval way, by lawsuits and by petitions to various kings interspersed with considerable resort to violent action. Walberswick, certainly in the earlier years, was much more involved than Southwold, although doubtless Southwold men aided and abetted their neighbours.

In 1231 Sir Hugh de Cressy, Lord of Blythburgh and Walberswick, called a meeting at Westleton with the justices, Dunwich Corporation and lawyers for Gilbert de Clare, Earl of Gloucester and Lord of the Manor of Southwold, to settle the rights and liberties of each. It was agreed that the estuary south of Dingle, with the haven, belonged to Dunwich which could charge each ship anchoring 4d.; the rest came under Blythburgh. Ships for Blythburgh and Southwold using the haven could not be taxed. Most unfortunately, this document was mislaid by the lords of Blythburgh.

In 1286 the sea broke through to the north of Dunwich and provided Southwold, Blythburgh and Walberswick with a natural haven. Dunwich men blocked this entry up at enormous expense, causing great hatred. In 1299 the ships of the Earl of Gloucester, then serving with Edward I in the Scottish wars, were attacked and sunk in his harbour of Southwold, and his merchants were prevented from putting into port. It may have been some of the many pirates who infested the coast at that time who caused this trouble, but the men of Dunwich were blamed. Early in the 14th century men from Walberswick and Southwold reopened the harbour entrance which Dunwich men had blocked in 1286, and impeded the watercourse to Dunwich. The men of Dunwich kept petitioning the king to help them—petitioning and protesting, but not fighting.

In 1328 a great storm blocked the haven at Dunwich and destroyed the town as a port. The Blyth now flowed into the sea two miles from the town. Sir Edmund Clavering, Lord of Blythburgh and Walberswick, had a palisade of timber erected and guarded it with armed men so that boats dared not go to Dunwich, but unloaded at Walberswick. He then made a fierce attack on the Dunwich tollhouse, burned it down, killed the bailiff who had been assigned to collect dues, and took away boats, horses and oxen. Three years later Dunwich at last took action. Its men attacked a Walberswick boat off Southwold, and murdered its crew of sixteen. Dunwich and Blythburgh were now on such bad terms that Edward III complained of almost daily 'assemblies of men at arms, burnings, homicides, robberies, etc. between the men of Dunwich on the one part and John and Edmund Clavering on the other'. Southwold seems to have become more actively involved in disputes at this time. Dunwich merchants tried to put Southwold market out of business, but in 1371 they were ordered to leave it alone. Twenty years later the king ordered the shipmen of Southwold to pay their rightful dues to Dunwich. Dunwich then petitioned Parliament against the

fairs and markets held at Southwold, and in 1398 attacked the port of Southwold in force, but to no avail. In 1488-9 Dunwich was still claiming 6s. 8d. a year from every large ship coming up to Southwold, with lesser rates for smaller boats; and 4d. a year for anchorage in the haven. It was largely to remedy this that Southwold was now granted its Charter under which it became a Town Corporate and was freed from tribute to its rival.

The endless disputes with Dunwich can hardly be regarded as a war, but there was a prolonged state of hostility which gave rise to some warlike incidents. Walberswick, particularly in the earlier years, was much more involved than Southwold because of their geographical position, and because the lords of the manor of Blythburgh and Walberswick were on the spot. They were ready to give a lead, and were themselves aggressive. The de Clares, lords of the manor of Southwold, in contrast were absentee landlords and their successors even more so.

* * *

Southwold had a strongly Puritan background, as had most of East Anglia. During the Civil War, however, this did not spare it from the worst excesses of the Roundheads, and Dowsing's visitation of the town in 1643 left St Edmund's Church bereft of much of the decoration that graced it.

Later in the same century, in March 1672, war broke out between England and the Dutch Republic. The combined English and French fleet, numbering 71 warships, moved round the East Coast, putting in at Sole Bay to take on provisions and water. The Duke of York and the Earl of Sandwich established their headquarters in Sutherland House in the High Street, one of the few buildings in the town which survived the great fire of 1659.

Early in the morning of 28 May the Dutch fleet, 61 warships, was sighted heading towards the coast. Battle was inevitable. The Earl of Sandwich, in his flagship Royal James, *led his squadron towards the Dutch. The Duke of York in* Prince *followed with his squadron. Both squadrons were soon engaged in battle. The French fleet under the command of Admiral D'Estrees sailed southwards due to a misunderstanding of orders. The Dutch Admiral de Ruyter dispatched Admiral Banckers and 20 ships against the French. Sandwich was heavily attacked and surrounded by Dutch ships, and by midday a Dutch fireship had set* Royal James *on fire. Sandwich either died on board* Royal James, *or drowned in an attempt to transfer to another ship. His body was picked up several days later, identified by the Star of the Garter which he was wearing.*

The Duke of York transferred his flag to St Michael *because* Prince *was badly damaged. The* St Michael *also became disabled, and the Duke was once again forced to transfer to another ship, this time* London.

Watchers on the cliffs at Southwold would have seen little of the battle as it raged nine to 12 miles out to sea, and the clouds of smoke from burning fireships would have obscured much of the action. The battle continued all day, but by 9 p.m. the Dutch were beginning to withdraw. The following day saw the fleets preparing to resume battle. However, thick fog prevented any further fighting. The Dutch returned

home and the Allies to Sole Bay. The cost of the battle could now be calculated. The Dutch had lost two ships and about 1,800 men. The English had also lost two ships, and the combined loss of English and French men was around 2,000.

The battle was inconclusive, with no side gaining a complete victory—although both sides claimed it.

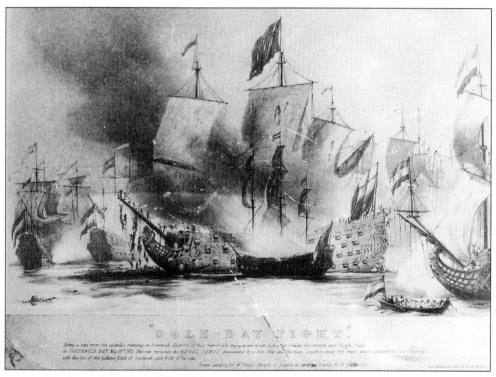

119 Engraving, 'The Sole Bay Fight' from *Southwold, and its Vicinity* by Robert Wake, 1839.

The Twentieth Century
GEORGE BUMSTEAD

World War One

Southwold's situation on the coast meant a closer involvement with the realities of war than was experienced by much of the country. Miss G.E. Daniel, who had been a housemistress at Saint Felix School, wrote:

> One event of general interest took place in the first term of the War, which seems worthy of note. Soon after the fall of Antwerp we were surprised to

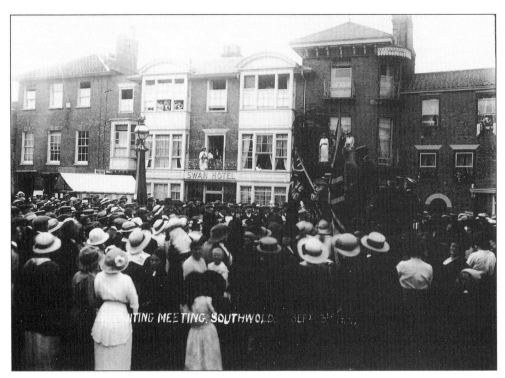

120 Recruiting, Market Place, 3 September 1914.

121 Recruits at the station, 7 September 1914.

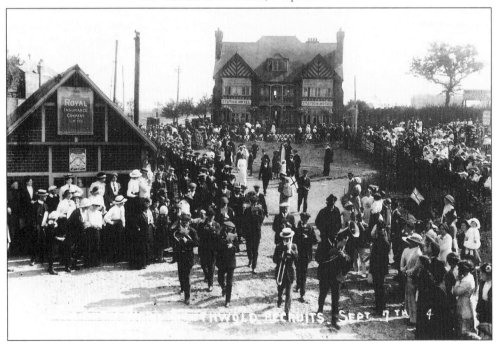

hear one afternoon that Belgian refugees were arriving in open fishing-boats from Ostend. I received a telephone message asking us to come down to Southwold and help. I asked whether food was wanted and, hearing that it was, I commandeered the cans of the milkman who was at the door and put into them the pea soup and curry which was ready for the girls' supper. Fortunately I had in the house waiting for the carrier a large bundle of clothes collected by the staff for Belgian refugees in London. This was quickly put on a wheelbarrow and taken down to Mrs Foster's cottage (in Park Lane), where a family of six had already been taken. The party consisted of four women and two men. They had spent an enormous sum to charter a boat to bring them across, but of course it afforded them no protection from the spray, and they were all drenched to the skin. Some of the women seemed unable to think of anything but their deserted homes, where they had been obliged to leave so many things precious to them. 'My linen chest, my linen chest!' was a cry which echoed in my ears as I went home to a warm and comfortable house.

On 25 January 1917, Southwold was bombarded from the sea. The official German version states that:

> On the evening of 25th January 1917, the VI Flotilla with the I Destroyer Half Flotilla (without the V.68), the S.51 and S.60 left for an enterprise in the direction of Southwold. As well as attacking merchant shipping, the English coast and patrol craft were to be bombarded.
>
> The bombardment of Southwold was carried out at midnight according to plan, at a range of 5,000 metres, and 92 rounds were fired. The town was easily recognised by lights from flares we sent over. No merchant or patrol ships were encountered.

The German Navy appreciated the limited value of such a bombardment of coastal towns, and the intention was chiefly to embarrass the enemy by making him divert forces for protection of such places.

Extracts from a private diary of 1917 give more impressions of this troubled time:

<u>8th January:</u> Hear that a Minesweeper was blown up yesterday when engaged in destroying mines a short distance from the coast. Some lives lost.
<u>19th January:</u> New weekly paper called 'Food' is coming out. Production and consumption of food are the absorbing subjects nowadays.

122 *(above)* The National Reservists leaving Southwold, 3 September 1914.

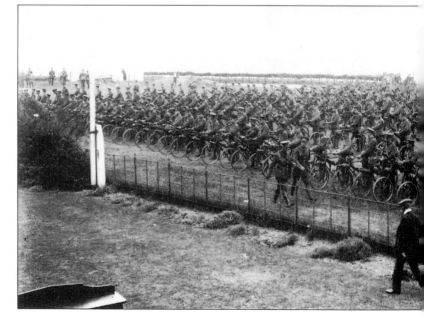

123 *(right)* The Royal Sussex leaving Southwold, 1 July 1915.

<u>23rd January:</u> Elaborate fresh instructions just issued for the guidance of the civil population, in case of a German raid.

<u>26th January:</u> At 11.15 p.m. a short bombardment from a submarine: about sixty shells were fired, mostly falling on the marshes, and as far away as Reydon and Wrentham. Three houses were struck, Balmore (on the seafront), a house on South Green (Iona Cottage) and the police station. Damage not great.

<u>28th January:</u> Berlin reported that a Torpedo Boat shelled 'the fortified' place of Southwold.

<u>29th January:</u> Newspaper statement that the population is shortly to be put on rations.

<u>2nd February:</u> Town Council to ask Admiralty 'to keep an eye on the safety of Southwold'.

<u>20th February:</u> Ship sunk about half a mile off here. Only two masts visible.

<u>22nd February:</u> Two guns arrived in Southwold, and are now in the Sandpit.

<u>27th February:</u> Capture of Kut announced.

<u>12th March:</u> News of capture of Baghdad: we hoisted our flag.

<u>16th March:</u> Astonishing news of revolution in Russia and abdication of the Tsar.

<u>3rd May:</u> A second detachment of Dutch people arrived by the 2 p.m. train to cross to Holland under 'safe conduct' allowed by German Government.

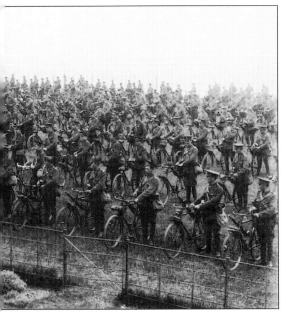

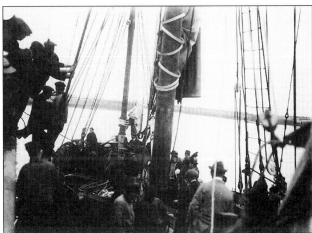

124 Belgian refugees arriving, 15 October 1914.

7th May: Mrs Gordon, by writing to some high military authority, got a letter conveyed to Lord French about the peril of Southwold in case of an invasion, and this has resulted in a footbridge being built over Buss Creek, to be approached by the footbridge over the railway, then up Shepherd's Lane, by Saint Felix School, into the main road.

12th May: A number of Dutch and Belgians arrived by morning train, to cross to Holland.

[The transport of Belgian and Dutch nationals from Southwold Harbour was carried on for weeks by arrangement with the German Emperor. The parties arrived by train under police supervision, and were escorted across The Common to the harbour where boats took them across to a ship anchored outside. Southwold was the only 'port' from which safe conduct was promised.]

17th June: Zeppelin brought down at Theberton.

1st July: A camp of about twenty five tents is being erected on The Common.

12th August: About 5.45 p.m. the church bells 'jangled', indicating an air raid somewhere near. The 'danger off' signal came about an hour later.

9th September: Bells jangled.

29th September: Air raids almost every day this week, but electric light has not been put out once.

21st October: Four or five Zeppelins brought down in France.

17th November: Rumours that we may have no electric light this winter. Am buying a case of candles. Paraffin can hardly be got now.

The three houses struck by shelling referred to in the entry dated 26 January were Balmore in North Parade; Iona Cottage on Constitution Hill, and the police station, which at this time was situated on the high ground at the end of Station Road, and is now a block of flats. There is a story about Balmore, which may or may not be true: during the bombardment the occupant was bending over tying a shoelace in his bedroom, when a shell entered the house by the front window, passed over him, and then made its exit through a back window. There is no record of its final resting place.

The entry of 7 May explains how the Gordon Bridge across Buss Creek got its name. The footbridge over the railway cutting was for golfers, for at the time the golf course had 18 holes; it was demolished many years ago. It is now possible to gain access to the Halesworth Road via a footpath, flanked on one side by Saint Felix School grounds and on the other by Lakeside Park. Shepherd's Lane must be the lane which divides Saint Felix School grounds.

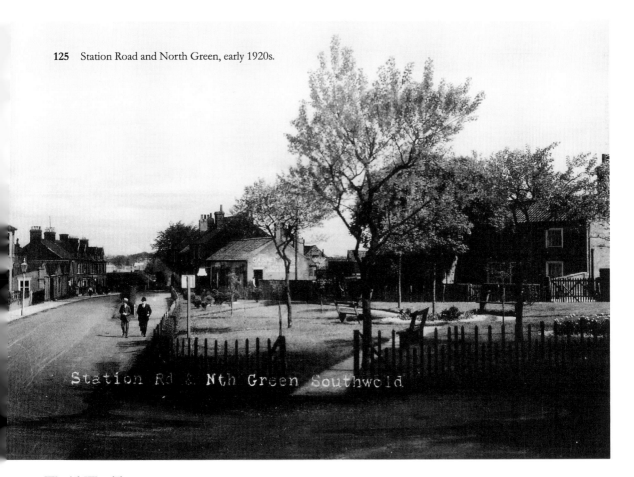

125 Station Road and North Green, early 1920s.

World War Two

For most of the 1939-45 war Southwold was very much a front line town. Anti-invasion precautions could be seen at every turn: the entire seafront and as far as the eye could see to the north and south was a mass of barbed wire, steel scaffolding spikes set in concrete, and land mines buried in the sand. This was considered to be an adequate defence against landing craft. Fortunately, it never had to be put to the test.

Even the beach huts played their part, scattered as they were all over The Common to deter enemy aircraft from attempting to land. A boom was fixed across the harbour mouth consisting of a series of sharp iron spikes attached to a strong steel cable.

At the northern end of the town, the Royal Engineers blew a hole in the Pier, which so weakened the structure that it has now almost completely disappeared. Winston Churchill, with a world war resting on his shoulders, came to Southwold to inspect the defences and was apparently satisfied with what he saw.

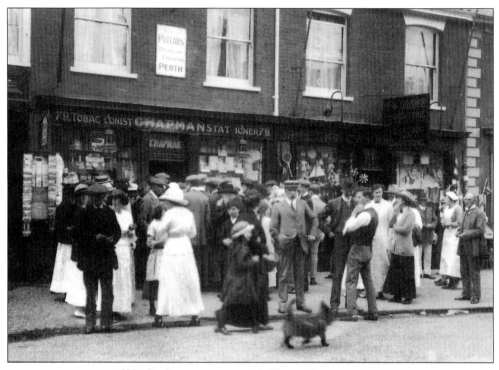

126 Reading war news outside Chapman's newsagents.

All men and women of military age were conscripted into some form of war service, only people working in essential services and those over a certain age were left behind to keep the place ticking over. When the threat of invasion was at its height, there were probably fewer than 500 people left in the town.

'Essential services' were the fire brigade, the first aid and ambulance services, special constables, air-raid wardens, the Observer Corps and the Home Guard. On the sounding of the air-raid alert most of these people had to drop everything and report to their respective stations. The air-raid wardens had the unenviable duty of doing night patrols: showing a chink of light through the blackout curtains was a serious offence.

Sometimes the chilling sound of the air-raid siren would cut through the air first thing in the morning, and people didn't know whether to dive for their shelters or get on with their lives. They would greet each other in the street by asking if the warning was still on, as they couldn't remember hearing the All Clear.

In terms of human misery, the breaking up of families was probably the most traumatic experience of life at this time; husbands were separated from wives, children from parents. Imagine a nine-year-old child with his gas mask on a piece of string, clutching a small suitcase containing all his belongings and with a label for identification

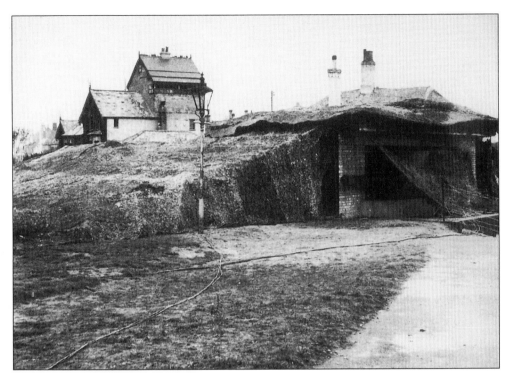

127 World War II gun position at White Lodge, Southwold. Extracts from Fort Record Book WO 192/79 at the Public Record Office, Kew: 438 Battery 547 Coast Regiment, Royal Artillery: two 6" naval guns Mark XI, range 13,000 yards, made by Vickers Son & Maxim in 1906. 13.12.1940: Site inspected. 3.6.1941: Officer Commanding 547 Coast Regiment decided on site. 16.6.1941: Camouflage erected. 2.10.1941: Site occupied. Brickwork believed to have been carried out by Field of Southwold. 28.10.1941: Three rounds per gun practice fired. 28 South Green: Battery Office and Stores. 30 South Green: Battery Observation Post – extra storey built above second floor for Observation Post. Gun Hill Cottage: Sergeants Mess. Windy Peak: Officers Mess. Battery Offices closed May 1944; one officer and seven other ranks remained. January 1945: two other ranks left. November 1945: guns taken away for scrap.

purposes attached to his overcoat, boarding the train on his evacuation to the Midlands, to be billeted with complete strangers. Maybe he felt he was embarking on a great adventure—let's hope so.

Food, tea, soap, clothing, sweets and petrol were all rationed. Every civilian was supplied with a gas mask; even newly born babies were provided with something that looked like a present-day life-support machine. If there was one good thing in this horrific war it was that neither side resorted to the use of gas.

This tiny and unimportant community—unimportant, that is, from the strategic point of view—paid a very high price: 13 killed, 49 injured, 2,299 properties damaged and 77 properties destroyed. Towards the end of the war there were times when the sky was full of sound, when wave after wave of American Fortresses went out by day and RAF

Lancasters by night; then there were times of absolute silence, more frightening than the noise. The most anyone could hope and pray for was a good night's sleep.

People have often asked the reason for bombing an insignificant spot like Southwold. I believe, though I have no evidence to support my theory, that the German aircrew's real targets were the RAF Air-Sea Rescue unit and the Naval minesweeper base at Lowestoft. Lowestoft was protected from low-flying aircraft by a balloon barrage which forced enemy aircraft higher and brought them into range of the anti-aircraft guns, and also reduced the accuracy of their bombing. Southwold was unfortunately the next door neighbour, with no balloons.

Some time ago Mrs. Barbara Challener of Reydon, in the process of clearing out a drawer, found a crumpled typewritten authority from her husband's Commanding Officer, dated 13 June 1940, telling him exactly when to blow up Mights Bridge. John Challener's first visit to Southwold was in 1940 as a Second Lieutenant in the South Lancashire Regiment. In a letter home to his parents in Lancashire, John speaks of life as it was in Southwold at this time:

> Thank the Lord we soon shall have finished most of our digging and may then rest until the Jerries arrive, and the Army certainly expects them to do so. They are spending piles of money fortifying Southwold and anything we ask for comes up at once.
>
> The pier is mined and the promenade covered with wire—my platoon is about a mile inland and has four separate positions to take up should they arrive from north, east, south or west—that meant digging four sets of eight weapon pits and building five road blocks. My headquarters will be in one of these, an old pill box from the last war.
>
> I am having a lot of trouble from the local inhabitants—farmers for digging their fields, carters for pinching their lorries, chalet owners for moving their huts, and scores of people I have sent to the police station for not carrying identity cards when crossing my road blocks at night. I may be lynched if Hitler fails to arrive.

In spite of all this, John fell in love with the place and determined one day to return. Some forty years later he came back as a retired headmaster to live in Reydon with his wife, whom he had met and fallen in love with during his wartime tour of duty in the area.

His orders concerning Mights Bridge ran thus:

SECRET

ORDERS FOR DEMOLITION OF SOUTHWOLD BRIDGE

To: 2/Lieut Challener
2/4 S. Lan. R.

You are authorised to order the destruction of Southwold Bridge. The demolition party consists of 1 R.E. and 3 O.R.s 2/4 S. Lan. R. You are responsible for ordering the destruction of Southwold Bridge when it is in danger of being captured by the enemy.

As a guide to making your decision it will be assumed that if: (a) The enemy gains possession of Warren North of pier or parachutists arrive on high ground North or North West of the Bridge making for the Bridge, or (b) If enemy lands on Southwold Beach and are gaining a footing in the town, the Bridge is in danger of being captured.

<div align="right">

N Proctor
Lt-Col. COMDG 2/4 Lan. R.

</div>

Bulcamp
13.6.40
FS

<div align="center">* * *</div>

An old friend of the editors was stationed at Saint Felix School for about six months in 1941-2 while serving as Regimental Signal Officer with the 1st Battalion Hertfordshire Regiment. Its task was to prevent the Germans landing, to which end a 24-hour watch was maintained covering the sea approaches and also on the landward side to protect the town from any flanking movement from landings beyond the range of their seafront Observation Post. In the low-lying ground behind the school there were four disused air-raid shelters which had been filled with ammunition. These, he says, they were to guard with their lives.

A group of WRNS was stationed at the time in a house on Gun Hill. Our friend never discovered exactly what they were in Southwold to do, but it was obviously hush-hush and he has since assumed it was to do with the experimental radar installations further down the coast. One evening he and a fellow officer were entertaining two WRNS to drinks in The Swan bar. One of the WRNS looked at the time and said she must go or she would be late on watch. 'On watch? What are you going to see?' said someone, and our friend, quoting a popular song of the time, sang 'They're off to see the Wizard, the wonderful Wizard of Oz!' Chaos broke out immediately, and within a matter of hours our friend found himself up against

the Senior Naval Officer of the region in Harwich, who had great difficulty in believing that one of the WRNS had not inadvertently let slip that 'Wizard of Oz' was in fact the code name of their secret operation.

* * *

Brian Burrage, a former Mayor of Southwold, recounts the following tale:

The 15th May 1943 was a Saturday, and Saturday was bath night. The zinc bath was brought into the kitchen from the shed, the copper filled and lit and I, being the youngest in the house, was first in. My two older brothers followed me, then we were put to bed.

It was just before 10 pm and still quite light. We had double summer time in operation. Suddenly German planes roared low over the town, machine-gunning as they went. We three boys were out of bed and looking at the tracer bullets through the window. Our Dad came rushing into the bedroom and practically threw us down the stairs and then under the Morrison shelter. This was a steel table with wire mesh on the sides, and did in fact act as our table in the living room. Our Mum was under the shelter with nothing but a towel wrapped round her. She had been next in the bath and had obviously left it in rather a hurry.

The German planes, having strafed the town, then carried out a bombing run. One bomb aimed at the Water Tower skidded where the Sports Pavilion now stands, then went through the roof of 47 High Street, skidded on Bartholomew Green and then hit the front door of a house four doors away from 15 Bartholomew Green where we lived. Here it decided to explode. At the same time another bomb exploded on Hollyhock Square, which was immediately behind our house. All our ceilings came crashing down, doors were blown off and the entire window and frame was blown into the room. It was the most frightening moment of my life. I clearly remember that as the window was blown in my dog Peter, who lived in a kennel in the back yard, came in with it and shot under the shelter with us. Whether he was blown in or jumped I don't know.

Six people were killed by those two bombs: one of them was my best friend.

As far as bath night was concerned, when we emerged from the ruins of our house we were all absolutely covered with muck and debris, but at least we were alive. We spent the night in 'Mobbs' Mayhew's house in Victoria Street, then were placed in a house in Reydon till ours was repaired.

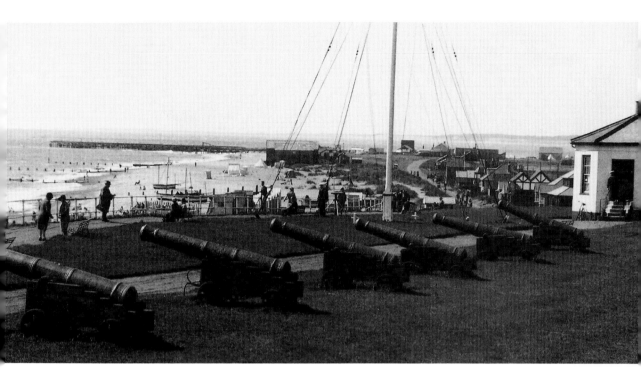

As the Cold War has gradually given way to something approaching peace, reminders of Southwold's front line status are still served up regularly by the heavy throb of low-flying Hercules from Lyneham in Wiltshire at night, or the earsplitting screech of Tornados from RAF Brüggen in Germany as they fly, it seems, down the High Street and perform hand-brake turns over the North Sea during the day. And when, as with the celebrations to mark the 50th anniversary of VE Day, there is a major flypast in London, military aircraft old and new gather over the sea off Southwold before making their way inland to ensure a perfectly timed arrival at The Mall, 100 miles away.

Visiting and Resident Artists, 1820-1960

RICHARD SCOTT

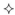

The Blyth estuary has exerted a strong pull on artists since the beginning of the 19th century. A zenith was reached in 1885 and 1886, when a large number of painters and etchers—many on the threshold of distinguished careers—spent their summers in Southwold or Walberswick, swelling the ranks of the more 'establishment' artists already working there.

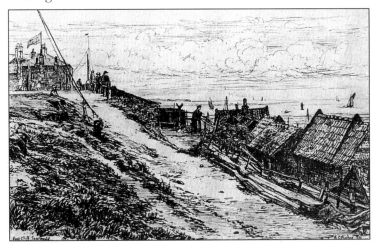

129 Etching by Dr. A. Evershed, 1881: East Cliff

Long before the 1880s influx, several artists of note worked in Southwold. One of the first was William Daniell, RA (1769-1837). Over a period of several years Daniell completed a body of work during what he called his 'Voyage Round Great Britain'. In 1822, the year of his Royal Academy election, he reached Southwold and produced an engraving of a small craft battling through the heaving waters of the river mouth. The scene is drawn from the Walberswick jetty, with Southwold, complete with contemporary windmills, in the background.

The prolific topographical artist Henry Davy (1793-1865) lived in Southwold in the 1820s. During this time he compiled a substantial collection of work which depicted, in meticulous detail, the major country houses of Suffolk, together with 136 of its churches. This work was published in two volumes of etchings in the 1830s, by which time the artist had moved to Ipswich. The etchings have proved to be an invaluable source of information for historians.

During the third quarter of the 19th century the most significant artist to work in and around Southwold was undoubtedly Charles Keene (1823-91). Principally remembered as a humorous illustrator for *Punch*, which then only employed the very best of draughtsmen, he was also held in the highest regard by his contemporaries as an artist in the more general sense. We learn from Derek Hudson's 1947 biography, for instance, that Whistler regarded him as 'the greatest English artist since Hogarth', while Sickert—a devoted champion—opined that he had been a greater influence on Monet and Sisley than had Constable. Others to express similar levels of respect included Degas, Pissarro and Tonks. Keene's subjects were quite diverse but much of his Suffolk work centred around the Blyth and its associated buildings and paraphernalia. In his pen drawings he worked searchingly in front of the subject, with his ink-bottle wired to a waistcoat button. Among the work later developed into etchings was a study, *c.*1868, of the legendary Ferryman Todd. The centenary of the artist's death was marked in 1991 with a major exhibition at Christie's in London, and in Ipswich, his birthplace, with exhibitions at Christchurch Mansion and at Ipswich School, where he had been educated.

Keene's visits to the Suffolk coast were usually made in the company of the distinguished etcher Edwin Edwards (1823-79), who latterly had a house in Dunwich, and Henry Stacy Marks, RA (1829-98), whose paintings, while beautifully executed in the best traditions of the time, were often imbued with a quirky humour. This was reflected in some of his RA exhibition titles: *Experimental Gunnery in the Middle Ages* and *An Amateur Taxidermist* are two examples which convey the general spirit, and explain to an extent why he and Keene were drawn to each other.

Another etcher to work in Southwold in the 1860s was the Ipswich-based artist Henry B. Hagreen. Photographs of some of his Southwold etchings survive in the Gooding Collection at the Town Hall; they reveal strong qualities of draughtsmanship.

Several Irish painters were to visit the area in the 1870s and 1880s. Prominent among these were Edwin Hayes, RHA (1819-1904) and Walter Osborne, RHA (1859-1903). Hayes was a prolific and widely-travelled coastal and marine artist, whose fine painting of the mouth of the Blyth—*Over the Bar, Southwold*—was hung at the RA in 1887.

Osborne's work, full of atmospheric resonance yet underpinned with superb draughtsmanship, doubtless owes much to his rigorous early training at the Royal Hibernian Academy Schools and at Antwerp Academy. His most celebrated Southwold work was *An October Morning*, painted on the north bank of the river during his second stay in Walberswick in 1885. This superb painting hangs in the Guildhall Gallery in London, and was shown at the 'Impressionism in Britain' exhibition at The Barbican in 1995.

By the mid-1880s access to Southwold had been greatly eased by the opening in 1879 of the narrow gauge rail link from Halesworth. Prominent among the artists to make early use of this facility was Philip Wilson Steer (1860-1942) who made his first visit in 1884 and returned with various young contemporaries every summer until 1889. After a painting

visit to Swanage in 1890 he came back to Suffolk in the early 1890s, making a final visit in 1906 with the Yorkshire painter Mark Senior (1864-1927) who was more usually to be found at this period painting at Runswick Bay, near Scarborough.

Although Steer and several of his fellow-artists stayed in Walberswick, the river was no boundary and several of them worked also on the Southwold side. Steer's paintings of Southwold beach are well known and much reproduced, and the painting which is arguably his best known work of the area—*Walberswick: Children Paddling*, which hangs in the Fitzwilliam Museum in Cambridge—shows children on the Southwold bank, close to the landing point for the ferry.

Two of Steer's companions particularly linked with Southwold were Frederick Brown (1851-1941) and Walter Sickert (1860-1942). Brown, who was teaching at Westminster School of Art at the time of his Suffolk visit in 1888, exhibited the resulting work (with Steer's) at the London Impressionists exhibition the following year. A painting with the title *Whin Hill, Southwold*, attributed to Brown, hangs in the permanent collection at Ipswich Museum and Galleries.

Walter Sickert made a fleeting visit to the area with Steer in an informal teaching capacity *c.*1893. This has gone unrecorded by biographers, but is remembered by the painter Clare Atwood (1866-1962) in a letter to Margaret Thomas around 1959: she remembered with pleasure the two artists' inspiration and helpfulness. Better documented was Sickert's visit to Southwold in 1927, when he came to Saint Felix School as a guest speaker. The school bought one of his paintings, which remained in their ownership until 1974.

The Oulton Broad-based painter Thomas Goodall (*c.*1857-1944) and the pioneer photographer Peter Emerson (1856-1936) both worked in the area in the late 1880s. They were inspired by the mood and atmosphere of Broadland subjects, and the work of both was represented in 'Impressionism in Britain' in 1995. Emerson had a house in Southwold for a period from 1885.

Several of the artists associated with the artist colony at Newlyn in Cornwall in the 1880s and 1890s were to spend shorter periods of time in or near Southwold. Fred Hall (1860-1948), mainly a landscape painter but known at Newlyn as a gifted caricaturist, stayed in Southwold in 1885, while Walter Langley (1852-1922), the subject of a major touring exhibition in 1998, made two visits to the Southwold area, in 1891 and 1892. Several watercolours by Langley with Southwold and Walberswick titles were shown at the Fine Art Society in 1893.

Other eminent Victorian watercolourists who spent time in the town at this period included Walter Crane (1845-1915) and Myles Birket Foster (1825-99). Crane came on a working holiday in 1886, and at least two of his paintings of the ferry area survive in private collections in Suffolk. Foster exhibited Southwold work in London in 1895, suggesting a visit a year or two earlier. It seems quite possible that his interest in Southwold might have been kindled by Charles Keene, who had been a close friend.

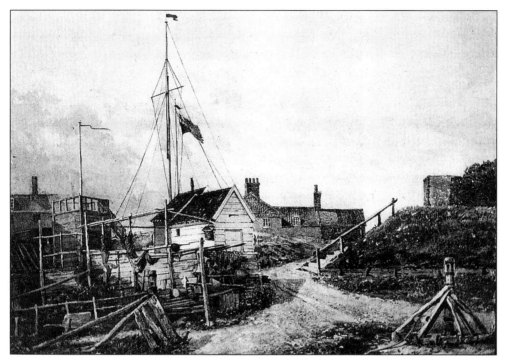

130 Watercolour of Kilcock Cliff by H.B. Hagreen, *c*.1860, showing the site of the two-gun battery (left), Haines Score (centre) and the coastguard station (right).

Etchers were particularly numerous in the 1890s, and several of the visiting painters etched as well. A practitioner of this exacting craft who worked around the Blyth was Theodore Dalgleish (1855-1941) who had studied at the Slade under Alphonse Legros and Edward Poynter. One of his local etchings, together with one by Keene, had appeared in *The Etcher* in 1881 accompanied by the gloomy prediction that the opening of the Southwold Railway would sound the death-knell of the Blyth estuary as a haven for artists.

The artist influx continued unabated into the Edwardian era. Shortly after the turn of the century several of these visitors were to reach a wide public through the medium of picture postcards, mostly published by Faulkner, Tuck or Hartmann and printed to very high standards in Germany. Those most involved in this new outlet were Frank Emanuel (1865-1948), H. Sylvester Stannard (1870-1951) and Lilian Stannard (1877-1944), Sylvester's sister. Emanuel had been an award-winning student at the Slade before continuing his studies at L'Académie Julian in Paris; later, he was to teach etching for 12 years at the Central School of Art and is remembered as a critic with strongly anti-modernist views. The Bedfordshire-based Stannards were among the most prolific and successful painters of landscape, village scenes and gardens of their time.

Much has been written about the Suffolk visits of Charles Rennie Mackintosh (1868-1928), especially his productive but troubled stay in Walberswick in 1914-15. The well-known and much-reproduced flower drawings occupied much of his time, and were intended for a book which was never published. He also produced some topographical drawings and watercolours, including a study of Blackshore seen from across the river with the town in the background. There is evidence, too, of a much earlier visit: sketchbook drawings of Southwold and Blythburgh church details, and of Halesworth street furniture, indicate that he was in the area in 1897.

A number of fine paintings hang in the Council Chamber of Southwold Town Hall. These include several mayoral portraits, the earliest being of John Eustace Grubbe painted in 1891 by his sixth son, Lawrence Carrington Grubbe, a highly regarded local artist of his time. Others include a later one by Sir John Seymour Lucas, RA (1849-1927), who had a studio in Blythburgh and is mainly remembered for his historical and battle scenes, and one by John Kenneth Green, who had a house in Southwold in the 1920s and made many sensitive and searching drawings of local people.

Before we leave the Council Chamber, mention must be made of a splendid painting by Henry Saul. *The Proclamation*, painted in 1901, is a scene of the Market Place in which a crowd has gathered to hear formally the news of Queen Victoria's death and King Edward VII's accession.

Many Southwold residents and visitors will be familiar with the fluent and energetic work of Harry Becker (1865-1928). In his later years Becker lived a short distance inland, first at Wenhaston and later at Hinton. He was a solitary worker, though not quite as reclusive as some have suggested. His passion was the representation of a labour-intensive, unmechanised way of agricultural life which was soon to disappear forever. His keenly observed but spontaneous work seems to derive from the particular sequence of his early training. When very young he was sent to Antwerp Academy, where the training was extremely rigorous, followed by a spell in Paris with the fashionable portrait painter Carolus Duran, to whom swiftly observed and direct statements were all-important. Experienced in that order, this sequence of study could be a winning combination for a young artist of Becker's generation.

A notable contemporary of Becker was the much under-rated Allan Davidson (1873-1932). An award-winning student at the Royal Academy Schools who followed the trend of his times with further study at L'Académie Julian in Paris, he became a painter of rare sensitivity and skill. A portrait by Davidson hangs in the Sailors' Reading Room in Southwold, while several others survive in private collections locally.

During the 1920s Southwold and Walberswick were a working destination for the Gorleston-on-Sea painter Campbell Mellon (1876-1955), a prolific painter in oils, mostly of coastal subjects. His style was influenced by the work of Sir Arnesby Brown, RA, under

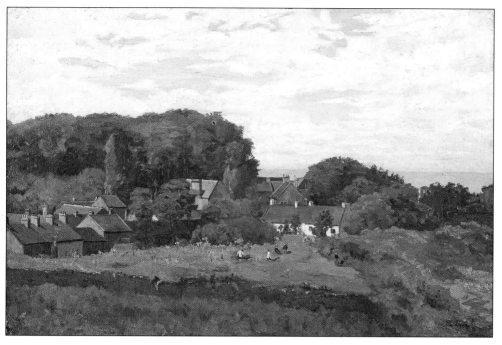

131 Frederick Brown (1841-1941), *Whin Hill, Southwold*, oil on panel, painted around 1888. (Ipswich Borough Council Museums and Galleries)

132 Allan Davidson (1873-1932), *The Orchard Path*, oil on panel, painted around 1928. (Private Collection)

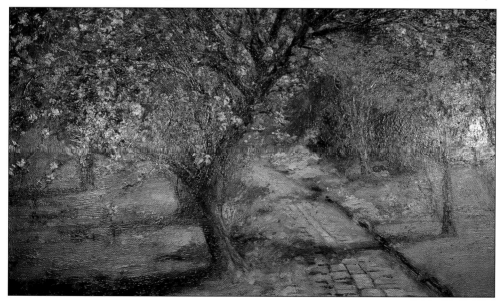

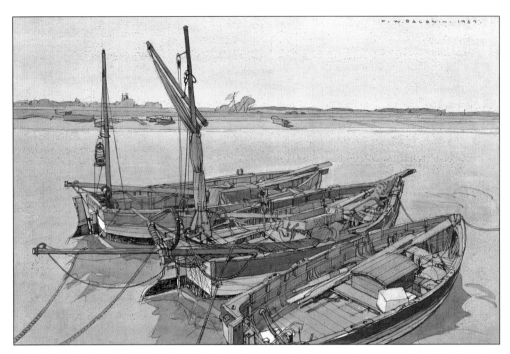

133 Frederick W. Baldwin (1899-1932), *Fishing Boats at Southwold*, watercolour, painted in 1939. (Ipswich Borough Council Museums and Galleries)

134 Philip Wilson Steer (1860-1942), *Knucklebones*, oil on canvas, painted in 1888. (Ipswich Borough Council Museums and Galleries)

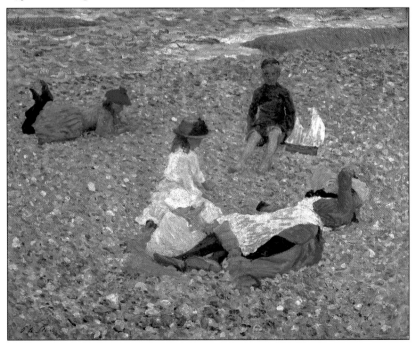

whom he had studied. Mellon's palette was generally more sombre, with liberal use of dark greys.

By the time the Southwold Railway closed in 1929 it had provided inspiration for two very different artists, William Benner (1884-1964) and Reg Carter. Splendid paintings of the railway stations by Benner hang in Southwold Museum (he was still painting prolifically in the area in the 1950s, when his tall, kit-laden bicycle was a familiar sight), while the rather mysterious Carter—a Southwold man, with a studio in Bank Alley—was responsible for the well-drawn and extremely funny postcards, still on sale, which poked fun at every aspect of the railway and its staff.

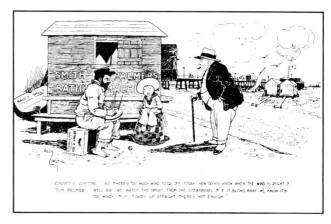

135 *(right)* Reg Carter's 'Sorrows of Southwold' series made use of well-known local personalities.

136 *(below)* The wreck of the *Idun*, 17 January 1912, painted by Reg Carter.

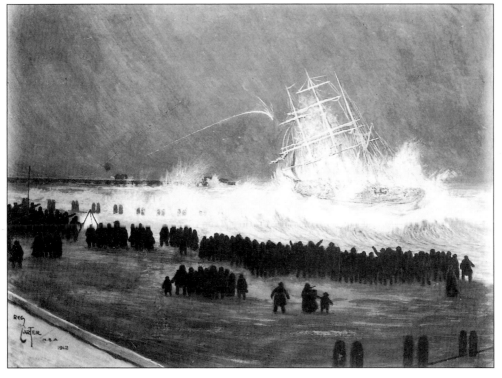

John Doman Turner (1873-1938) was a watercolourist of great originality whose work—sometimes subtle, sometimes clumsy, but always unaffectedly charming—was imbued with an odd mixture of searching honesty and almost childish naivety. A pupil of both Walter Sickert and Spencer Gore, he was a member of the influential but short-lived Camden Town Group, formed in 1911. In 1930 he painted the Southwold Scroll—a study of the eccentric shoreside dwellings of Ferry Road, then much more numerous—on a long roll of paper. The riverside buildings also depicted Turner's own summer quarters, a caravan deprived of its wheels and mounted on a solid plinth. The following year he painted a similar but more ambitious scroll of Walberswick. It is pleasing to record that after years of obscurity, and billed as 'The Forgotten Camden Towner', he was remembered in 1997 with an exhibition at the Michael Parkin Gallery in London.

While living at Old Farm, Walberswick, in the early 1930s W.F. 'Pink' Crittall (1887-1956), a gifted artist who seldom exhibited, played host to a number of extremely prominent British artists of the period. Some of these formed an exhibiting body called The Sole Bay Group, organising summer shows—'just for fun' according to Elizabeth Crittall—at the Stella Peskett Memorial Hall near Mights Bridge. Exhibitors listed in the 1933 catalogue include several Royal Academicians—Sir Arnesby Brown (1866-1955), Sir George Clausen (1852-1944), R.O. Dunlop (1894-1973) and Algernon Talmage (1871-1939). Other Sole Bay Group exhibitors included Gilbert Spencer (1892-1979), whose brother Sir Stanley Spencer, RA (1891-1959) was to spend working time in Wangford in the 1930s. Stanley's first wife Hilda Carline (1889-1950)—also a Sole Bay exhibitor—had been a Land Girl there in the 1914-18 war, and when his fortunes and spirits were at a low ebb he revisited old haunts and painted some fine landscapes, which he regarded as pot-boilers. His much-reproduced 1937 painting of Southwold beach hangs in Aberdeen City Art Gallery, and was shown in 'The Walberswick Enigma' at Christchurch Mansion, Ipswich, in 1994.

Also at work on Southwold beach in 1937 was Claude Rogers (1907-79), co-founder of the Euston Road School with Victor Pasmore and Sir William Coldstream (1908-87). Coldstream was later to spend holiday periods in Southwold, staying near the lighthouse.

Two artists whose work in the town spanned the 1939-45 war were Frederick Baldwin (1899-1984) and Edward Bishop (1902-97). Baldwin's superb draughtsmanship and subtle use of watercolour perfectly matched his chosen subjects—boats, landing stages and riverside clutter. Bishop's painting, mostly in oils and much more concerned with rich colour and pattern, could scarcely have been more different.

In the 1950s many visitors to the town still came by rail as far as Halesworth, and were given an introductory glimpse of the Blyth by prints of watercolours then to be found above the seats in railway compartments, by Eric Scott (1904-60). Much of this artist's work survives in private collections locally, and he was represented in the Walberswick Enigma exhibition in 1994.

My chosen cut-off point of 1960 was a time of dramatic change. A whole new generation of artists was starting to colonise the area, providing copious material for further study. No living artists have been included in this brief survey, and for reasons of space many with reasonable claim for inclusion have been omitted. Artists visiting the town today find a place which is much more exposed and cosmopolitan than the slightly bleak and mysterious place their forebears would have found, yet the magic remains unextinguished.

Bibliography

McConkey, Kenneth, *British Impressionism* (Phaidon Press, 1989)

McConkey, Kenneth, *Impressionism in Britain* (Yale University Press/Barbican Art Gallery, 1995)

Billcliffe, Roger, *Architectural Sketches and Flower Drawings by Charles Rennie Mackintosh* (Academy Editions, 1977)

Hudson, Derek, *Charles Keene* (Pleides Books, 1947)

Langley, Roger, *Walter Langley—Pioneer of the Newlyn Art Colony* (Sansom & Company/Penlee House Museum & Gallery, Penzance, 1997)

Exhibition catalogues of The Royal Academy of Arts and of The Royal Society of British Artists

Acknowledgments

The late Derek Allen, Chloë Bennett, R.R. Brown, George Bumstead, Mary Clayton, Elizabeth Crittall, Eveline Hastings, Ipswich Museum & Galleries, John Hill, Ros McDermott, Edna Mirecka, Michael Parkin, David Routledge, Margaret Sanders, Southwold Museum, David Thompson, Rebecca Weaver, Roderick Winyard.

Conclusion

JOHN MILLER

Like the town itself, the Southwold Museum is small but perfectly formed. Situated in Victoria Street, the building was among the houses built after the Great Fire of 1659 which destroyed much of the town. It was called Dutch Cottage—reflecting the Dutch influence—and it could well have been a weaver's cottage before becoming home to two families and eventually being given to the town in the 1930s to be used as a museum.

Every year some 9,000 people visit the Southwold Museum, which is open for seven months of the year. They are not disappointed. It is a gem of a small museum, and here unfolds the historical panorama of Southwold and its people over the years: its rise from a small fishing community within the bounds of the parish of neighbouring Reydon to an extraordinary, charming, but living town perched on the pebbly edge of eastern England.

Southwold has been called by many names over the centuries—variously Suwald, Sudholda, Southwaud, Southwood (almost certainly named from a wood near it), and even Stole and Sole. And it has known some tragic moments. From time to time the town has suffered much from fires. The first on record occurred in 1591, when the place was pitifully defaced by a fire on a Friday. But the greatest calamity—until the 1953 Great Flood—was the fire of 25 April 1659. Unlike the Great Fire of London there are no records about how and where it started. But in the space of four hours and fanned by the sort of wind that blows so often in these parts it effectively wiped out the town.

Thomas Gardner, the town's historian, wrote in 1754 that the fire consumed the Town Hall, the Market House, the Market Place, the prison, granaries, shops, warehouses, and 238 houses and other buildings. More than that, the fire destroyed fishing nets and tackling, as well as corn, malt, barley, coals and other merchandise. Some three hundred families were ruined.

The good people of Yarmouth sent food and money for the poor. But it was not enough, and the Bailiffs petitioned for help to the king and Parliament in London. The 'Keepers of the Liberty of England' promptly met the request and urged churchmen and authorities throughout the country to collect money for the suffering of Southwold. It was believed to be the first general collection ever made in church in England.

So bad and bleak was Southwold's future that many families moved away and it took a hundred or so years for the town to regain its former importance. But there was some good news for some people. The fire destroyed all the important documents kept in the

Town Hall relating to so-called copy-holders, and thus they suddenly became freeholders and much less shackled to the town's authorities.

Southwold had to be entirely rebuilt. Some of the labour force were Dutch seamen who had been taken prisoner at different times—hence the Dutch gables and brick-coursing on the Museum and a few other buildings.

Nearly three hundred years later another major disaster was to hit Southwold, now a unique tourist centre and home of a major independent brewery. Standing as it does in a very exposed position on the East Coast, the town and its shoreline, with fishing huts and boats, have taken a battering over the years. There was a severe storm in March 1906, when gales whipped up a sea which struck already damaged sea defences and washed away large tracts of the cliff. In 1938 a very heavy sea fanned by a cruel northerly gale accompanied the tide and wreaked devastation on dozens of beach huts and the pier, as well as flooding the marshes and the end of Pier Avenue.

But the Great Flood of 1953 was something else. Hurricane force winds combined with high tides swamped the sea defences along the East Coast from Lincolnshire to Kent, and Southwold suffered too. The cliffs protected the town itself but it was surrounded by water and cut off from the mainland for more than 48 hours—effectively once again what it had been for centuries, an island.

Three elderly ladies and a woman and her son living in Ferry Road were drowned and their homes washed away. In all about thirty homes were seriously damaged, some of those

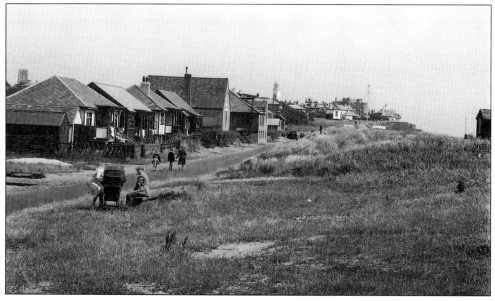

137 Ferry Road in the early 1930s.

in Ferry Road totally wrecked. Many people had to be rescued by local lifeboatmen and others.

The 1953 floods led to a major strengthening of the sea defences around the town. A sea wall was built north of the pier to the cliffs at Easton Bavents, and other defences protect Ferry Road. Only time will tell how effective they will be if there is ever a repetition of the Great Flood.

People have also determined the character, the style and the look of Southwold by their life and work. A great debt is owed to Thomas Gardner who wrote the first history of the town—and of Dunwich and Blythburgh—which appeared in 1754. One of his theories was that the Danes camped in the area when they invaded the country in 1010. Gardner married twice, and is buried in the churchyard between the graves of his two wives who predeceased him. He was not without a sense of humour: his headstone reads 'Between Honour and Virtue here doth lie the remains of old antiquity'.

Southwold's most important social document was compiled by James Maggs, schoolmaster, auctioneer and general factotum. From 1818 to 1871 Maggs chronicled local events, putting the texture of small town life under the microscope. With scrupulous accuracy and an eye for the interesting and unusual, Maggs recorded the fortunes as well as the misfortunes of traders, fishermen and other fellow townsmen. His diary became largely a chronicle of the lives of ordinary people. When he came to live in Southwold in 1818 it occupied only the southern half of its present site. At one time he was bailiff, borough surveyor, and ground rent collector—a town official—and when he died in 1890 at the age of 93, Southwold realised that it had lost a great character. He was buried in St Edmund's churchyard and his tombstone merely notes his name and dates of birth and death, as terse as any entry in a remarkable diary that is his true monument.

Agnes Strickland was another important historian whose name is linked to Southwold—in fact for 100 years she was one of the most popular and widely read of all British historians. But her canvas was not Southwold, where she moved from Reydon Hall, settling with her sister in Park Lane. Her *Lives of the Queens of England*, a series of 12 volumes published between 1840 and 1848, spanned the reigns of Matilda of Flanders to Queen Anne, her greatest achievement being that she was the first historian to focus exclusively on the female lines who had previously been relegated into the shadow of their male partners or parents. The marble scroll on the grave of Agnes Strickland in St Edmund's churchyard states that she was 'Historian of the Queens of England'.

Another formidable woman who spent much of her life in Southwold has also left her mark. She was Fanny Foster, who went to Saint Felix School shortly after it was opened at the turn of the century, and then in 1910 to Newnham College, Cambridge. On her return to Southwold she studied photography and book-keeping and learned the rudiments of Serbo-Croat. Shortly after the First World War she settled down to spend the rest of her

life in Southwold, and the conservation of the town, constantly threatened by development, became her passion.

Emerging as the town's leading lady, she opposed those who wished to modernise Southwold and its amenities and turn it into a money-making holiday resort like others along the East Coast that were attracting many thousands of people. Fanny Foster served on the Town Council for 32 years, was three times Mayor and became a Freeman of the Borough in recognition of her 'untiring services to Southwold and vigilance in seeking to preserve all that is good in the life and character of the Borough'. In 1974 at the age of 83 she was found unconscious in the street. She had been hit by a boy on a bicycle whom she refused to name. She never fully recovered, and died the following year. Her funeral was a grand occasion, for she typified the spirit of Southwold.

Fanny Foster may or may not have been Southwold's most prominent person for many decades, but there can be no doubt that Gun Hill is the most prominent feature of the town. It is an open grass plot between some fine houses and the sea. It has a Casino, a little octagonal building put up in 1830 as a reading room, but those days are long gone. Once in the late 19th century it was the Conservative Party headquarters in Southwold. Eventually it became the Coastguard lookout, and now it has become the museum of the Royal National Lifeboat Institution.

Once there was some kind of fort on Gun Hill and until recent times its foundations could be traced on the turf. But Gun Hill's attraction to families across the years has been six old cannon—great for children to climb on and be photographed. These are Tudor guns, and some of them bear the emblem of the Tudor Rose and Crown.

Some interesting but fanciful stories are told about the guns. Tradition says the guns were captured from Bonnie Prince Charlie at the Battle of Culloden in 1746 by the young Duke of Cumberland. Sailing back from Inverness after his victory—according to the story—he stopped off at Southwold and delighted by his reception he presented the guns to the town. A good story, but like so many good stories it is alas far from the truth.

It is now generally accepted that the guns were issued by the Master of the General Ordnance in 1746 for coastal defence as a result of a petition to King George II by the inhabitants of the Borough. From time to time they were used for festive occasions, and were last fired on the Prince of Wales' birthday in 1842. On this occasion one cannon failed to fire, and a volunteer gunner took a look down the bore to see what the reason was. His head was blown off. There were no more firings of the Gun Hill cannon after that.

The guns also had a curious role to play in the two world wars. In the First World War Southwold was bombarded because the Germans decided that the cannon suggested the town was fortified. Came 1939 and the guns were removed immediately. At the time there was a nationwide drive to collect scrap metal for making tanks and guns, and it was suggested

that Southwold do its bit for the war effort and offer up four cannon. The Council disagreed, and the guns were saved.

Gun Hill remains a special place for local people and for visitors. In 1995 thousands of people followed the Southwold & Reydon Corps of Drums to Gun Hill for a moving ceremony to mark the 50th anniversary of the end of World War Two. Like so many of the events staged in Southwold, it was absolutely 'right'.

The Southwold calendar is extraordinary. Although no longer a Borough, Southwold has preserved all the trappings of one, including Beating the Bounds, said to be an old Roman ceremony and held every few years during the summer. The Mayor and Councillors and others interested enough will walk the boundaries of the town carrying long, thin sticks, which in former times would be used to beat or bump small boys accompanying the party. Plenty of time is allowed for rest and refreshment on the four and a half mile route.

And finally, one of the quaintest of all of Southwold's ceremonies is that tied to the town's Charter, granted by Henry VII. There is a Fair on South Green, and the Mayor and Councillors, Mace-Bearer and Bellman, in brilliant robes and old-time liveries, walk in procession to open the Fair, then to two other places in the town to hear the Town Clerk read out the words of the Charter. These unique ceremonies—and the Christmas Lights switch-on in the first week of December—are why Southwold is such a very special and charming place. May it always be so!

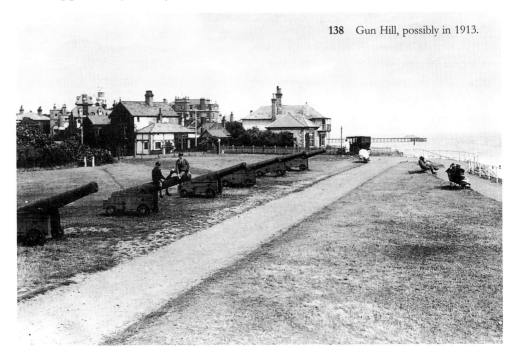

138 Gun Hill, possibly in 1913.

Acknowledgements

In the months during which we have been preparing this book we have been delighted by the immediate and generous help we have received. Lady James, in her Foreword, notes that the book has been written by the people of Southwold. But apart from the authors and the illustrators, brief biographies of whom appear elsewhere in this book, there are many others whose ready assistance we wish to acknowledge.

For information and anecdotes, we especially thank John Alington, Dennis Ball, Brian Burrage, David Smith, Colonel I.L. Watkins and Squadron Leader Jonathon White. Berta Browett and David Lee, curator and librarian respectively at the Southwold Museum, have been an invaluable source of historical facts—the discussion of which usually led to finding something else that had to be included somewhere in this book.

The two major sources of historical pictures have been Southwold Town Council and Southwold Museum. We are greatly indebted to the Town Council for permission to use pictures from its archive of glass photographic plates and early negatives, and to John Wells, who made such excellent prints from them. The Town Council also gave us access to the Gooding Collection, from which we have been able to include engravings documented at the turn of the century by Donald Roper Gooding, one-time Town Clerk of Southwold. The photographic archive at Southwold Museum was most generously made available for our picture search, and again Berta Browett and David Lee were more than helpful with their authoritative advice. Other pictures are from private collections: we should like to thank Adnams Brewery, John Alington, Dennis Ball, George Bumstead, Tom Gardner, John Goldsmith, David Lee (for use of his personal photographic collection, including photographs by Dr. I.C. Allen and A.R. Taylor), Jack Parnell, Bernard Segrave-Daly, John and Brenda Smith, Southwold Golf Club, Southwold RNLI Museum, Jane Williams and John Winter. Andrew Jenkins kindly gave permission for the use of photographs taken by his father and his grandfather, A. Barrett Jenkins and F. Jenkins, and thanks are also due to Stephen Wolfenden for the prints he made from the Adnams collection.

There are three original maps. The first, a conjectural map of how Southwold appeared when Domesday Book was compiled, was researched by Tom Gardner and drawn by Jasmine Arustu. The map of the route of the Southwold Railway line was drawn by Nancie Pelling, and the map of Southwold's prominent features, present and bygone, was drawn by John Bennett.

Thanks, also, to those who have offered help with the commercialisation of the project, including Simon Loftus and Cathy Oliver of Adnams Wine Merchants, Pam Calver, Jackie Cheek and Clare Trayler of the Norwich & Peterborough Building Society, Paul Ogden of

Bookthrift, Rosemary Stoodley of the Orwell Bookshop, Dudley Clarke and Sheena Doy of Adnams Hotels, and the Southwold Archaeological and Natural History Society. Many others have helped by their suggestions, practical advice and encouragement, and we apologise for not mentioning them all by name.

Our daughter Erika suggested that we should contact Lady James and ask her if she would contribute a Foreword to the book. Her immediate and enthusiastic response of 'Yes!' was an enormous boost to our enterprise—as her name will undoubtedly be of benefit to the project to which the book's royalties are dedicated. Her association with the project is gratefully acknowledged.

When Stephen and I decided to put this book together we knew that there was a great well of expertise and scholarship in Southwold waiting to be tapped. It was easy to draw up a list of possible subjects to be covered—but someone with extensive local knowledge was needed to suggest exactly who should be approached. Southwold's Local History Recorder, Ros McDermott, gave us all the information we needed, and without her help this book would never have happened.

<div style="text-align: right">REBECCA CLEGG</div>

Biographies

JOHN BENNETT is an architect with a practice in Southwold, where he also lives with his family. Originally from London he has, in addition to architectural practice, taught at schools of architecture in this country and in the USA. He has drawn the elevated map of Southwold, reproduced as endpapers to this book.

GERALDINE BRYANT was born in Southwold. She trained as a teacher, and taught at primary level in Southwold and Lowestoft. She is married with three children; she has begun her third term as Town Councillor, and was Town Mayor from 1996 to 1998.

The cover of this book is from an original watercolour of Southwold Market Place by MICHAEL BULLEN. After a brief career as a surveyor Michael worked as a freelance photographer and travelled extensively, working for charities in Britain, Africa and India. While living in France he taught himself to paint and since then he has been based in Suffolk working full-time as an artist, holding more than 30 one-man exhibitions both in Suffolk and in London.

GEORGE BUMSTEAD: 'My character is flawed by an inability to say "no" to almost anything I am asked to do, which in a nutshell is the story of my life. There was a time when I was involved in about sixteen different organisations and trusts, in all of which I held some sort of office. The most notable of these were two excursions into the corridors of power, that of County Magistrate and General Commissioner of Taxes, unpaid jobs that required the skill of distinguishing fact from fiction. My only form of recreation has been amateur showbiz.'

DUDLEY E. CLARKE arrived in Southwold in April 1988, originally to manage *The Crown* but some nine months later was placed in charge of the major refurbishment at *The Swan,* which he managed for the next five years. Having served in the Royal Air Force for 20 years, Dudley has also made his mark with Fortnum & Mason and Waitrose and, prior to joining Adnams, ran his own pub, the *Three Horseshoes* in Charsfield, known for its connection with the book by Ronald Blythe, *Akenfield*. Dudley is General Manager of Adnams Hotels and Chairman of the Southwold Christmas Lights Committee.

BARBARA DAVIS: 'I have known and loved Southwold since childhood. I even met my future husband on the beach, our respective parents having adjoining huts for the holidays. When my husband retired in 1983 it was obvious to us that Southwold would become our permanent home. For several years I was secretary of the Southwold Hospital League of Friends and then, upon George Bumstead's retirement, became the Chairman, and am looking forward to the reconfiguration plan, starting this year.'

TOM GARDNER: 'For my interest in Southwold I am indebted to my grandfather, who often visited Dunwich, and to my mother, who used the Belle Steamers when returning home to Bedfordshire from Gorleston where she was teaching. It was actually in 1936 that I became so fascinated by the geology of Easton cliffs that I made up my mind to make it a definite research study, so from 1952 onwards to 1967 I came down twice a year to work upon the cliffs to build up a collection of the bones washed out during high tides. From 1968 to date I have recorded and photographed the geological exposures in East Suffolk, and also made detailed investigations into the antiquities of East Suffolk. I must remark how very helpful everyone has been in encouraging me to pursue this extremely rewarding task.'

JOHN GOLDSMITH: Born in Southwold. Joined the Southwold lifeboat crew in August 1963 and received RNLI Long Service badge in 1988. Helped to establish the Lifeboat Museum in 1976, initially in the Old Water Tower on The Common and now in the Casino on Gun Hill. Received the RNLI Silver Badge for work with the museum in 1997. Has served on Town, District and County Councils.

FELICITY GRIFFIN, née Dobson. Daughter of a Rector of Huntingfield, Suffolk. Educated at Felixstowe College. Wartime service in the WAAF. Married, in 1946, Paul Griffin. East Anglia Tourist Board Blue Badged tourist guide with interests in ecclesiastical and local history. Thirty years resident in Southwold.

JENNY HURSELL: 'I moved to Suffolk in 1979 because I was loth to bring up my two daughters in London. After a year in Westleton we moved to Reydon, and have lived there ever since. In 1985 I was lucky enough to be offered the position of Clerk to Southwold Town Council. This must be the most interesting part-time employment available, combining as it does the work of a local government officer, estate manager, events organiser and archivist. It has been a privilege and, for the most part, a pleasure to work in the Town Hall and learn what makes a community tick.'

RACHEL LAWRENCE, M.A. and her husband came to live in Southwold when he retired in 1980. She had been enjoying, over many years, professional research on business histories, including ICI and the electricity industry, and in Suffolk she was greatly attracted by the stories of the Blyth Navigation and of the merchants and landowners for whom the river was so important. Now a great-grandmother, her interest in the Blyth Valley has not diminished.

DAVID LEE: 'The subject of railways, both model and the real thing, has been a source of fascination to me and later a great interest. Having travelled on the Southwold Railway at a tender age my enthusiasm for it developed over the years resulting in the decision to research its history in depth since around 1978. The work is still not complete, but in time I intend producing a full account of the Company's activities. Matters of a maritime nature have also appealed to me, particularly historical events, and after reading a book on lighthouses which included Southwold I observed the date quoted did not agree with other sources; ultimately I was able to consult the archives of Trinity House and establish the correct dates contained here in the chapter on the Southwold lighthouses.'

JOHN MILLER has lived in Southwold since 1987. For many years he was a foreign correspondent and a specialist on Soviet-Russian affairs. He serves on the Town Council and takes an active interest in the town's life. He is the author of *The Best of Southwold*, an anthology.

DR ZOË RANDALL: The Randalls have had a house in Southwold since 1979 and retired here permanently in 1986. Zoë was a doctor in Sheffield, initially in general practice then a consultant radiotherapist and oncologist. History has always been a major interest. When her husband was curator of the Southwold Museum in 1989 he mounted a prize-winning exhibition of Local Trades to mark the town's Charter Year, which stimulated her to research this topic. She is active in the Southwold WEA and enjoys being a Town Guide.

RICHARD SCOTT is a painter and writer, with a special interest in the history of Walberswick, Southwold, Blythburgh and Dunwich as an artists' Mecca. For some years before retirement he was a lecturer in the School of Art and Design at Suffolk College, Ipswich.

BERNARD SEGRAVE-DALY is Deputy Chairman and Production Director of Adnams, which he has served for 34 years. A founder member of Southwold Rugby Club, he enjoys tennis too. Originally from Ireland, he is Chairman of two Charitable Trusts, a Housing Trust for homeless people, the R.C. Diocesan Pastoral Council until recently, and a General Commissioner of Taxes.

The atmospheric colour photographs of Southwold in all seasons, and many of the modern photographs illustrating the text, have been taken by RICHARD WELLS. Richard has followed in the family tradition of professional photography, winning several awards including an entry in the prestigious Fujifilm calendar. Inspired by the local landscape, more of his work can been seen on display in his shop in Queen Street.

JOHN WINTER was born in Southwold in 1932, went to Southwold and Reydon schools, left at 14 to become a painter and decorator's apprentice, spent two years National Service in the RAF, decided to go fishing for a living, then ran the caravan site and also became Harbour Master. He worked at Saint Felix School for the last few years before retirement. His hobbies include model making, fishing and playing jazz on a cornet. He has been a member of the Town Council since 1972 and has twice been Town Mayor.

Index

Page numbers in **bold** refer to plates.

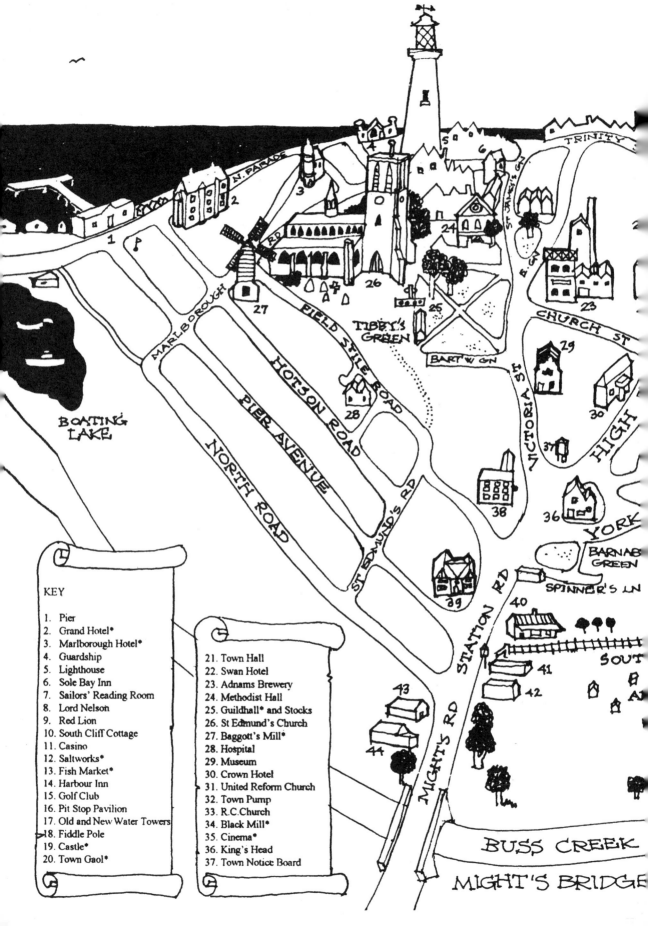

KEY

1. Pier
2. Grand Hotel*
3. Marlborough Hotel*
4. Guardship
5. Lighthouse
6. Sole Bay Inn
7. Sailors' Reading Room
8. Lord Nelson
9. Red Lion
10. South Cliff Cottage
11. Casino
12. Saltworks*
13. Fish Market*
14. Harbour Inn
15. Golf Club
16. Pit Stop Pavilion
17. Old and New Water Towers
18. Fiddle Pole
19. Castle*
20. Town Gaol*

21. Town Hall
22. Swan Hotel
23. Adnams Brewery
24. Methodist Hall
25. Guildhall* and Stocks
26. St Edmund's Church
27. Baggott's Mill*
28. Hospital
29. Museum
30. Crown Hotel
31. United Reform Church
32. Town Pump
33. R.C.Church
34. Black Mill*
35. Cinema*
36. King's Head
37. Town Notice Board